# CINCINNATI
# STREETCAR
## HERITAGE

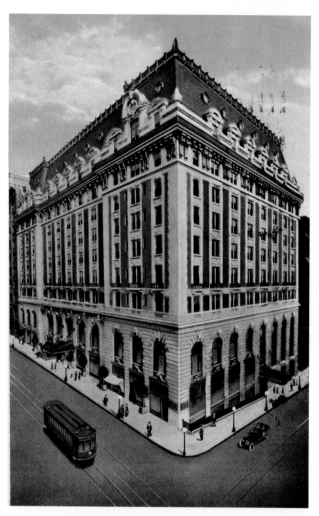

*Left:* A Cincinnati Street Railway Company car is passing by the historic Hotel Sinton on Vine and Fourth Streets in Cincinnati's central business district in this postcard scene around 1910. According to the *McGraw Electric Railway List August 1918*, the Cincinnati Traction Company operated 1,287 streetcars on 227.99 miles of track. The Hotel Sinton with its "French Second Empire" architectural look (characterized by its Mansard roof with dormer windows and tall windows on the first floor) was opened in 1907 and demolished in 1964. Vine Street, the dividing line for the east and west side of Cincinnati, bisects the downtown neighborhood and the Over-the-Rhine neighborhood.

*Below:* In 1949, Cincinnati Street Railway Company car No. 2428 is on Winchell Avenue in front of the Brighton car house on a rail excursion. This curved side car was one of 75 "curved side cars" Nos. 2400-2474 built by Cincinnati Car Company and delivered in 1923. Each of these cars was powered by four type 510-A motors and seated 46 passengers. These cars introduced one-man operation in Cincinnati. (Pat Carmody photograph—Clifford R. Scholes collection)

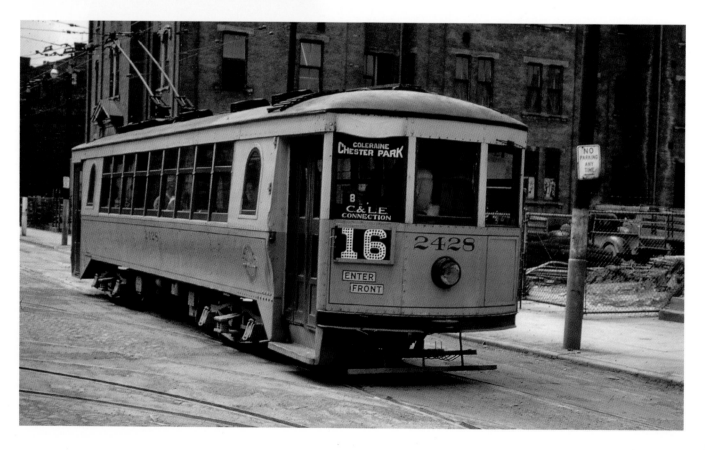

# CINCINNATI STREETCAR
## HERITAGE

KENNETH C. SPRINGIRTH

AMERICA
THROUGH TIME®
ADDING COLOR TO AMERICAN HISTORY

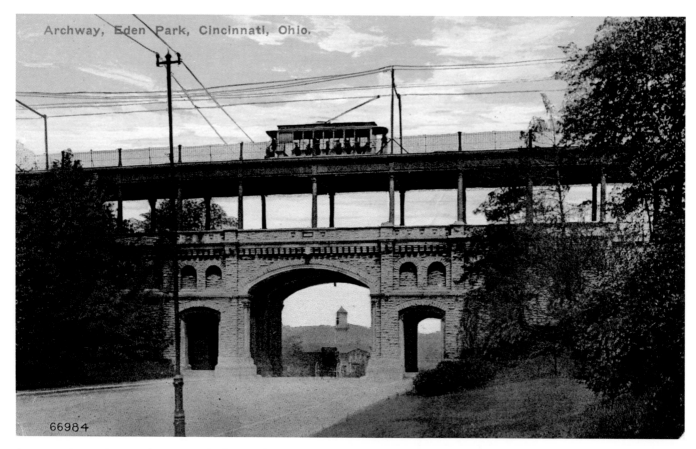

Archway, Eden Park, Cincinnati, Ohio.

66984

A streetcar is crossing over the entrance bridge to Eden Park in this postcard scene around 1900. On November 16, 1877, the Mount Adams & Eden Park Inclined Railway received a charter to build a horse car line from the Ida Street incline depot through the park grounds over the entrance bridge to Gilbert Avenue. The company was required to repair the stone bridge over the park entrance and build an ornamental iron superstructure. The line though Eden Park was electrified in 1890. Buses took over this line in 1947.

*On the top portion of cover:* On May 7, 1950, Cincinnati Street Railway car No. 2258 is on Burnet Avenue and Katherine Street on a rail excursion over route 46. This was one of 105 cars Nos. 2200-2304 built by the Cincinnati Car Company in 1919 for the Cincinnati Traction Company. Weighing 39,500 pounds and seating 48 passengers, each car was powered by four Westinghouse type 532 motors. Known as the 2200 series cars, these cars provided dependable service for 30 years and could handle heavy passenger traffic and steep hills. (Clifford R. Scholes photograph)

*On the bottom portion of cover:* Route 61 on Ludlow Avenue east of Middleton Avenue is the location of Presidents' Conference Committee (PCC) car No. 1170 operating on a rail excursion over the Cincinnati Street Railway system in 1950. This was one of 25 PCC cars Nos. 1150-1174 built by St. Louis Car Company in 1947. (Pat Carmody photograph—Clifford. R. Scholes collection)

*Back cover:* Open air observation car "Hiawatha" (named after an old parlor car) is on Woodbine and Anthony Wayne Avenues for a rail excursion at the route 74 terminus on May 20, 1939. This car was built by removing the top part of car No. 1894 from the window sill line making a roofless car. With terraced seats for 46 passengers and painted a brilliant cream with well-designed stripes, the car was placed in service on July 2, 1939. (Pat Carmody photograph—Clifford. R. Scholes collection)

America Through Time is an imprint of Fonthill Media LLC

First published 2017

Copyright © Kenneth C. Springirth 2017

ISBN 978-1-63499-033-2

Typeset in Utopia Std

Published by Arcadia Publishing by arrangement with Fonthill Media LLC

For all general information, please contact Arcadia Publishing:

Telephone: 843-853-2070
Fax: 843-853-0044
E-mail: sales@arcadiapublishing.com
For customer service and orders:
Toll-Free 1-888-313-2665

Visit us on the internet at www.arcadiapublishing.com

# Contents

# Acknowledgments

Thanks to the Erie County (Pennsylvania) Public Library system for their excellent interlibrary loan system. Numerous pictures were purchased from Clifford R. Scholes. Books that served as excellent reference sources were *Cincinnati Streetcars No. 1 Horsecars and Steam Dummies* by Richard M. Wagner and Roy J. Wright; *Cincinnati Streetcars No. 3 Cable Cars and Earliest Electrics* by Richard M. Wagner and Roy J. Wright; *Cincinnati Streetcars No. 5: 1895-1911* by Richard M. Wagner and Roy J. Wright; *Cincinnati Streetcars No. 6: 1912-1922* by Richard M. Wagner and Roy J. Wright; *Cincinnati Streetcars No. 7: Progress and Prosperity* by Richard M. Wagner and Roy J. Wright; *Cincinnati Streetcars No. 8: Through the Thirties* by Richard M. Wagner and Roy J. Wright; *Cincinnati Streetcars No. 9: Streamliners and War Horses* by Richard M. Wagner and Roy J. Wright; *Cincinnati Streetcars No. 10: To the End of the Track* by Richard M. Wagner and Roy J. Wright; *The Trolley Coach in North America* by Mac Sebree and Paul Ward; and *PCC Cars of North America* by Harold E. Cox. Thanks to the Pennsylvania Trolley Museum located at 1 Museum Road in Washington, Pennsylvania (telephone number 724-228-9256) for acquiring and restoring the last operating streetcar of the Cincinnati Street Railway Company.

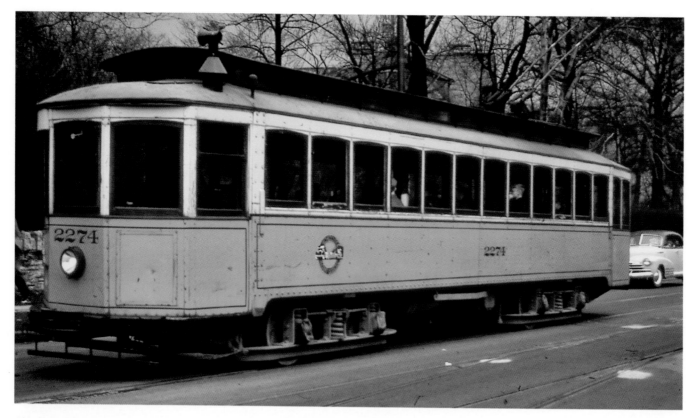

Cincinnati Street Railway Company car No. 2274 is at a photo stop on Oak Street and Reading Road for a 1949 rail excursion. Cincinnati Car Company built the 105 cars of the 2200 series Nos. 2200-2304 in 1919 at a cost of $7,061 per car. Weighing 39,500 pounds, each car was powered by four Westinghouse type 532 motors and had Elliott type 50D trucks which had a bar encircling the entire truck. (Clifford R. Scholes photograph)

# Introduction

The Cincinnati Street Railroad Company opened Cincinnati's first horse-drawn street railway on iron rails laid in the street on September 14, 1859. It operated from Fourth and Walnut Streets via Walnut, Ninth, Baymiller, Maple (now York), Freeman, Western Row (now Central Avenue), Seventh, Vine, and back to Fourth. Other horse drawn street car companies built new lines. During 1873, a number of lines were merged into the Cincinnati Consolidated Railway and the East & West End Street Railroad Company. In June 1880, another merger of street railway companies resulted in the formation of the Cincinnati Street Railway Company.

A steam dummy locomotive was tested in Cincinnati in 1860, but was not placed in regular service as it terrified horses. The Mount Lookout & Columbia Steam Dummy Railroad was placed in service on May 10, 1882, and was abandoned July 4, 1897.

On July 17, 1885, the Mount Adams & Eden Park Inclined Railway Company completed Cincinnati's first cable car line on Gilbert Avenue. The Vine Street cable line was opened by the Cincinnati Street Railway in 1887 followed by the Mount Auburn Cable Railway which opened in 1888.

In June 1888, the Mount Adams & Eden Park Inclined Railway Company had the Daft Company electrify its cable car line on McMillan Street from Gilbert Avenue to Oak Street and Reading Road. On July 29, 1896, the Mount Adams & Eden Park Inclined Railway Company became part of the Cincinnati Street Railway Company. During 1896, with the exception of the outer portion of the Cincinnati Inclined Plane Railway from the Zoo to Carthage and lines in northern Kentucky, street car lines in Cincinnati were now operated by the Cincinnati Street Railway Company. The Gilbert Avenue Cable line became an electric line on January 2, 1898, followed by the Vine Street cable line was on September 17, 1898. At midnight on June 10, 1902, cable car service ended on the Mount Auburn Cable Railway, which was the last of Cincinnati's three cable car lines.

Since the horse car rails had not been electrically bonded, they could not be used for the return path for the electric current collected by the trolley pole. There were restrictions on digging up the streets to bond the track. Current leakage could accelerate corrosion of underground conduits and water piping because of electrolytic reactions. Hence a double overhead wire (two wires for each track) was installed over the system except for the portion of route 78 outside city limits.

Cincinnati; Merrill, Wisconsin; and Havana, Cuba, were the only North American cities that had a double wire system. On April 3, 1898, electric streetcar service connected St. Johns Park at Delta and Erie Avenues in Cincinnati to Madisonville.

With approval of the City of Cincinnati, on February 21, 1901, the Cincinnati Street Railway Company leased everything to the Cincinnati Traction Company which would operate the streetcar lines, make all necessary extensions and improvements, and pay an annual rental sufficient to pay five percent interest at the end of 1901 and increase each year, reaching six percent at the end of 1905. The lease was to run to the end of the 50-year franchise that was granted to the Cincinnati Street Railway Company in 1896. Under Ohio laws, the Ohio Traction Company was organized to own the Cincinnati Traction Company, operate the property of the Cincinnati & Hamilton Traction Company, own the Cincinnati Car Company, and own the Traction Building at the southeast corner of Fifth & Walnut Streets. Cincinnati Traction Company track gauge was 5 foot 2.5 inches compared to the 4-foot-8.5-inch standard gauge used on railroads and most of the interurban rail lines.

During 1901, "high water" cars were constructed with motors above the floor and raised car bodies. These cars, built to go through four feet of water, were in service until the 1940s. In July 1901, the first electric switch was installed on the northwest corner of Fifth and Walnut Streets. Electric switches replaced switchmen at busy downtown intersections which speeded up streetcar movements. In September 1901, the Madisonville shuttle was replaced by through service from downtown Cincinnati to Madisonville. A downtown shopper's shuttle was started in 1901 every five minutes from Fifth and Walnut via Elm, Seventh, and Vine to Fountain Square from 8 a.m. to 6 p.m. On November 3, 1901, the railway purchased controlling interest of the Cincinnati Zoological Gardens, and in January 1902 took over its operation.

Cincinnati's last horsecar line, operating from the top of the Price Hill Incline to Hawthorne and Warsaw Avenues, made it last run on November 2, 1904, and was replaced by an extension of the Eighth Street car line. During 1907, the Cincinnati Traction Company began providing stools for the motormen to sit on because of motormen's concerns over the tiring long hours of standing on their feet and legs. Motormen were still required to stand when crossing intersections, up or down on steep grades, and at passenger stops.

Motormen and conductors (who made 23 cents per hour) of the Cincinnati Traction Company went on strike on the evening of Friday, May 9, 1913, for higher wages and recognition of their union. The company hired strikebreakers from other cities to operate the streetcars. Violence erupted; however, the strike ended on May 19, 1913, when the company agreed to recognize the union and an arbitration board was set up with agreement reached for a 25-cents-per-hour wage after two years, and 28-cents-per-hour wage after five years. The agreement noted that no matter what differences occur, there should not be a strike in the future. Wage and working condition issues that could not be resolved were left to an impartial Board of Arbitration which resulted in pleasant relations for many years.

As ridership increased, in 1914, 60 new trailers numbered 3000-3059 were purchased by the Cincinnati Traction Company from the Cincinnati Car Company. The first trailer was placed in service on February 5, 1914, on the Clark Street line. During 1916, the last new streetcar line in Cincinnati, route 42 (Bond Hill), was built from Reading Road and Clinton Springs via Paddock Road to the Baltimore & Ohio Railroad crossing north of Tennessee Avenue, which opened on December 17, 1916.

In 1916, Cincinnati voters approved a $6 million bond issue to build a subway rapid transit system. Construction began on January 28, 1920. About two miles of tunnel and seven miles of surface route was completed, but track was never installed. The subway was never completed. In 1966, the city's debt of over $13 million was paid off and the project was scrapped.

Beginning June 1, 1920, each route was assigned a number. The Winton Road line was abandoned on June 15, 1920, followed by the Norwood-Gilbert line on July 29, 1920. During 1921, the following streetcar track was abandoned: on Orchard Street, Mulberry Street between Main and Sycamore, Main Street between McMicken Avenue and Mulberry Street, the southbound track on Main Street between Ninth Street and Fourth Street, wire and poles were removed from Gray Road, Straight Street line between McMillan Street and Clifton Avenue, and streetcars were removed from the Fairview Incline. The Depot Street Power House was shut down on December 26, 1921. Streetcar service began on February 5, 1922, over a Warsaw Avenue extension; however, abandonments in 1922 included: Mitchell Avenue between Spring Grove and the Cincinnati, Hamilton & Dayton Railway; Court Street; and the Sedamsville line was single tracked from Riverside to Anderson's Ferry.

In January 1923, the first of 75 new "curved side" 2400 series cars, built by Cincinnati Car Company and designed by its chief engineer Thomas Elliott, was placed in service. Up to this time, Cincinnati streetcars had a motorman operating the car and a conductor collecting fares plus signaling the motorman when all passengers were on board or to stop for passengers to exit the car. While these new cars could be operated by one man or two men, they were placed in one-man operation with the fare box placed beside the motorman beginning February 23, 1923, on the Court House-Union Depot line. On May 23, 1923, the Court House-Union Depot line was discontinued, and one-man operation began on the McMicken-Main line with the new cars. One-man operation was successful and reduced expenses. The new cars were equipped for multiple unit operation on the city streets. However, the City of Cincinnati said no to multiple unit operation on city streets. The cars were changed to single unit control, and the couplers were soon removed.

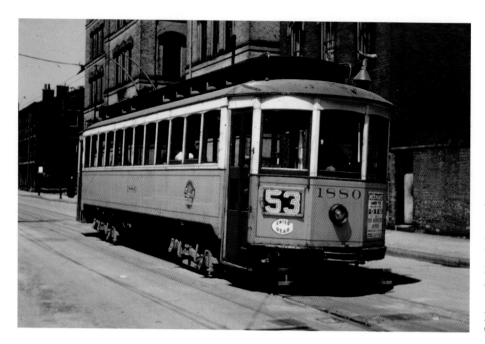

In 1947, Cincinnati Street Railway Company (CSRC) car No. 1880 is at Woodward and Sycamore Streets on a rail excursion. This was one of 50 double truck closed cars Nos. 1850-1899 built by the Cincinnati Car Company for the Cincinnati Traction Company during December 1911 to January 1912, with a car body weight of 34,620 pounds. (Pat Carmody photograph— Clifford R. Scholes collection)

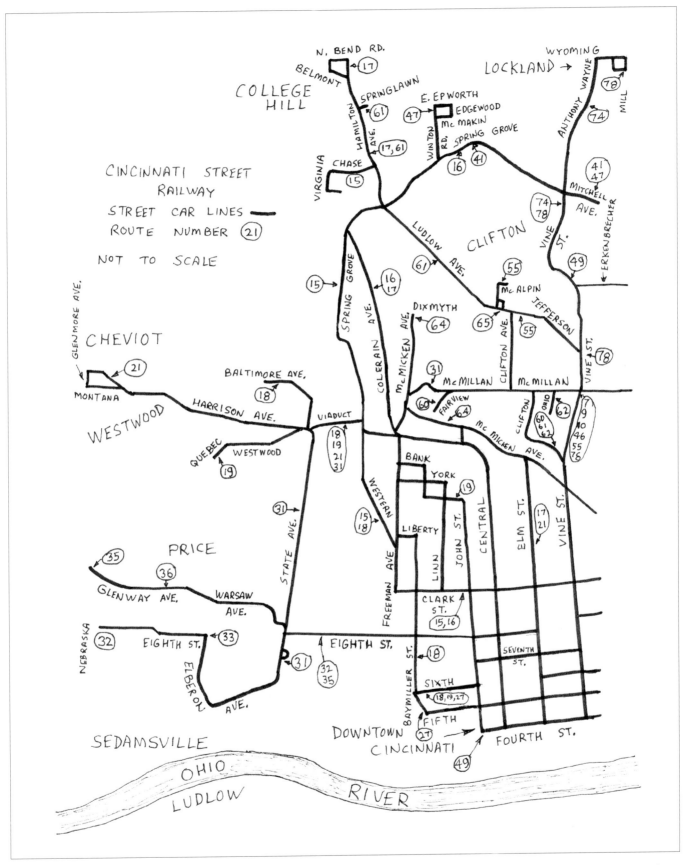

This is a map of the Cincinnati Street Railway Company from Vine Street to the west. The original Cincinnati Street Railway Company 1943 map showed route 15 (Clark Street) and 64 (McMicken-Main) as streetcar routes. However, trackless trolleys replaced route 15 street cars on December 1, 1936, and route 64 streetcars on October 9, 1938.

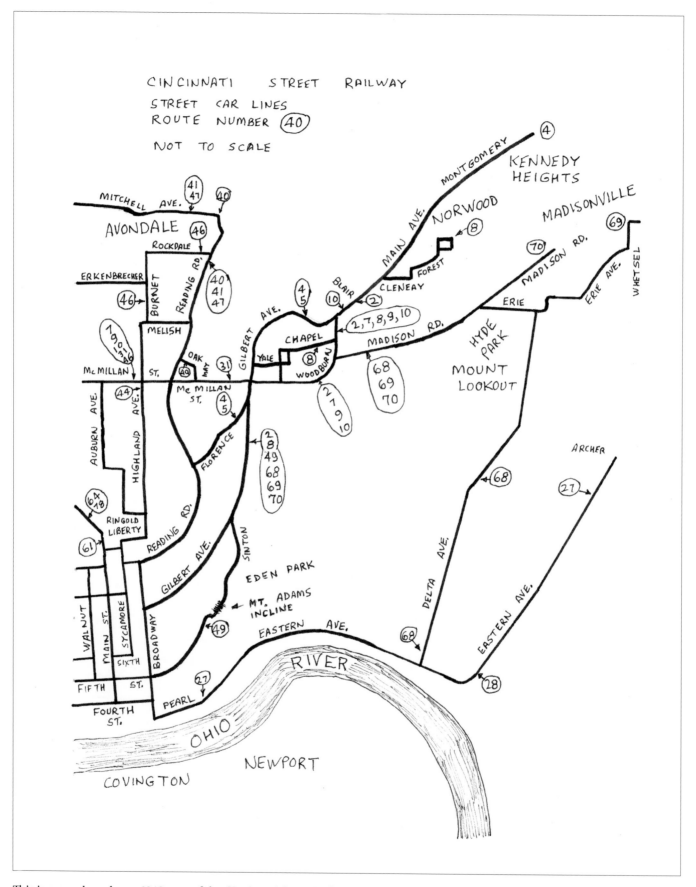

This is a map based on a 1943 map of the Cincinnati Street Railway Company east of Vine Street. Buses replaced route 71 (Milford) streetcars on August 24, 1936. Streetcar routes 30 (Fernbank) and 34 (Sedamsville) became bus route K on June 1, 1941.

# Chapter 1

# Cincinnati Street Railway Company

With the Cincinnati Street Railway Company under lease to the Cincinnati Traction Company, whose parent company was the Ohio Traction Company, concern was expressed by the Board of Directors of the Cincinnati Street Railway Company during the years prior to 1925 that the system had been allowed to deteriorate with track, equipment, and overhead wire not repaired or replaced as quickly as possible. The Cincinnati Traction Company countered that there was not enough money available to take care of the system. On November 1, 1925, the Cincinnati Street Railway Company (CSRC) once again began managing the system. Before the end of 1925, company policy was formed that buses would be used for service where they can perform it better or at less cost than streetcars. On April 4, 1926, CSRC began its first bus routes E (Clifton-Hyde) and route F (Cumminsville-Oakley) followed on May 2, 1926, by the Bond Hill-Lockland bus line on Reading Road, Paddock, 73rd street, Hartwell, and Wyoming to Lockland. The Bellevue Incline closed on June 6, 1926, and streetcar route 62 began service from the head of the incline via Ohio Avenue to McMillan Street and downtown via Clifton Avenue. Streetcar route 60 was changed to go to Fairview via Clifton instead of using the Bellevue Incline. On July 15, 1926, the Glendale-Hamilton streetcar line was discontinued followed by the Edwards Road line on July 28, 1926. Beginning October 17, 1926, streetcar route 42 was reduced to morning and evening rush hour service. By the end of 1926, CSRC operated 62 buses on nine routes.

With the abandonment of the Cincinnati Milford & Blanchester Railway (CM&B) in January 1927, the CSRC obtained an eleven-mile section of the line from Hyde Park to Milford and operated it as route 71 (Mariemont-Milford). CM&B had the same track gauge as CSRC. Mariemont was important for being a planned community founded by Mary Emery and has been noted for its English architecture. Effective September 8, 1928, rush hour service on streetcar route 42 was discontinued making it the first Cincinnati streetcar line replaced by buses.

In 1928, the Winton Place car shops were completed at a cost of about $1,186,000 with a floor area of more than four acres. Streetcars were scheduled for overhaul every 60,000 miles.

The 102 million passengers carried in 1928 declined to 62.5 million in 1933 because of the Depression. On November 22, 1930, the Cincinnati, Lawrenceburg & Aurora Street Railway (CL&A) ended service. Route 30, operated by CSRC from Cincinnati to Anderson's Ferry, connected with the CL&A at Anderson's Ferry. CSRC purchased six miles of the CL&A from Anderson's Ferry to Fernbank. It was necessary to move one rail of the 4-foot-8.5-inch standard gauge CL&A six inches to match the 5-foot-2.5-inch CSRC track gauge plus a second overhead wire was added for the two pole CSRC system. South Eastern Lines, an independent bus line, serviced the remainder of the CL&A.

On July 29, 1931, route 43 (Depot-Hotels), which connected the Union Central Depot at Third and Central with downtown hotels, was discontinued and was replaced by route 49 (Zoo-Eden Park) which had its downtown terminus changed to Central Union Depot. During the building of the Cincinnati Union terminal, the double deck Western Hills Viaduct was constructed from Central Parkway at Brighton (top deck) and Spring Grove Avenue (Lower deck) across the railroad tracks in the valley to Harrison Avenue on the west side. Streetcar routes 18 (North Fairmount), 19 (John Street), 21 (Westwood), and 31 (Crosstown) used the lower deck, and buses plus motor vehicles used the upper deck. The Cincinnati Union Terminal was completed March 31, 1933. However, streetcars were almost four blocks from the terminal. As revenues continued to decline, route 7 (Norwood) was cut to rush hours only in 1932 with route 10 taking its place. On October 16, 1932, the Hartwell car house closed with its cars transferred to the Vine Street car house. The East End car house closed on November 15, 1932, with its cars transferred to the Hyde Park and Avondale car houses.

Cincinnati's first trackless trolleys replaced streetcar route 15 (Clark Street) on December 1, 1936. Streetcar route 71 (Milford) was replaced by buses on August 24, 1936. Heavy flooding shutdown all streetcar service in Cincinnati on January 24, 1937. Buses were used until streetcar service was restored on seven routes on February 2, 1937, and all streetcar service was operating on February 8, 1937. The Mount Adams Incline was kept in service during the flood.

On October 9, 1938, streetcar route 64 (McMicken-Main) was converted to trackless trolley operation. Ridership on the line had declined, and there was a need to replace track on a large portion of the line.

On November 23, 1938, one Brilliner was ordered from J. G. Brill Company followed by ordering one Presidents' Conference Committee (PCC) car from St. Louis Car Company plus one PCC car from Pullman Standard Car Building Company on December 20, 1938. The PCC car was the result of a cooperative effort of the Presidents' Conference Committee formed in 1932 by presidents of 25 of the larger United States streetcar companies working with car builders. The result was a beautiful streamlined car designed for quiet, comfortable, and fast operation. CSRC wanted to see which car would be the best for their riders, which is why the three different cars were ordered. The Brilliner car No. 1200 arrived on May 31, 1939, the Pullman Standard PCC car No. 1000 arrived two weeks later, and the St. Louis Car Company PCC car No. 1100 arrived on September 4, 1939. On December 12, 1939, CSRC ordered 25 PCC cars from St. Louis Car Company.

Open air observation car "Hiawatha," built from car No. 1894 with the top removed at the window sill line, made its first trip on July 2, 1939. Its seats were terraced up from the front of the car to give its capacity of 46 riders a clear view forward and upward. There were three trips from Fourth and Walnut Streets each evening with five trips on Sundays and holidays. With a successful response, a second car open air observation car "Maketewah" was built from car No. 1891 with the terraces of the seats not elevated as much as on the "Hiawatha." The "Maketewah" was placed in service on August 6, 1939.

On September 22, 1940, PCC car No. 1101 arrived from St. Louis Car Company. Route 21 (Westwood) received the new PCC cars in regular service on October 1, 1940, followed by route 69 (Madisonville) on October 25, 1940, and route 4 (Kennedy Heights) on November 1, 1940. CSRC streetcar routes 30 (Fernbank) and 34 (Sedamsville) were converted to bus operation on June 1, 1941. Streetcar service on the Mariemont line ended in 1942. On August 20, 1942, route 5 (Norwood) streetcar service ended, and additional streetcars were added to route 4 (Kennedy Heights). As part of the World War II effort, the "Hiawatha" was decorated as the "The Bond Wagon" to help sell United States war bonds. During the summer of 1942, tire and gas rationing resulted in a cutback of bus service. To fill that void, by January 30, 1943, 25 of the 2200 series streetcars were refurbished, repainted, and renumbered into the 400 series. In 1945, there were 433 streetcars, 34 trackless trolleys, and 261 buses in operation.

After World War II, in 1947, 147 buses, 30 trackless trolleys, and 25 PCC streetcars were ordered. On July 6, 1947, trackless trolleys replaced PCC streetcars on route 69 (Madisonville). Streetcar routes 44 (Highland) and 53 (Auburn) were converted to trackless trolley operation on August 17, 1947. By August 1947, 25 new PCC cars Nos. 1150-1175 were received from St. Louis Car Company. Later in 1947, the new PCC cars handled the basic service on route 78 (Lockland). On September 28, 1947, streetcar route 27 (East End) was converted to trackless trolley operation. Extensive rail replacement projects took place in 1947, including 10,400 feet of track on Eighth Street between Central Avenue and McLean Street, 7,000 feet on the Eighth Street viaduct, and 900 feet on Beekman Street. During 1947, buses replaced streetcars through Eden Park and on the Mount Adams Incline.

Streetcar route 31 (Crosstown) was converted to trackless trolley operation on April 11, 1948, followed by streetcar route 16 (Colerain) converted to trackless trolley on June 6, 1948, and streetcar route 17 (College Hill) converted to trackless trolley on June 27, 1948. On April 15, 1948, the Mr. Adams Incline was shut down for repairs. The repairs were not made, and the incline was torn down by 1954. Streetcar route 2 (Evanston) was abandoned on January 1, 1949; however, one daily trip was operated from January 24 to February 22, 1949. Trackless trolleys took over streetcar route 8 (South Norwood) on January 1, 1949. Streetcar service ended January 1, 1949, on route 9 (Vine-Norwood). Trackless trolleys replaced route 60 (Fairview) streetcars on March 6, 1949, and the line was combined with route 62 (Ohio Avenue) and became route 60 (Fairview-Ohio). Streetcar route 61 (Clifton-Ludlow) became a trackless trolley line on March 6, 1949, and its outer terminal was changed from Spring Lawn Avenue and Hamilton Avenue to Chase and Dane Avenues. On April 17, 1949, trackless trolleys took over streetcar routes 47 (Winton Place) and 41 (Chester Park). That same day, route 49 (Zoo-Gilbert) and bus route 49B (Mt. Adams) were merged into bus route 49 (Zoo-Eden) and route 40 (Avondale) was abandoned. Effective July 10, 1949, route 78 streetcars were cutback to Millsdale Avenue loop, and buses operated from that point via Anthony Wayne Avenue to the former Lockland loop. On July 24, 1949, trackless trolleys replaced streetcars on route 4 (Kennedy Heights), route 7 (North Norwood, and route 10 Vine-Woodburn).

In March 1950, the ten remaining CSRC streetcar lines represented 20 percent of the company's mileage. On June 18, 1950, trackless trolleys replaced route 68 streetcars with through service to downtown Cincinnati only during rush hours. At all other times, a shuttle bus operated from Delta Avenue and Erie Avenue, the connection point for route 69 (Madisonville) trackless trolleys, down Delta Avenue to Delta and Eastern Avenues which was the connection point for route 27 (East End) trackless trolleys. The loss of through fulltime route 68 streetcar service to downtown Cincinnati represented a major service reduction. Route A (Mariemont) buses replaced route 70 (Oakley) streetcars on June 18, 1950. With these changes, the Hyde Park car house, established in 1912, now housed only trackless trolleys. Trackless trolleys replaced route 46 (Vine-Burnet) streetcars on July 23, 1950. Route 46 was the last streetcar line housed at the Avondale car house. None of the seven remaining streetcar lines operated east of Vine Street.

With the decision made to eliminate all streetcar service, CSRC decided to sell the PCC car fleet. Officials of the Toronto

Transit Commission (TTC) inspected during 1950 the fleet of PCC cars built by St. Louis Car Company for CSRC and because of their excellent condition purchased the entire 52 cars Nos. 1100-1126 and 1150-1174 for about $750,000. Pullman built PCC car No. 1127 and Brilliner No. 1128 were not purchased by the TTC and were kept in service by the CSRC. PCC car No. 1122 built in 1940 was shipped by railroad flat car to the TTC on August 30, 1950, and in 1947 all-electric-built PCC car No. 1151 was shipped to the TTC on September 1, 1950, so that the TTC mechanical department could determine what changes would be needed for each group of cars. PCC cars series 1150-1174 were sent to the TTC at a rate of about three cars per week followed by cars series 1100-1126. With the departure of the PCC cars, CSRC had no problem meeting the August 1950 peak period requirement of 101 streetcars for the seven remaining streetcar lines.

With the closure of the Hyde Park car house on October 8, 1950, operators, mechanics and 52 trackless trolleys were transferred to the Hewitt Avenue car house. Heavy snow hit Cincinnati with six foot drifts on November 25, 1950, followed by another snow storm on December 7, 1950. Snow plows, salt cars, and sand cars were used to clear the streetcar tracks. CSRC 2400 series curved side cars built in 1923 were the company's most reliable streetcars operating during that harsh winter weather without any failure in service. A heavy February 1, 1951, snow storm with subzero temperatures contributed to overhead wire breaks.

On March 25, 1951, streetcar route 32 (Elberon Avenue) was converted to bus operation, streetcar route 35 (Warsaw Avenue) was converted to trackless trolley operation, and the Eighth Street car house was closed. The five remaining streetcar lines required 68 streetcars during peak periods. Three of the streetcar lines were housed at the Brighton car house: 18 (North Fairmount), 19 (John Street), and 21 (Westwood). Two streetcar lines: 55 (Vine-Clifton) and 78 (Lockland) were housed at the Vine Street car house. Saturday, April 28, 1951, was the last full day of streetcar operation. Trackless trolleys took over route 21 and route 55 on Sunday April 29, 1951. Route 18 was combined with bus route 49 (Zoo-Eden Park) by extending route 49 from Fourth over John Street following route 19 to Harrison and Beekman, and then following route 18 to Baltimore and Casper. The outer portion of route 19 from Harrison and Beekman to Quebec Road was covered by rerouting bus route C over Westwood Avenue between Beekman and Quebec Road. Brighton car house now housed only trackless trolleys. Route 78 (Lockland) was converted to bus operation with through service restored between Lockland and downtown Cincinnati. On April 29, 1951, CSRC car No. 129 made the last regularly scheduled streetcar trip in Cincinnati leaving Fifth and Vine Streets at 5:55 a.m. for the final route 18 trip, which arrived at 6:17 a.m. at Brighton car house.

In June 1951, negotiations began with the Philadelphia Transportation Company (PTC) with CSRC offering to sell the 100 series streetcars for $2,500 per car. PTC rejected the offer. CSRC made a counteroffer on July 13, 1951, to sell the 100 series streetcars for $2,000 per car, which included a $500 per car shipping charge. That offer was rejected, and the 100 series streetcars were scrapped by Armco Steel Company at Middletown, Ohio.

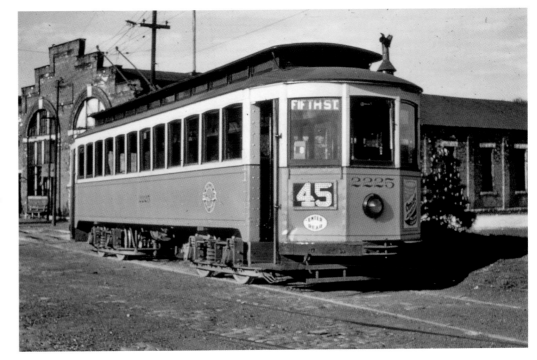

The Ohio Avenue car house is the location of CSRC streetcar No. 2225 on a 1948 rail excursion. This was one of 105 cars Nos. 2200-2304 built by the Cincinnati Car Company for the Cincinnati Traction Company in 1919. Each car was powered by four Westinghouse type 532 motors and weighed 39,500 pounds. Route 45 (Fifth Street) did not operate in regular service over this trackage. (Pat Carmody photograph—Clifford R. Scholes collection)

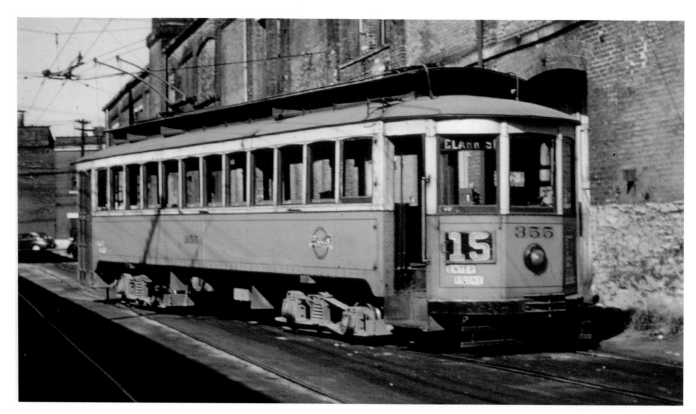

In 1949, CSRC car No. 355 is on Koebel Street behind the Brighton car house. This was originally two-man operated car No. 2155 that was rebuilt into one-man operated car No. 355 in 1943. Generally, when a deck roof car was converted for one-man operation, the number was changed by adding the first two digits in the old number, thus 2155 became 355. (Pat Carmody photograph—Clifford R. Scholes collection)

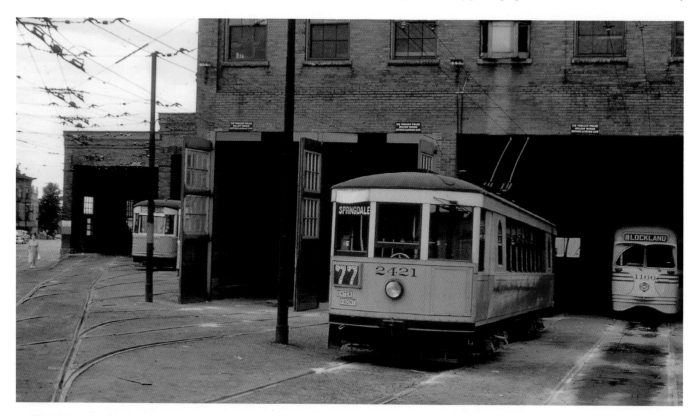

CSCR car No. 2421 (one of 75 cars Nos. 2400-2474 built in 1923 by Cincinnati Car Company) and PCC car No. 1166 (one of 25 Nos. 1150-1174 built in 1947 by St. Louis Car Company) are on the right hand side while a 100 series car (one of 100 cars Nos. 100-199 built by Cincinnati Car Company in 1928) is on the left at the Vine Street car house on August 6, 1949. (Pat Carmody photograph—Clifford R. Scholes collection)

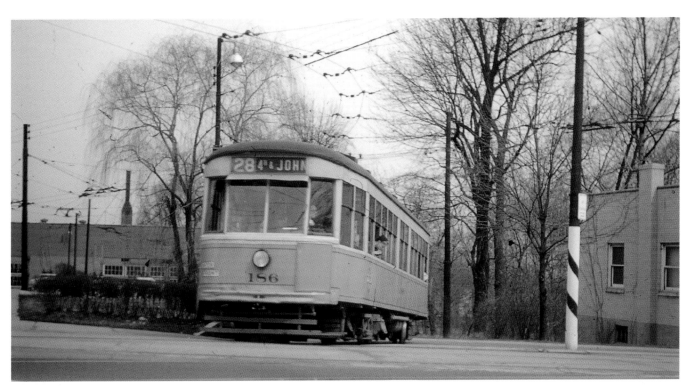

In 1949, CSRC 100 series car No. 186 is leaving the Hyde Park car house turning onto Erie Avenue. The 100 series cars were 100 cars Nos. 100-199 built in 1928 by the Cincinnati Car Company. These quiet running cars with a sloping front window were a forerunner of the later PCC cars. Originally designed for 30 to 32 miles per hour operation, 56 of the cars received replacement motors that permitted 40 to 45 miles per hour operation. This series of cars provided dependable service up to the end of Cincinnati streetcar operation on April 29, 1951. (Clifford R. Scholes photograph)

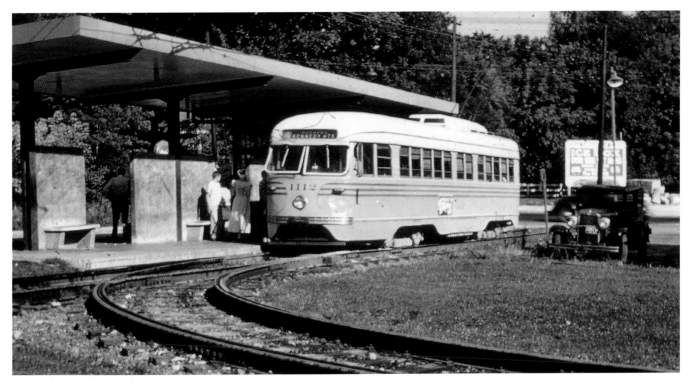

CSRC route 4 (Kennedy Heights) streetcar terminal loop off Montgomery Road at Tyne Road is the location of PCC car No. 1112 in 1949. This was one of 26 PCC cars Nos. 1101-1126 built in 1940 by the St. Louis Car Company for CSRC. Weighing 35,600 pounds, each car (46 foot long and 8.33 foot wide) was powered by four Westinghouse type 1432 motors and seated 53 passengers. (Pat Carmody photograph—Clifford R. Scholes collection)

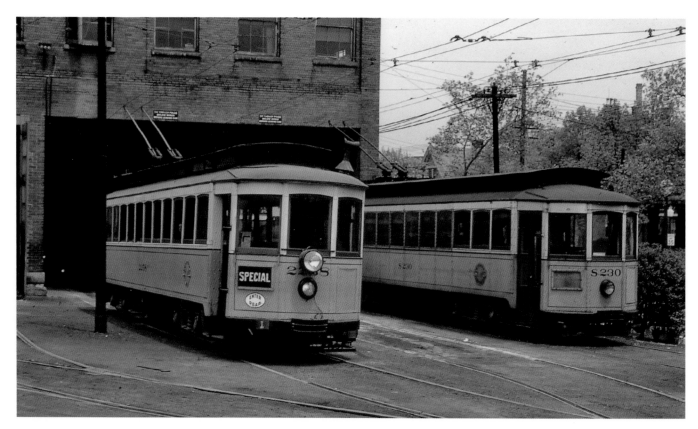

Vine Street car house is the location of CSRC car No. 2258 on a rail excursion and sand car No. S-230 (money car that originally was car No. 2241) on May 7, 1950. (Pat Carmody photograph—Clifford R. Scholes collection)

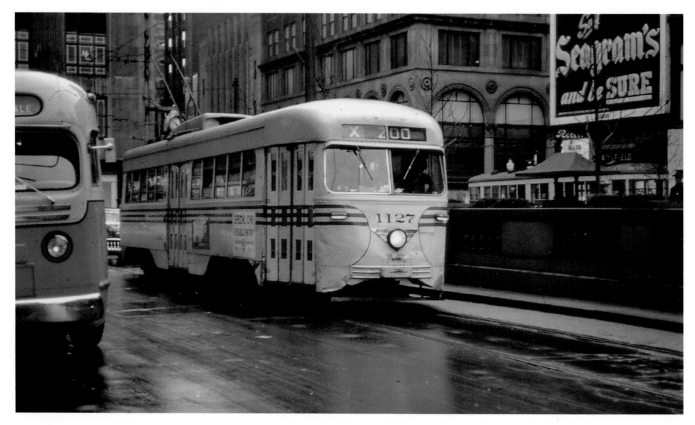

On April 22, 1951, the last full Sunday of CSCR streetcar operation, PCC car No. 1127 is on a rail excursion on Fifth Street on the south side of Fountain Square in downtown Cincinnati. (Pat Carmody photograph—Clifford R. Scholes collection)

# Chapter 2
# Routes 4, 5, 7, 8, and 9

Route 4 (Kennedy Heights) operated from the Kennedy Heights wye via Montgomery, Woodburn, Chapel, Alms, Yale, Gilbert, Florence, Reading, Broadway, and Sixth to Sixth and Main in downtown Cincinnati and returned via Main, Ninth, Sycamore, Reading, Florence, Gilbert, McMillan, Park, Chapel, Woodburn and Montgomery to Kennedy Heights wye. Trackless trolleys replaced route 4 streetcars on July 24, 1949.

Route 5 (Norwood) operated from Fenwick wye via Montgomery, Gilbert, Florence, Reading, Broadway, and Sixth to Sixth and Main in downtown Cincinnati and returned via Main, Ninth, Sycamore, Reading, Florence, Gilbert, and Montgomery to Fenwick wye. On August 20, 1942, route 5 streetcar service ended, and additional streetcars were added to route 4.

Route 7 (North Norwood) operated from Fenwick wye, via Montgomery, Gilbert, McMillan, Vine, Ninth, Walnut, and Sixth to Sixth and Vine in downtown Cincinnati and returned via Vine, McMillan, Gilbert, and Montgomery to Fenwick wye. Trackless trolleys replaced route 7 streetcars on July 24, 1949.

Route 8 (South Norwood) operated from Beech via private right of way, Forest, Williams, Floral, Cleneay, Montgomery, Woodburn, Chapel, Alms, Yale, Gilbert, Florence, Reading, Sycamore, and Sixth to Sixth and Main in downtown Cincinnati and returned via Main, Ninth, Sycamore, Reading, Florence, Gilbert, McMillan, Park, Chapel, Woodburn, Montgomery, Cleneay, Floral, Williams, Forest and Kenilworth to Beech. Trackless trolleys took over streetcar route 8 on January 1, 1949.

Route 9 (Vine-Norwood) operated from McNeil wye via Sherman, Montgomery, Gilmore, McMillan, Vine, Ninth, Walnut, and Sixth to Sixth and Main in downtown Cincinnati and returned via Vine, McMillan, Gilbert, Montgomery and Sherman to McNeill wye. On January 1, 1949, streetcar route 9 was replaced by the West Norwood and East Norwood bus routes.

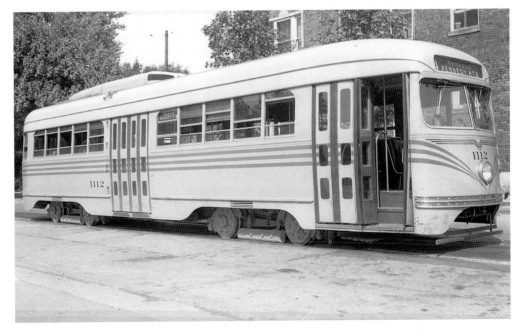

CSCR route 4 PCC car No. 1112, with the original front dash striping, is at the Kennedy Avenue and Montgomery Road streetcar terminal wye on September 13, 1941. This was the original route 4 terminal. A loop was constructed and completed on May 28, 1945. (Clifford R. Scholes collection)

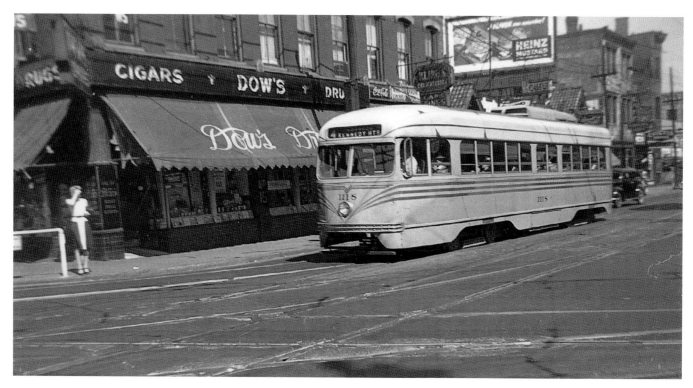

Gilbert Avenue at McMillan Street, in the Walnut Hills neighborhood of Cincinnati, is the location of CSRC route 4 PCC car #1118 on September 10, 1944. The neighborhood around the intersection was listed in the National Register of Historic Places on November 14, 1985, as the Peebles' Corner Historic District. This was the site of the Joseph R Peebles' Sons Company grocery store (until it closed in 1931) where store owners had conductors announce their store as a stop on the numerous streetcar lines that once passed through the intersection. (Clifford R. Scholes photograph)

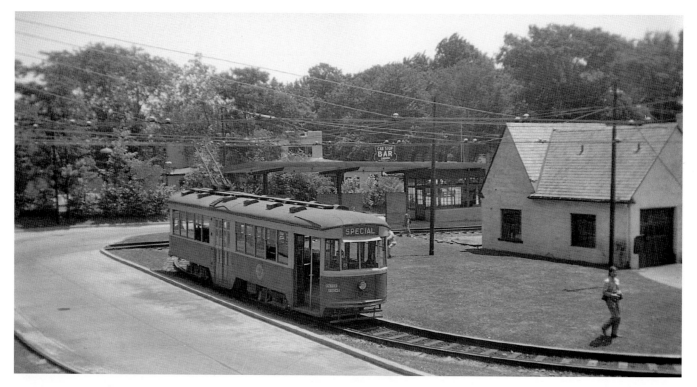

On May 30, 1948, CSRC 100 series car No. 197 is at the route 4 Kennedy Heights streetcar loop off Montgomery Road on a rail excursion. This was one of 100 cars Nos. 100-199 built by Cincinnati Car Company in 1928. These quiet running cars featured safety glass in the large front window and had a nice look. Kennedy Heights, a Cincinnati residential neighborhood, was named for Lewis Kennedy who built the Yononte Inn on Davenant Avenue in 1888. (Clifford R. Scholes photograph)

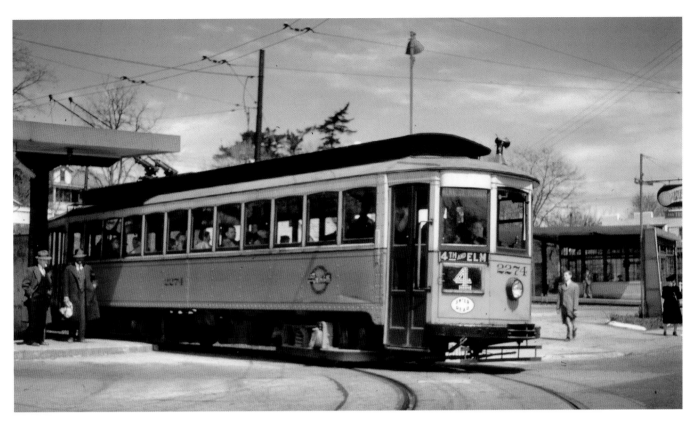

CSRC 2200 series car No. 2274 is at the route 4 Kennedy Heights streetcar terminal loop off Montgomery Road at Tyne Road on a 1949 rail excursion. The 2200 series cars were dependable cars that handled heavy passenger loads and steep hills. (Pat Carmody photograph—Clifford R. Scholes collection)

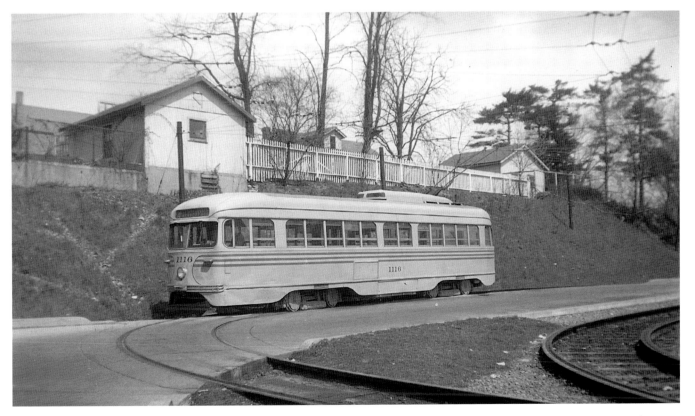

On November 4, 1949, CSRC route 4 PCC car No. 1116 is at the Kennedy Heights streetcar terminal loop off Montgomery Road. (Clifford R. Scholes photograph)

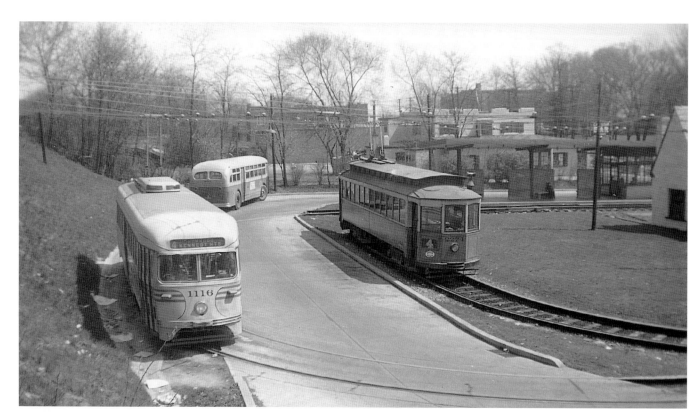

The CSRC route 4 Kennedy Heights streetcar loop off Montgomery Road is a busy place in this November 4, 1949, scene with PCC car No. 1116, Mack bus model C-41-G (C = City, 41 = 41 passenger, and G = gas bus one of ten Nos. 865-874 built by Mack Trucks, Inc.) No. 865, and car No. 2274 awaiting departure time. (Clifford R. Scholes photograph)

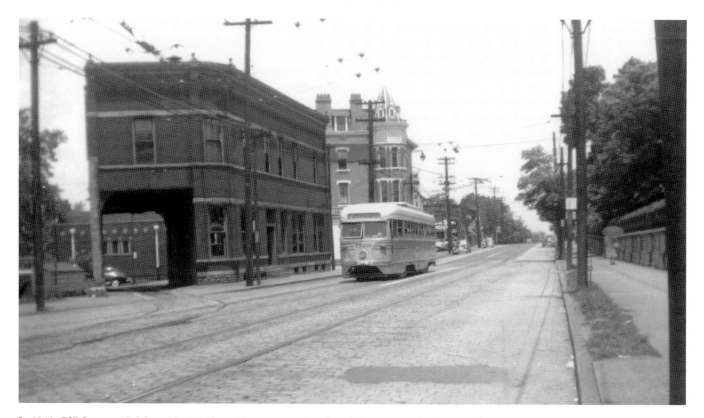

In 1949, CSRC route 4 PCC car No. 1126 is on Montgomery Road at Blair Avenue. The building on the left is the Transportation Office for the Hewitt Avenue car house. This was part of the car house that was not torn down in 1939. The curved track was the loop for regular service route 10 (Vine-Woodburn) streetcars. (Clifford R. Scholes photograph)

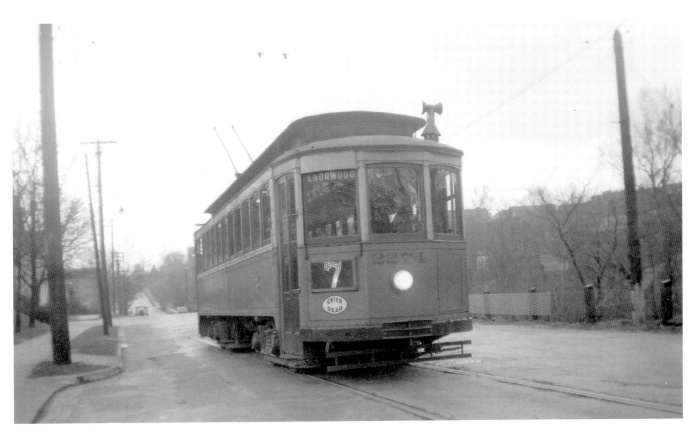

Fenwick Avenue and Montgomery Road at the route 7 streetcar terminal wye is the location of CSRC car No. 2274 on a 1947 rail excursion. Route 7 was a rush hour only cutback for route 4. (Clifford R. Scholes photograph)

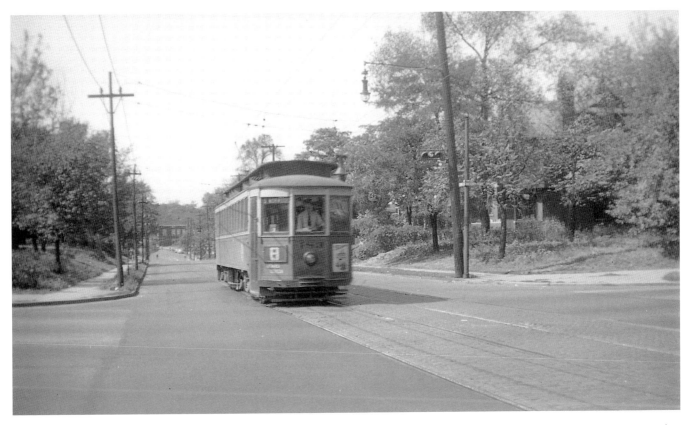

In 1948, CSRC route 8 car No. 483 is on Chapel Street and Victory Parkway. This car was originally car No. 2283 built for two-man operation and was converted for one-man operation and renumbered 483 around 1944. (Clifford R. Scholes photograph)

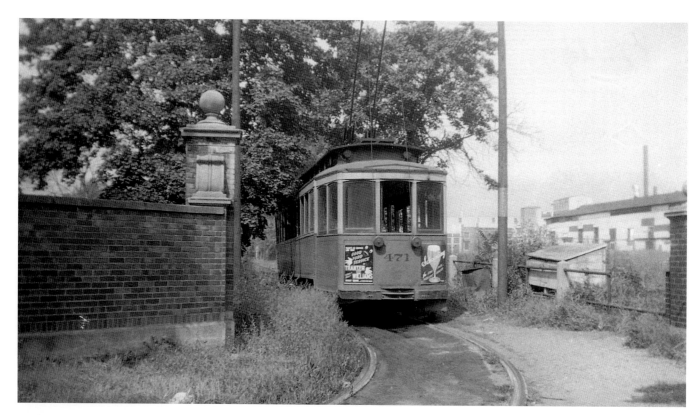

CSRC car No. 471 is on the Park Street private right of way at the US Playing Card Company on May 30, 1948, at the route 8 terminal on a rail excursion. Car No. 471 was originally two-man operated car No. 2271 and was rebuilt for one-man operation and renumbered 471 around 1944. In 2008, the US Playing Card Company moved their operations to the City of Erlanger in Kenton County, Kentucky. (Clifford R. Scholes photograph)

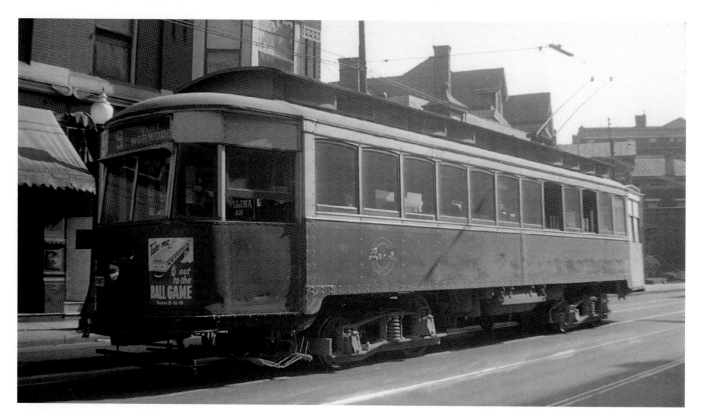

In October 1939, route 9 CSRC car No. 235 is on Sherman Avenue near McNeil Avenue. This car was originally two-man operated car No. 2035 that was rebuilt into one-man car No. 235 in 1932. (Bob Crockett photograph—Clifford R. Scholes collection)

# Chapter 3
# Routes 16, 18, 19, and 21

Route 16 (Colerain) operated from Virginia and Colerain via Colerain, Central, Freeman, York, Linn, Clark, Twelfth, Elm, Seventh, and Vine to Sixth and Vine in downtown Cincinnati and returned via Sixth, Elm, Twelfth, Clark, Baymiller, Liberty, Freeman, Central, Colerain, Spring Grove, Hamilton, Chase, and Virginia to Virginia and Colerain. Trackless trolleys replaced route 16 streetcars on June 6, 1948.

Route 18 (North Fairmount) operated from Casper and Baltimore via Baltimore, Beekman, Harrison, State, Western Hills Viaduct, Harrison, Spring Grove, Western, Liberty, Freeman, Clark, Linn, Ninth, and Vine to Sixth and Vine in downtown Cincinnati and returned via Sixth, Elm, Seventh, John, Eighth, Freeman, Liberty, Western, Spring Grove, Harrison, Western Hills Viaduct, State, Harrison, Beekman, and Baltimore to Casper and Baltimore. Route 18 was combined with bus route 49 (Zoo-Eden Park) on April 29, 1951.

Route 19 (John Street) operated from Quebec Road via Westwood, Harrison, State, Western Hills Viaduct, Harrison, Central, and Fifth to Fifth and Vine in downtown Cincinnati and returned via Vine, Fourth, John, Findlay, Baymiller, Bank, Colerain, Harrison, Western Hills Viaduct, State, Harrison, and Westwood to Quebec Road. Buses took over on April 29, 1951.

Route 21 (Westwood) operated from Harrison and Glenmore via Glenmore, Montana, Harrison, State, Western Hills Viaduct, Harrison, Central, Mohawk, McMicken, Elm, Seventh, and Vine to Sixth and Vine in downtown Cincinnati and returned via Sixth, Elm, McMicken, Mohawk, Central, Harrison, Western Hills Viaduct, State, and Harrison to Harrison and Glenmore. Trackless trolleys took over route 21 on Sunday April 29, 1951.

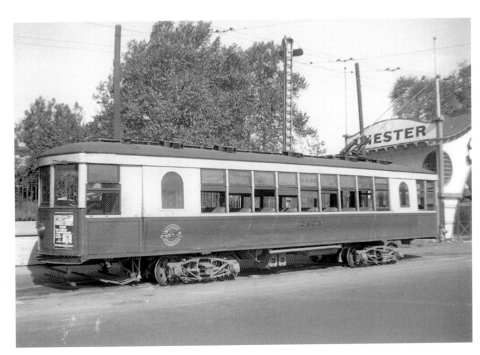

Spring Grove Avenue at the Chester Park streetcar route 16 terminal is the location of CSRC car No. 2425 in October 1939. This was one of 75 dependable one-man operated curved side cars Nos. 2400-2474 built by Cincinnati Car Company in 1923 with each car powered by four Westinghouse type 510-A motors. Seating 46 passengers the 40-foot-long by 8.17-foot-wide car weighed 31,000 pounds and had 26-inch diameter wheels. (Bob Crockett photograph— Clifford R. Scholes collection).

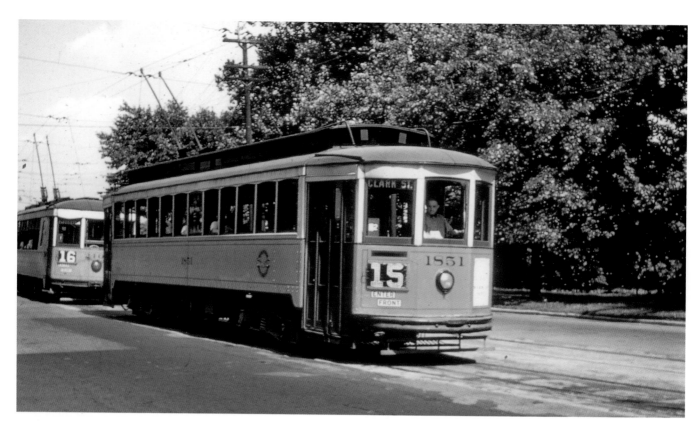

In 1946, route 15 CSRC car No. 1851 (one of 50 cars Nos. 1850-1899 built in 1911-1912 by Cincinnati Car Company with twelve windows on each side and equipped with Brill type 39E trucks) followed by a 2400 curved side series route 16 car are at Spring Grove Avenue south of Winton Road. (Pat Carmody photograph—Clifford R. Scholes collection)

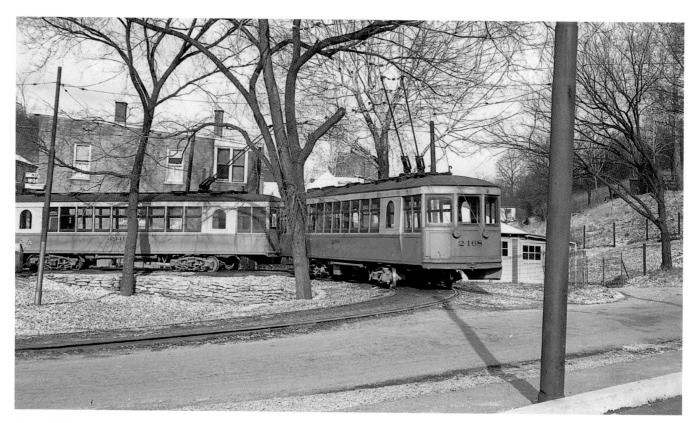

Curved side CSRC cars 2468 and 2441 are at the route 18 Baltimore Avenue and Casper Street streetcar terminal loop on August 30, 1944. (Clifford R. Scholes photograph)

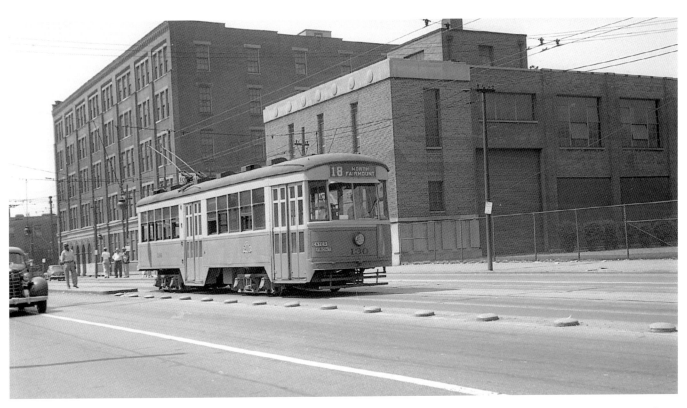

In 1948, route 18 CSRC 100 series car No. 130 is on Spring Grove Avenue south of the Western Hills Viaduct. Seating 50 passengers, these 44.61-long-by-8.209-foot-wide cars produced in 1928 exemplified the continuous improvements made over the years by Cincinnati Car Company and were used until all Cincinnati streetcar service ended on April 29, 1951. (Clifford R. Scholes photograph)

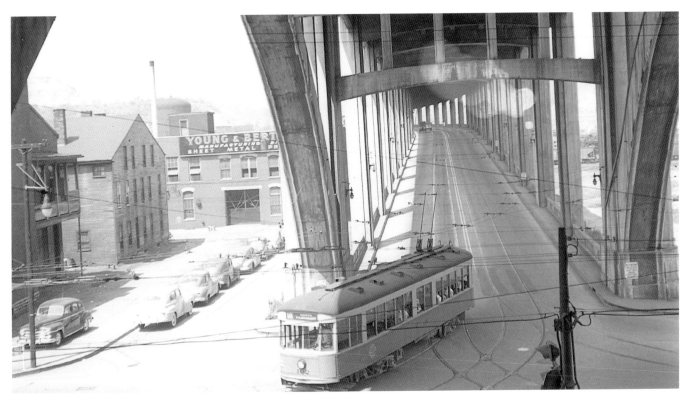

Route 18 CSRC 100 series car No. 102 is turning from the Western Hills Viaduct to Spring Grove Avenue in 1948. The 3,500-foot-long double deck Western Hills Viaduct opened on January 12, 1932, as part of the Cincinnati Union Terminal project. It crosses the Mill Creek Valley connecting Spring Grove Avenue and Central Parkway to the east with Queen City and Harrison Avenues to the West. The western end of the viaduct spans the CSX Queensgate yard, and the eastern half crosses above local roads. (Clifford R. Scholes photograph)

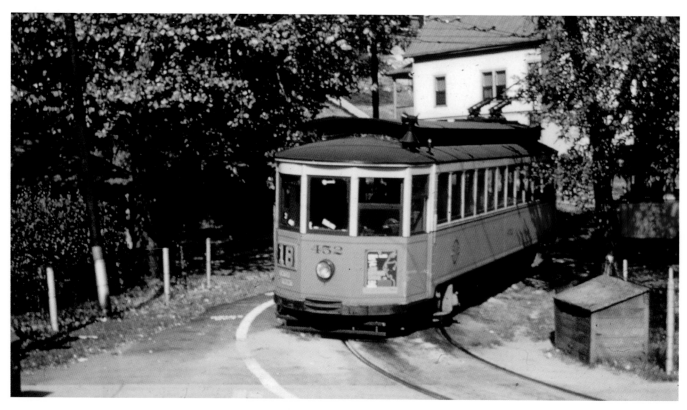

In 1948, route 18 CSRC car No. 452 is at the Baltimore Avenue and Casper Street streetcar terminal. This car was originally two-man operated car No. 2252. In 1944, it was rebuilt for one-man operation and was renumbered 452 by 1944. (Pat Carmody photograph—Clifford R. Scholes collection)

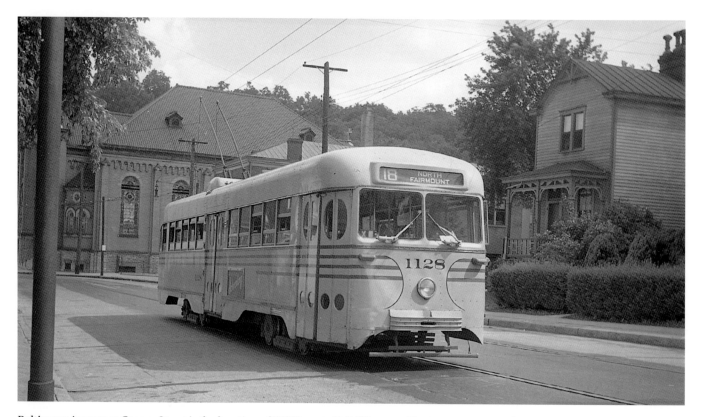

Baltimore Avenue at Casper Street is the location of CSCR route 18 Brilliner car No. 1128 on a 1949 rail excursion. This car was originally delivered on May 31, 1939, as No. 1200 by J. G. Brill Company and was later renumbered 1128. Circular door windows gave the streetcar a distinctive look. (Clifford R. Scholes photograph)

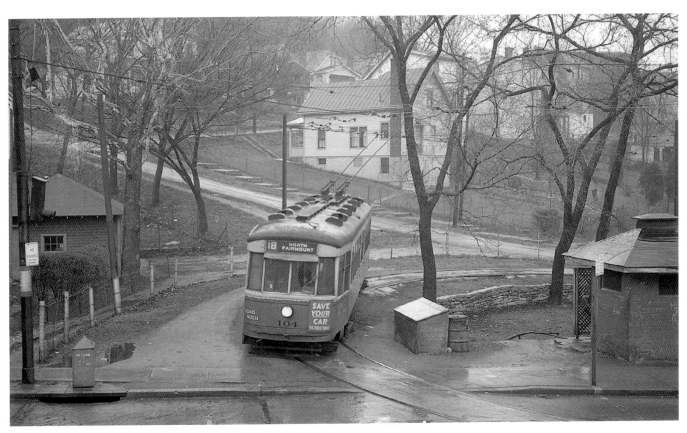

In 1949, CSRC 100 series car No. 104 is at the Baltimore Avenue and Casper Street streetcar route 18 loop. (Clifford R. Scholes photograph)

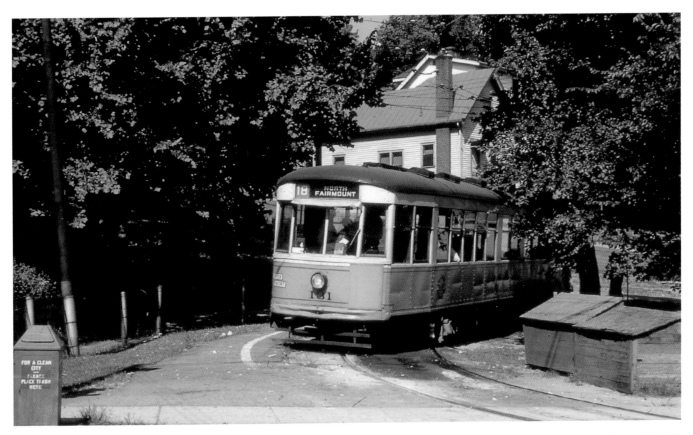

The Baltimore Avenue and Casper Street route 18 streetcar terminal loop is the location of CSRC 100 series car No. 131 on August 6, 1949. (Pat Carmody photograph—Clifford R. Scholes collection)

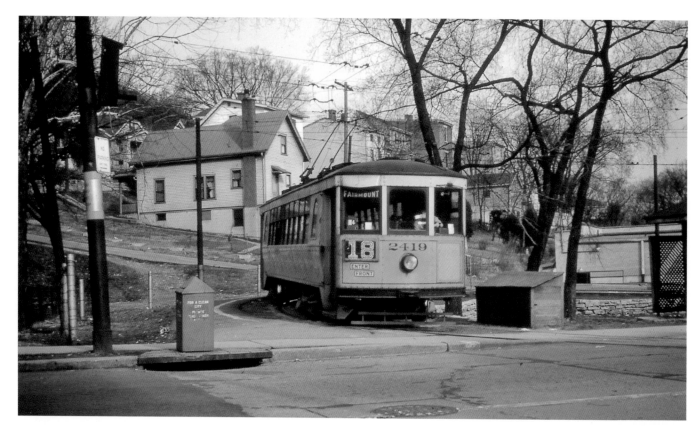

In 1949, CSRC curved side car No. 2419 is at the streetcar route 18 Baltimore Avenue and Casper Street loop. (Pat Carmody photograph—Clifford R. Scholes collection)

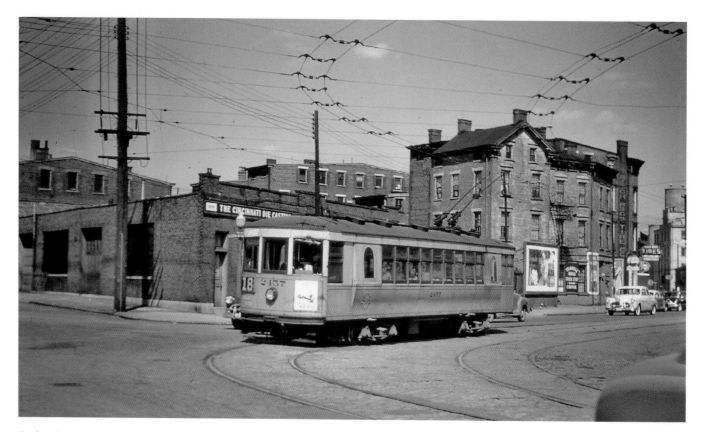

Spring Grove and Western Avenues is the location of route 18 CSRC curved side car No. 2457 in 1949. (Pat Carmody photograph—Clifford R. Scholes collection)

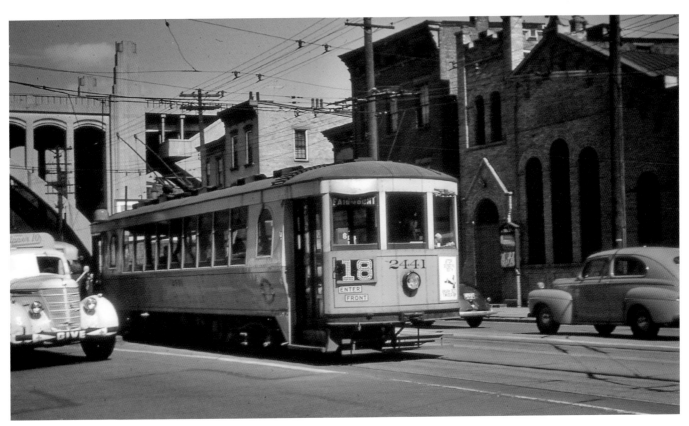

In 1950, CSRC curved side car No. 2441 is on Spring Grove Avenue with the Western Hills Viaduct in view north of the route 18 streetcar. (Pat Carmody photograph—Clifford R. Scholes collection)

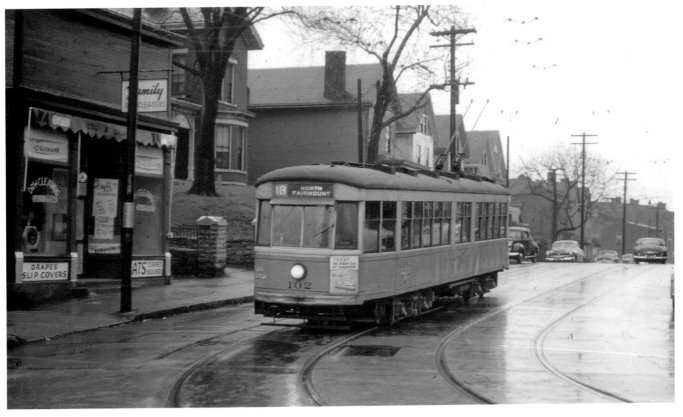

On a rainy May 7, 1950, this neat picture captures route 18 CSRC 100 series car No. 102 on Beckman Street ready to turn onto Baltimore Avenue. The smooth lines of the car body enhanced its appearance. (Pat Carmody photograph—Clifford R. Scholes collection)

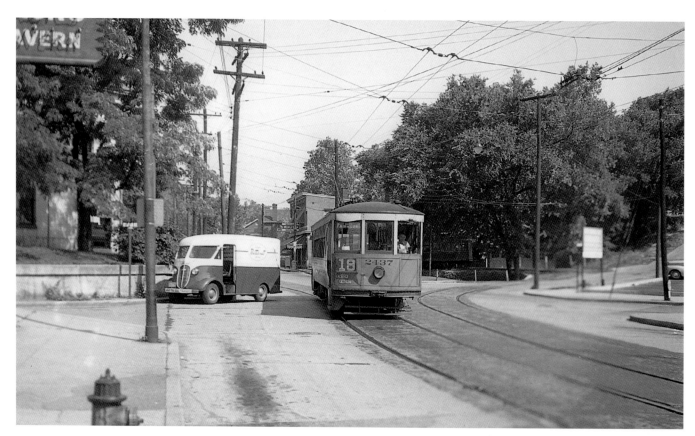

On March 11, 1957, CSRC curved side car No. 2437 has left the route 18 Carll Street streetcar terminal and has turned onto Baltimore Avenue in the North Fairmount neighborhood of Cincinnati. (Clifford R. Scholes photograph)

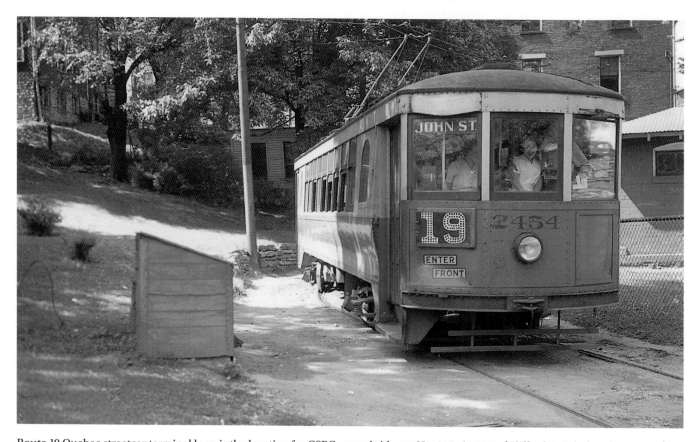

Route 19 Quebec streetcar terminal loop is the location for CSRC curved side car No. 2454 in 1948. (Clifford R. Scholes photograph)

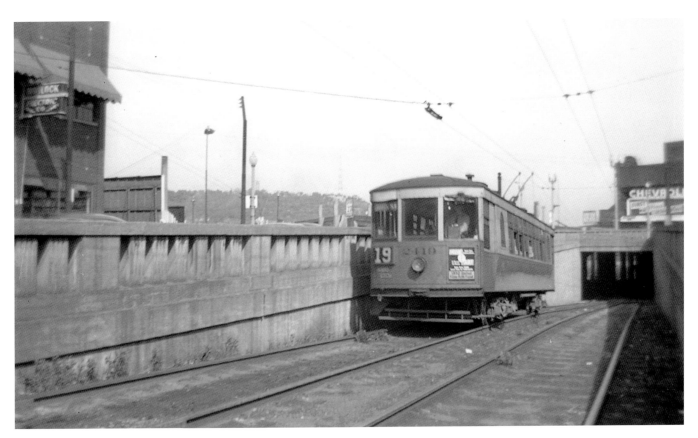

In this 1948 view, CSRC route 19 curved side car No. 2419 is on the Harrison Avenue ramp from the Western Hills Viaduct to Beekman Street. (Clifford R. Scholes photograph)

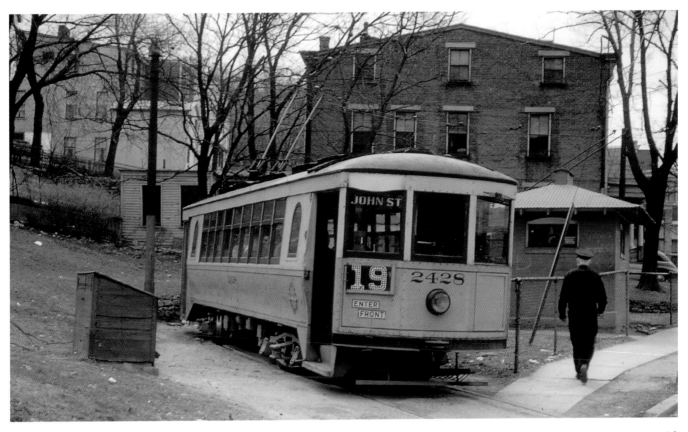

CSRC curved side car No. 2428 is at the route 19 Quebec Road streetcar terminal loop on a 1948 rail excursion. (Clifford R. Scholes photograph)

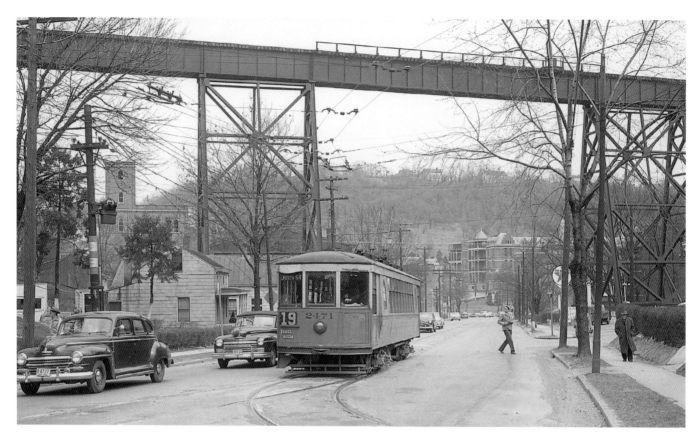

On a 1949 rail excursion, CSRC curved side car No. 2471 is at the Quebec Road streetcar terminal loop below the high trestle of the Indiana line of the Chesapeake & Ohio Railroad from Cincinnati Union Terminal via Cheviot yard to Chicago. (Clifford R. Scholes—photograph)

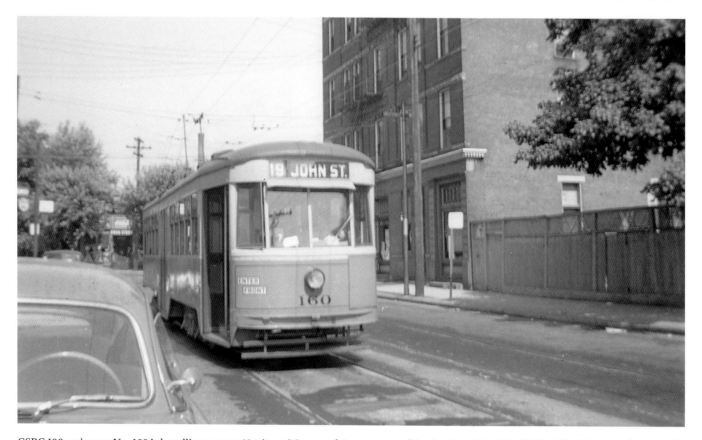

CSRC 100 series car No. 160 is handling a route 19 trip on Westwood Avenue east of Quebec Road in 1949. (Clifford R. Scholes—photograph)

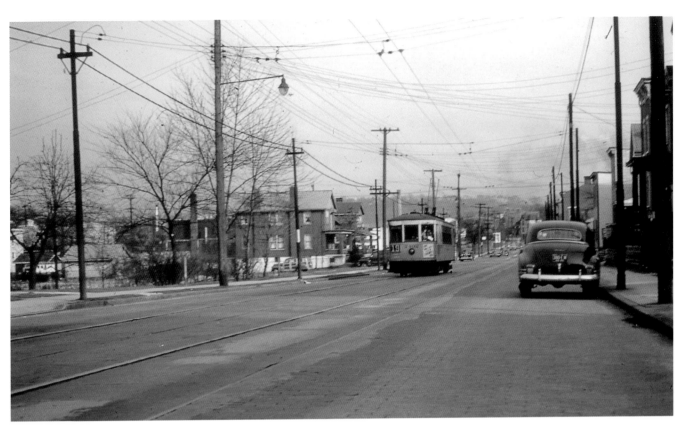

Westwood Avenue at Merton Street is the location of CSRC route 19 curved side car No. 2402 in 1949. (Pat Carmody photograph—Clifford R. Scholes collection)

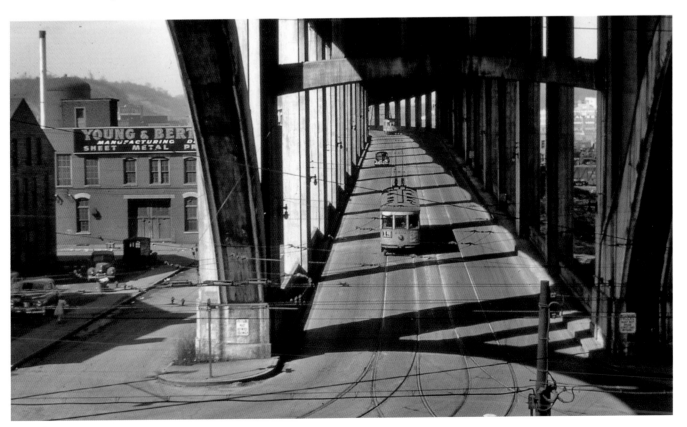

On March 5, 1940, CSRC route 19 curved side car No. 2402 is on the Western Hills Viaduct approaching Spring Grove Avenue. This picture was taken from the steps to the upper deck of the viaduct. (Pat Carmody photograph—Clifford R. Scholes collection)

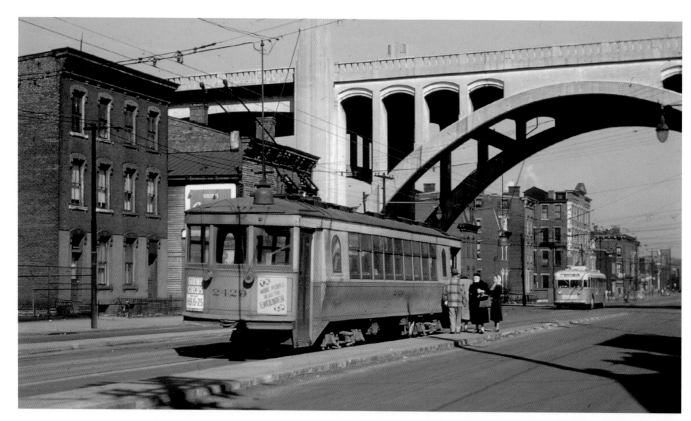

On March 5, 1950, CSRC route 19 curved side car No. 2429 is at a passenger stop on Spring Grove Avenue south of the Western Hills Viaduct (shown ahead of the streetcar), and a route 15 trackless trolley No. 608 (model 41RWFT built by Twin Coach in 1936) is about to pass in the opposite direction. (Pat Carmody photograph—Clifford R. Scholes collection)

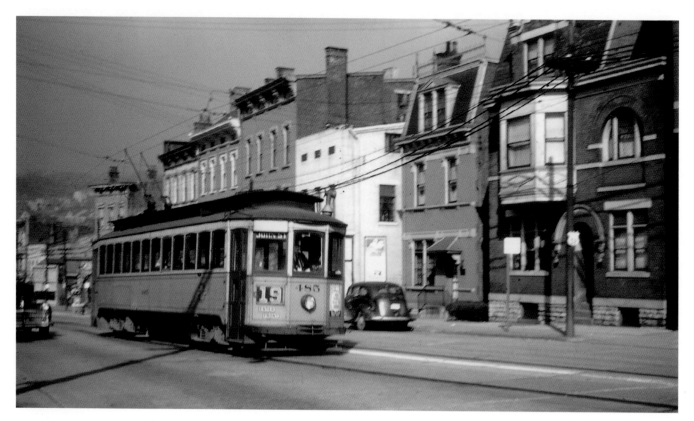

In 1950, CSRC car No. 485 is on a route 19 trip on Harrison Avenue west of Beekman Street. This car was originally two-man operation car No. 2285 and was rebuilt for one-man operation and renumbered 485 by 1944. (Pat Carmody photograph—Clifford R. Scholes collection)

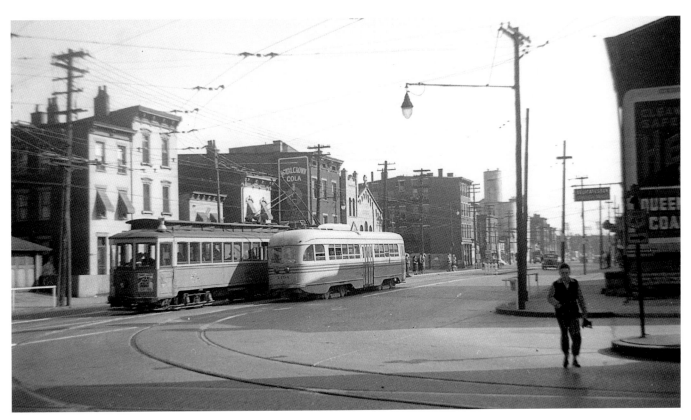

Spring Grove Avenue south of the Western Hills Viaduct is the location of CSRC route 19 car No. 485 passing route 21 PCC car No. 1104 on August 6, 1944. (Clifford R. Scholes photograph)

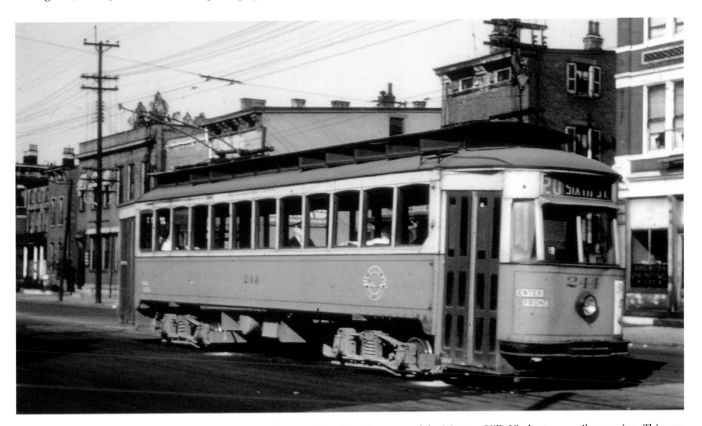

In 1948, CSRC car No. 244 is on Spring Grove Avenue between Harrison Avenue and the Western Hills Viaduct on a rail excursion. This was originally two-man operated car No. 2044 that was remodeled into one-man operated car No. 244. The route 20 destination sign was put on the car by rail enthusiasts. It should be noted that route 20 was abandoned in 1936. (Pat Carmody photograph—Clifford R. Scholes collection)

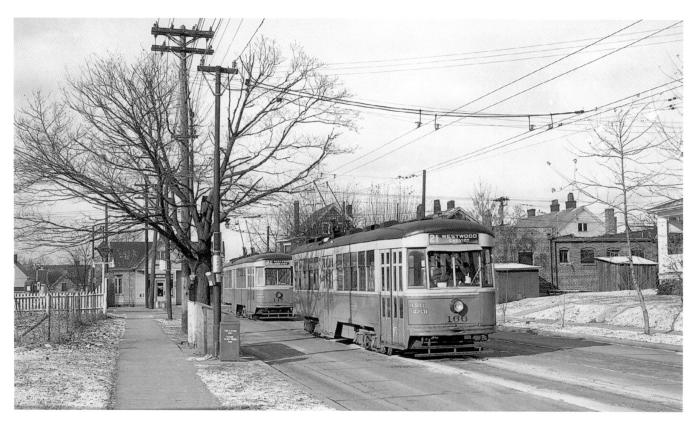

The Montana Avenue east of Glenmore Avenue streetcar route 21 terminal is the location of 100 series cars Nos. 166 and 147 in 1945. (Clifford R. Scholes photograph)

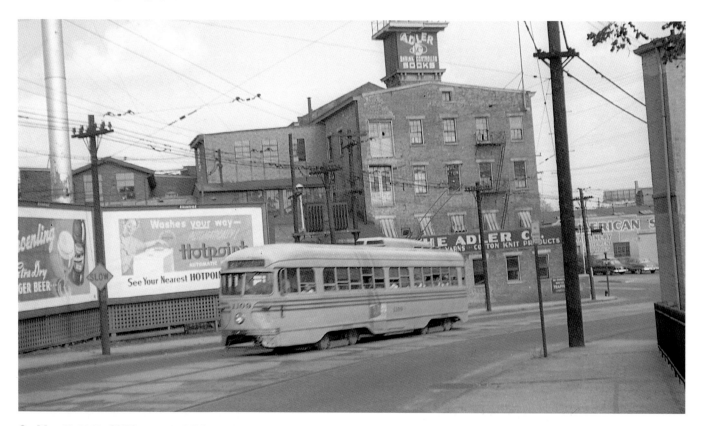

On May 30, 1948, CSRC route 21 PCC car No. 1109 is on Harrison Avenue west of Queen City Avenue. The large building behind the streetcar was the Adler Company. Founded in 1874, the Adler Company products included men's socks plus wash and dish rags. (Clifford R. Scholes photograph)

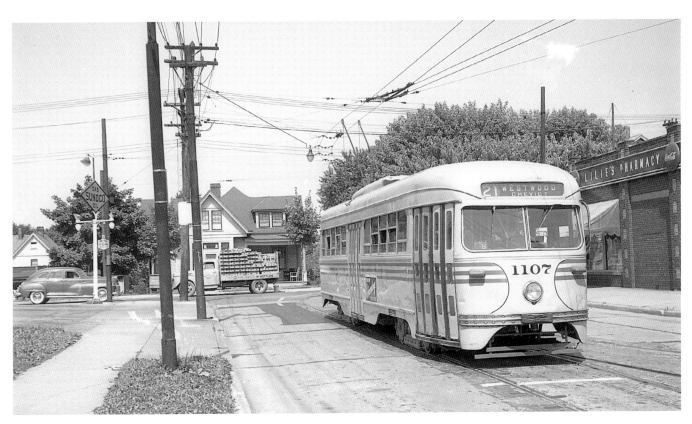

In the urban suburban neighborhood of Westwood, CSRC route 21 PCC car No. 1107 is at the route 21 streetcar terminal on Montana Avenue east of Glenwood Avenue in 1949. Westwood was incorporated as a village on September 14, 1868, and was annexed by the City of Cincinnati on May 8, 1896. (Clifford R. Scholes photograph)

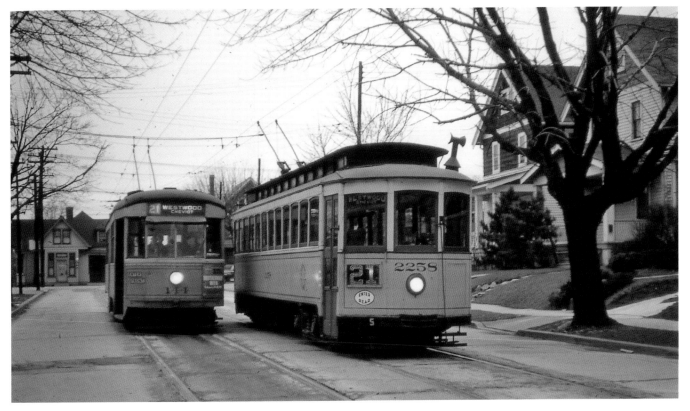

In 1949, CSRC 100 series car No. 174 is at the route 21 streetcar terminal on Montana Avenue east of Glenmore Avenue with rail excursion car No. 2258 positioned for a photo stop. (Pat Carmody photograph—Clifford R. Scholes collection)

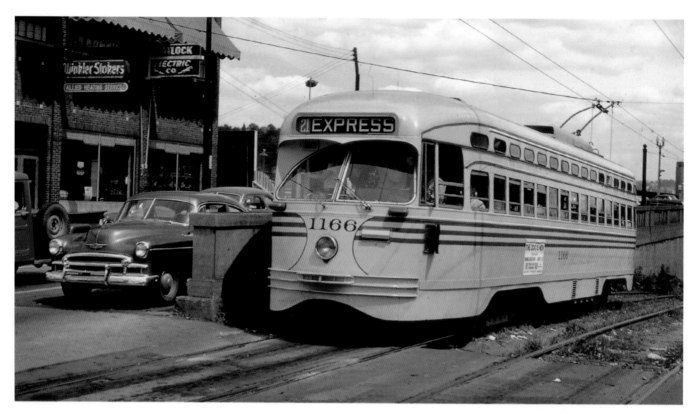

August 6, 1949, PCC car No. 1166 is operating a rail excursion on the CSRC route 21 Western Hill Viaduct ramp at Beekman Avenue. The ramp is from the lower level of the viaduct. This was one of 25 PCC cars Nos. 1150-1174 delivered by St. Louis Car Company in 1947. Weighing 36,000 pounds, the 46-foot-long-by-8.33-foot-wide car was powered by four Westinghouse type 1432 motors and seated 54 passengers. (Pat Carmody photograph—Clifford R. Scholes collection)

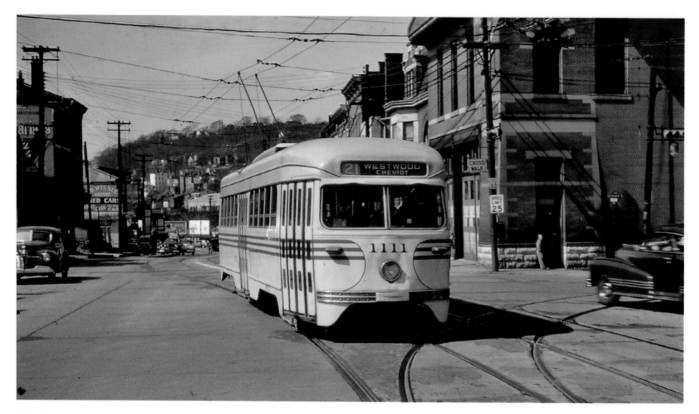

Harrison Avenue at Beekman Street is the location of CSRC route 21 PCC car No. 1111 on March 18, 1950. Route 18 streetcars used the tracks that bear off to the right. (Pat Carmody photograph—Clifford R. Scholes collection)

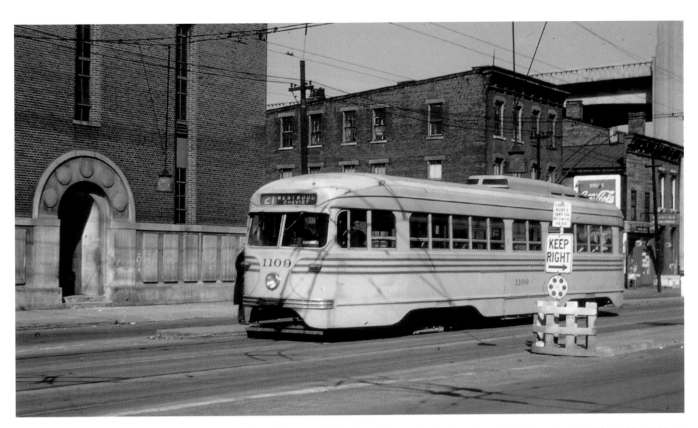

Spring Grove Avenue between the Western Hills Viaduct and Harrison Avenue is the location of CSRC route 21 PCC car No. 1109 on March 3, 1950. The large brick building on the left was a former substation for the streetcar line. (Pat Carmody photograph—Clifford R. Scholes collection)

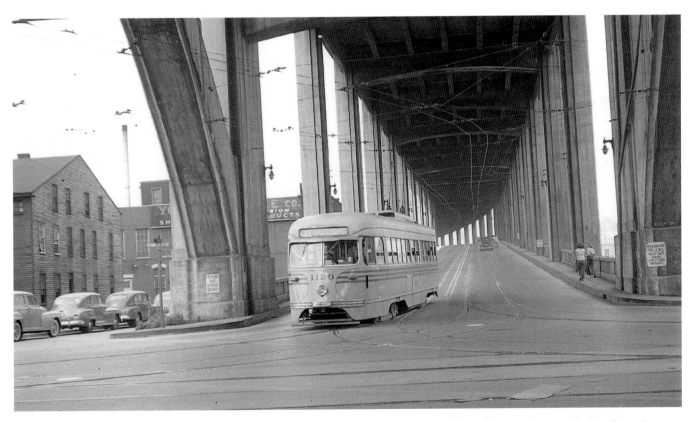

In 1950, CSRC route 21 PCC car No. 1126 is on the lower deck of the massive Western Hills Viaduct turning onto Spring Grove Avenue. (Clifford R. Scholes photograph)

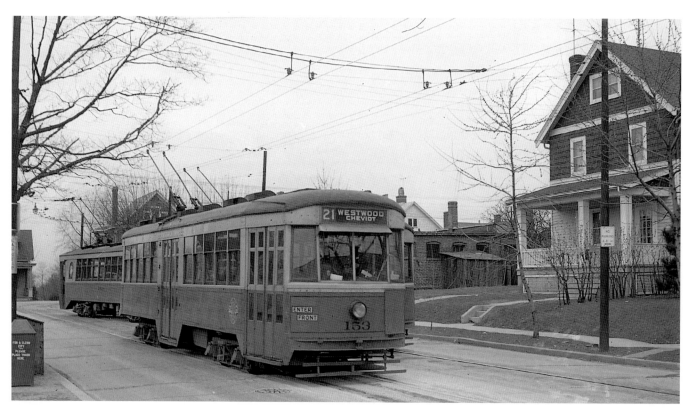

In Cincinnati's large Westwood neighborhood, route 21 CSRC 100 series car No. 153 with car No. 2428 behind it on another track are at the route 21 streetcar loop on Montana Avenue east of Glenmore Avenue in 1950. (Clifford R. Scholes photograph)

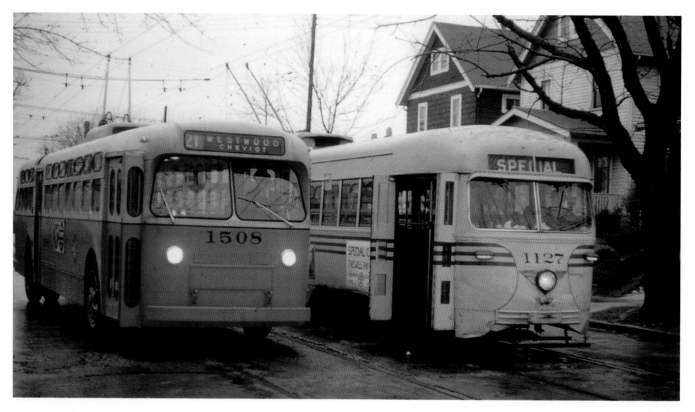

For a neat photo stop on a rainy April 22, 1951, CSRC trackless trolley No. 1508 (model TC48 built by Marmon-Herrington Company in 1951) is on a training run over route 21 and PCC car No. 1127 (originally car No. 1000 built by Pullman Standard Car Building Company in 1939 and renumbered 1127 in December 1947) is on a rail excursion at the route 21 streetcar loop on Montana Avenue east of Glenmore Avenue on the last full Sunday of revenue streetcar operation. (Pat Carmody photograph—Clifford R. Scholes collection)

# Chapter 4

# Routes 27, 31, 32, 35, 46, and 47

Route 27 (East End) operated from Eastern and Archer via Eastern, Third, Martin, Pearl, Broadway, Fourth and Baymiller to Fifth and Baymiller; returning via Fifth, Broadway, Pearl, Front, and Eastern to Eastern and Archer. Trackless trolleys took over route 27 on September 28, 1947.

Route 31 (Crosstown) operated from Eight and State via State, Harrison, Western Hills Viaduct, Harrison, Brighton, McMicken, McMillan, and Park to Park and Yale; returning via Yale, Gilbert, McMillan, McMicken, Brighton, Harrison, Western Hills Viaduct, and State to Eighth and State. Trackless trolleys took over route 31 on April 11, 1948.

Route 32 (Elberon Avenue) operated from Eight and Nebraska via West Eight, Elberon, State, Eighth, Central, and Fifth to Fifth and Vine in downtown Cincinnati and returned via Vine, Fourth, Elm, Seventh, John, Eighth, State, Elberon, and West Eighth to Eighth and Nebraska. Buses took over route 32 on March 25, 1951.

Route 35 (Warsaw) operated from Bridgetown and Cleves Pike via Glenway, Warsaw, Wilder, Glenway, Eighth, Central,

and Fifth to Fifth and Vine in downtown Cincinnati and returned via Vine, Fourth, Elm, Seventh, John, Eighth, Glenway, Wilder, Warsaw, and Glenway to Bridgetown and Cleves Pike. Trackless trolleys took over route 35 on March 25, 1951.

Route 46 (Vine-Burnet) operated from Reading and Rockdale via Rockdale, Burnet, Melish, Highland, McMillan, Vine, Twelfth, Walnut, and Sixth in downtown Cincinnati and returned via Vine, McMillan, Highland, Melish, Burnet, Rockdale and Reading. Trackless trolleys took over route 46 on July 23, 1950.

Route 47 (Winton Place) operated from Epworth and Edgewood via Epworth, Winton, Spring Grove, Mitchell, Clinton Springs, Reading, Broadway, Fourth, and Main to Fifth and Main in downtown Cincinnati and returning via Main, Ninth, Sycamore, Reading, Clinton Springs, Mitchell, Spring Grove, Winton, McMakin and Edgewood to Epworth and Edgewood. Trackless trolleys took over route 47 (Winton-Place) on April 17, 1949.

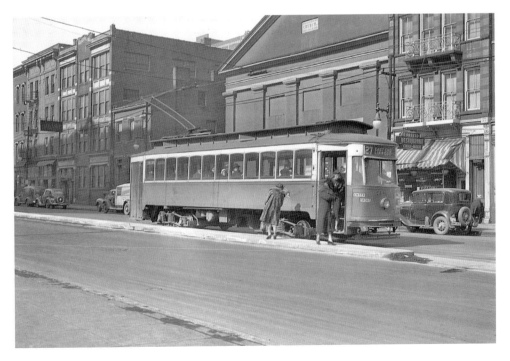

Fifth Street at Broadway is the location of CSRC route 27 car No. 387 in 1939. This car was originally two-man operated car No. 2187. It was rebuilt in 1933 for one-man operation and renumbered 387. (Bob Hadley photograph—Clifford R. Scholes collection)

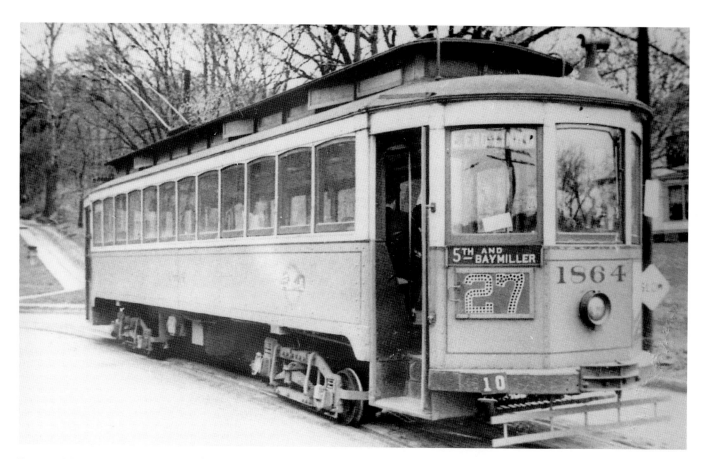

In 1939, CSRC route 27 car No. 1864 (one of 50 cars Nos. 1850-1899 built in 1911 by Cincinnati Car Company) is on the Archer Avenue and Eastern Avenue streetcar wye. The 44-foot-long-by-8-foot-wide car weighed 34,620 pounds and seated 50 passengers. (Clifford R. Scholes collection)

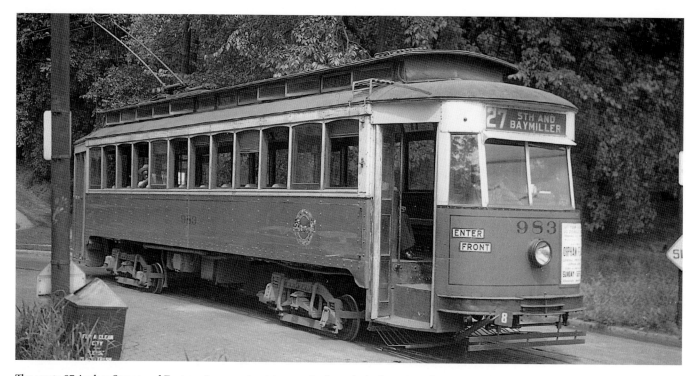

The route 27 Archer Street and Eastern Avenue streetcar terminal wye is the location of CSRC car No. 983. This car was originally two-man operated car No. 1883 (one of 50 cars Nos. 1850-1899 built by Cincinnati Car Company in 1911-1912). It was rebuilt to one-man operated car No. 983 in 1931. (Bob Crockett photograph—Clifford R. Scholes collection)

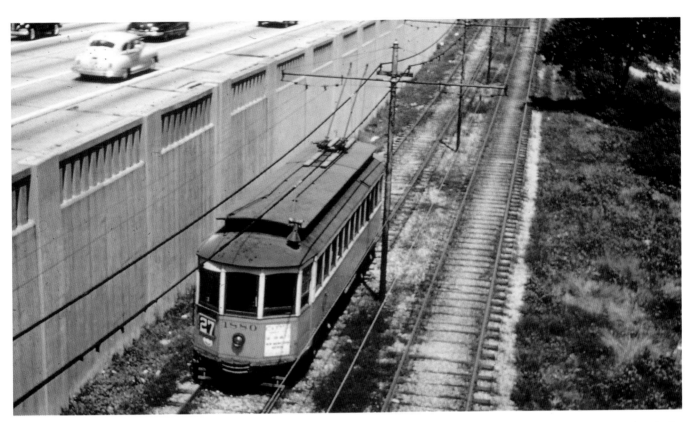

Just north of the Ohio River and east of downtown Cincinnati on the private right of way between Baines Place and Martin Place is the location of CSRC car No. 1880 on a route 27 rail excursion. The upper highway is the Columbia Parkway. (Pat Carmody photograph—Clifford R. Scholes collection)

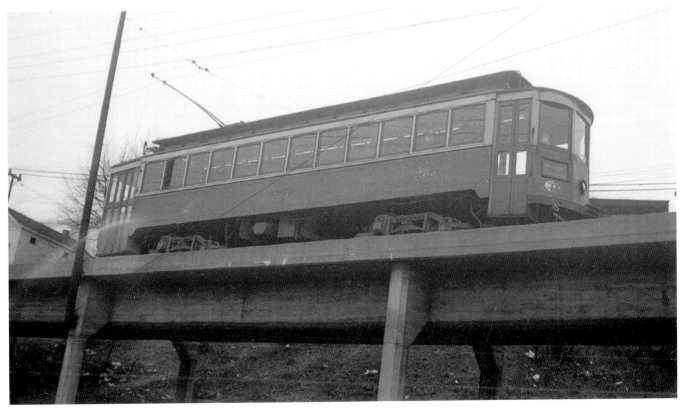

On May 27, 1946, CSRC route 28 car No. 1875 is at the Eastern Avenue and Carrel Street elevated streetcar loop. (Bob Crockett photograph—Clifford R. Scholes collection)

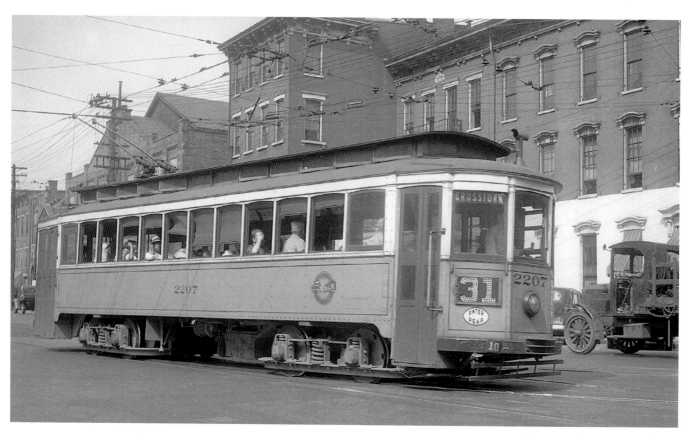

CSRC route 31 car No. 2207 is on Spring Grove Avenue turning onto Harrison Avenue in August 1942. (Clifford R. Scholes collection)

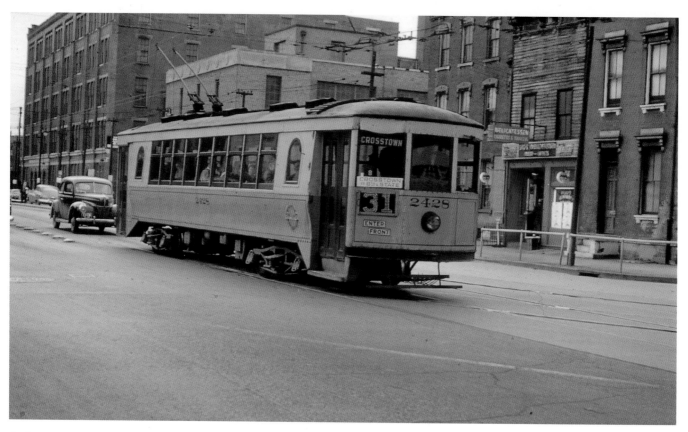

Spring Grove Avenue at the Western Hills Viaduct is the location of CSRC route 31 curved side car No. 2428 in 1949. The two-story brick building behind the streetcar was the substation. (Pat Carmody photograph—Clifford R. Scholes collection)

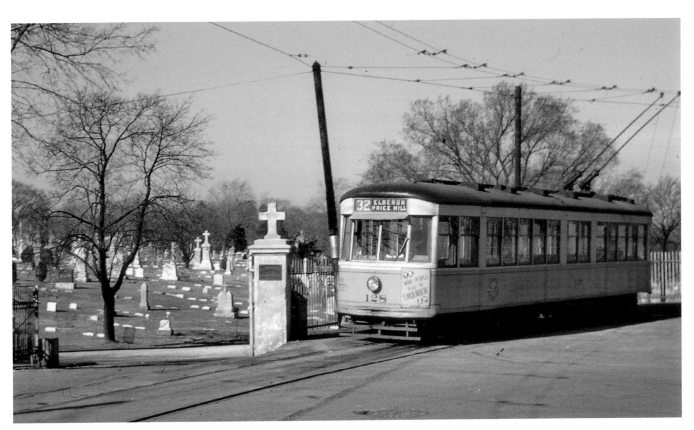

On March 5, 1950, CSRC 100 series car No. 128 is at the Eighth Street and Nebraska Avenue route 32 streetcar terminal loop in the West Price neighborhood of Cincinnati with the Cathedral Cemetery in the background. (Pat Carmody photograph—Clifford R. Scholes collection)

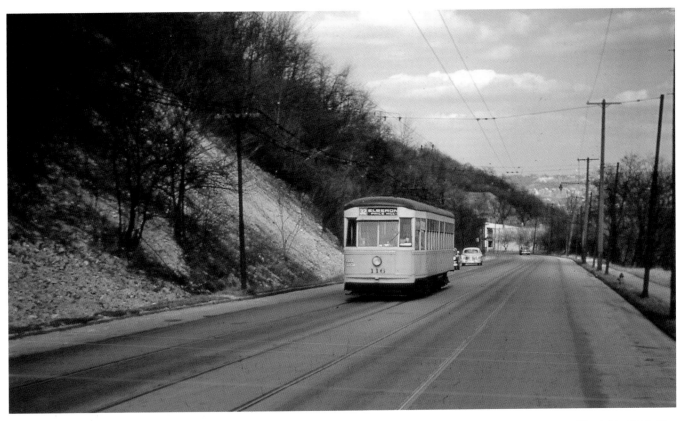

Elberon Avenue hill in the East Price neighborhood of Cincinnati is the location of 100 series route 32 CSRC car No. 116 in 1949. (Pat Carmody photograph—Clifford R. Scholes collection)

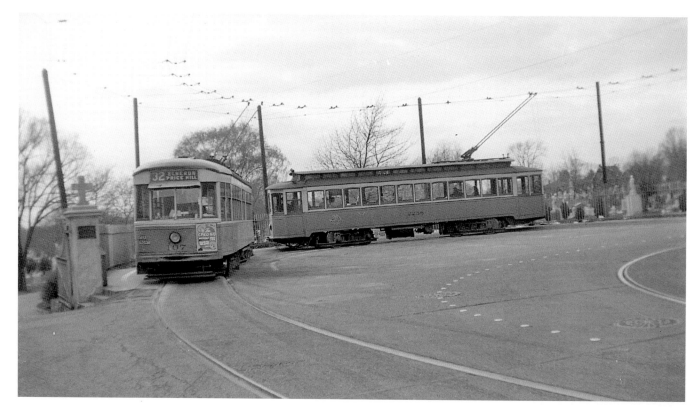

On March 6, 1950, CSRC 100 series car No. 107 followed by car No. 2258 are at the route 32 streetcar loop on Eighth Street and Nebraska Avenue with the Cathedral Cemetery behind the streetcars. (Clifford R. Scholes photograph)

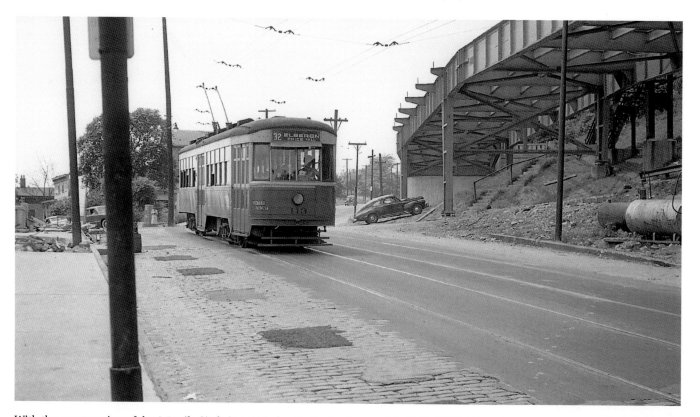

With the construction of the 0.5 mile Sixth Street Viaduct in the background in 1949, CSRC 100 series car No. 113 is handling a route 32 run on State and Elberon Avenues in the Lower Price Hill neighborhood of Cincinnati. The bridge, resembling a New York City elevated line with its steel legs, was later renamed the Waldvogel Memorial Viaduct in honor of Edward N. Waldvogel (1894-1954) who had been in the Ohio Senate and was Mayor of Cincinnati. (Clifford R. Scholes photograph)

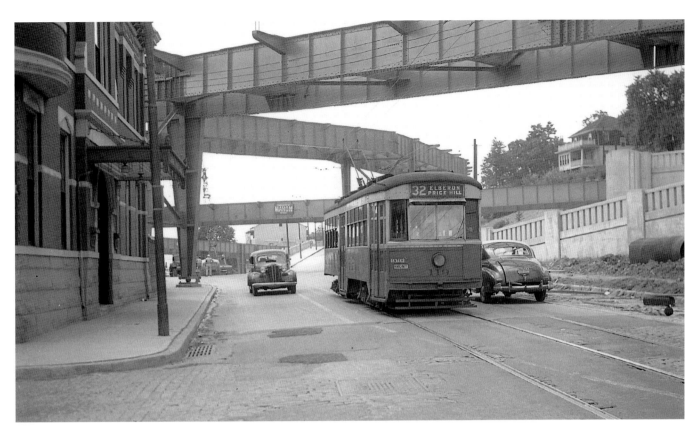

In 1948, CSRC 100 series car No. 119 is on State Avenue and Michael Street on streetcar route 32 amid the construction of the Sixth Street Viaduct that was later renamed Waldvogel Memorial Viaduct. (Clifford R. Scholes photograph)

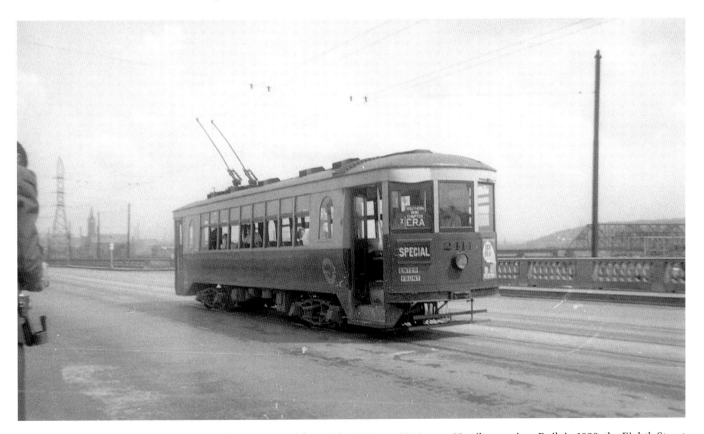

The Eighth Street Viaduct is the location of CSRC curve side car No. 2414 on a 1944 route 32 rail excursion. Built in 1928, the Eighth Street Viaduct was part of the plans for the Cincinnati Union Terminal. (Clifford R. Scholes photograph)

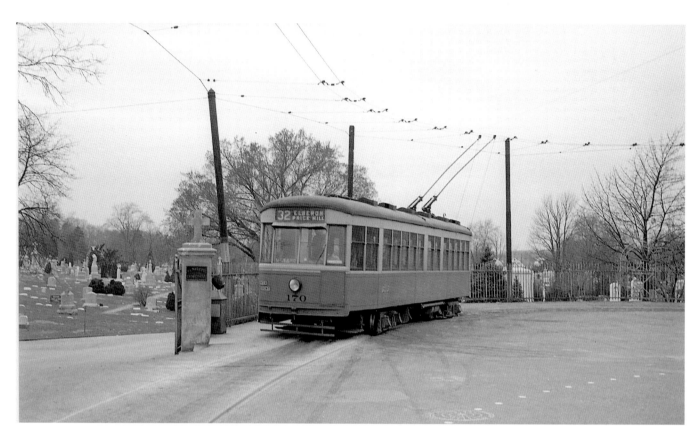

With the Cathedral Cemetery in the background, CSRC 100 series car No. 170 is at the route 32 Eighth and Nebraska Avenue streetcar terminal loop on March 26, 1950. (Clifford R. Scholes photograph)

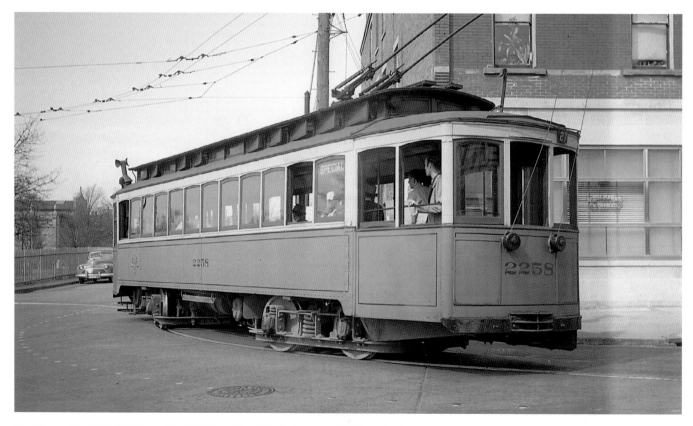

On March 26, 1950, CSRC car No. 2258 is at the Eighth Street and Nebraska Avenue route 32 streetcar terminal loop. The Cathedral Cemetery is on the left. (Clifford R. Scholes photograph)

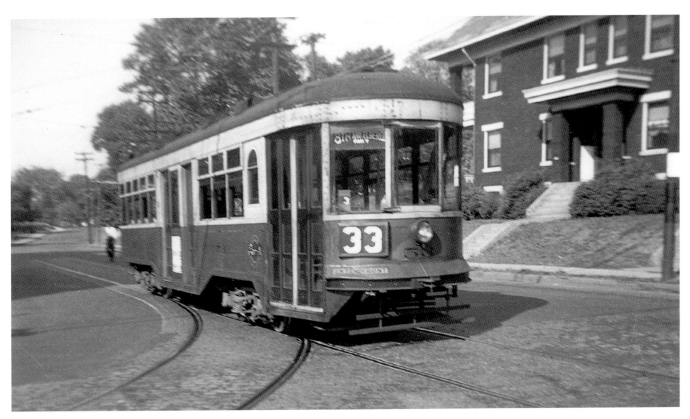

CSRC route 33 car No. 53 is at the Eighth Street and Elberon Avenue streetcar terminal wye (a short turnback of route 32) on September 10, 1944. This was one of four cars Nos. 50-53 made from trailer cars (of which there were 60 Nos. 3000-3059 built in 1914 by Cincinnati Car Company) and placed in service on July 31, 1928, for one-man operation. (Clifford R. Scholes photograph)

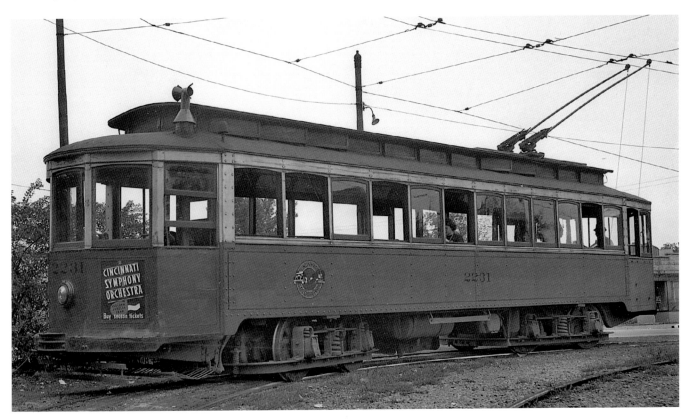

In 1945, CSRC car No. 2231 is at the Glenway Avenue and Ferguson Road streetcar terminal loop of streetcar route 35. (Ed O'Meara photograph—Clifford R. Scholes collection)

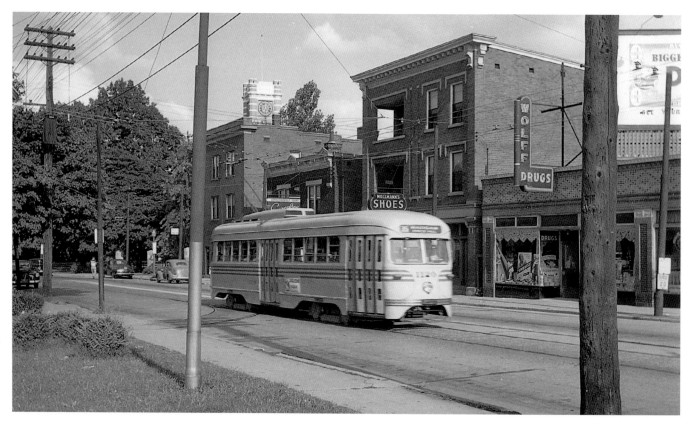

Glenway Avenue at Rutledge Avenue is the location of CSRC route 35 PCC car No. 1120 in 1947. Trackage shown turning at the rear of the streetcar was the short turn route 36 streetcar loop. (Clifford R. Scholes photograph)

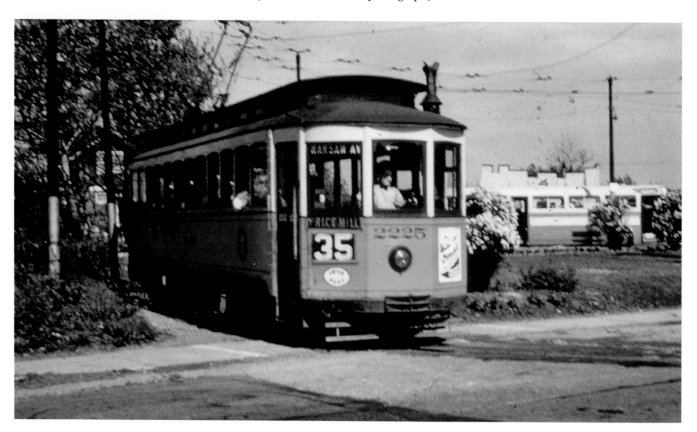

In 1947, CSRC car No. 2225 is at the Glenway Avenue and Ferguson route 35 streetcar loop. On the right, the bus built by Twin Coach Company is operating on the route G (Cheviot-Price Hill) suburban shuttle. (Pat Carmody photograph—Clifford R. Scholes collection)

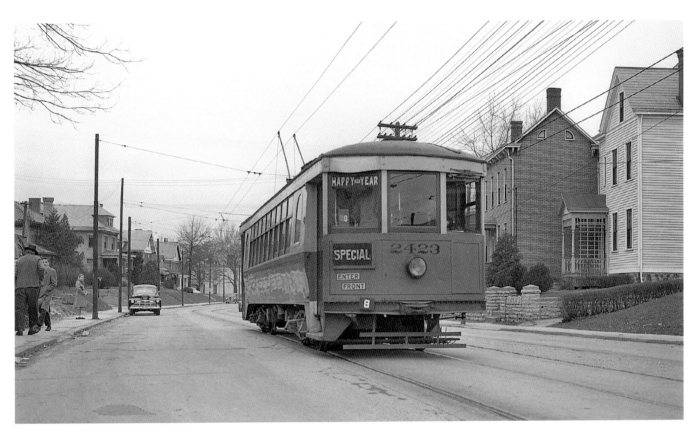

CSRC curved side car No. 2423 is on Glenway and Rutledge Avenues on a rail excursion on streetcar route 35 in 1948. (Clifford R. Scholes photograph)

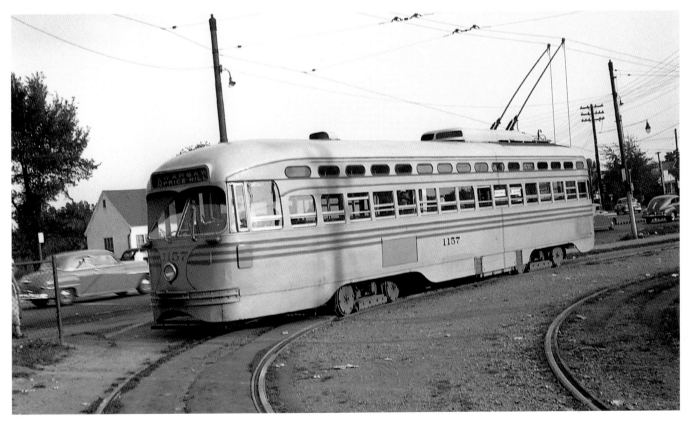

In 1948, CSRC route 35 PCC car No. 1157 is at the Glenway Avenue and Ferguson Road streetcar terminal loop. (Clifford R. Scholes photograph)

Warsaw Avenue and Peerless Street is the location of CSRC route 35 PCC car No. 1156 in 1948. (Clifford R. Scholes photograph)

On July 6, 1949, CSRC route 35 PCC car No. 1155 is on Vine and Fourth Streets in downtown Cincinnati. (Clifford R. Scholes collection)

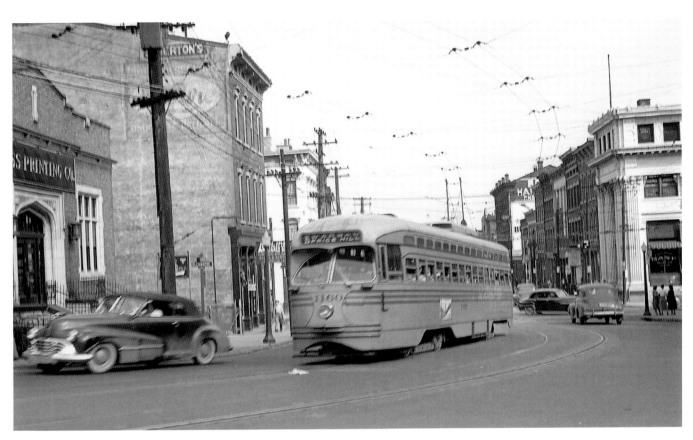

CSRC route 35 PCC car No. 1160 is on Eighth Street turning onto Glenway Avenue in 1949. (Clifford R. Scholes photograph)

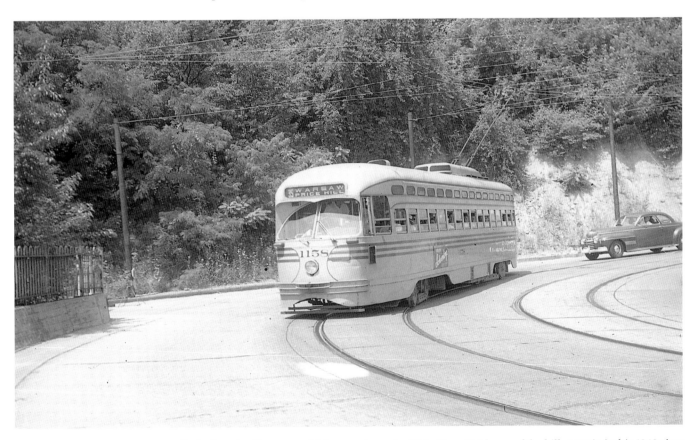

Cincinnati is built on a number of hills that rise like an amphitheater above the Ohio River. Evidence of the hilly terrain is this 1949 view of CSCR route 35 PCC car No. 1158 turning from Warsaw Avenue to Wilder Avenue. (Clifford R. Scholes photograph)

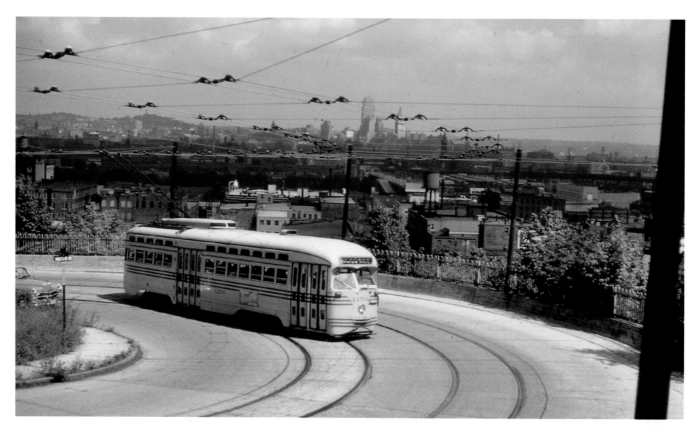

With a portion of the downtown Cincinnati skyline in the background, CSRC route 35 PCC car No. 1150 is turning from Wilder Avenue onto Warsaw Avenue in the East Price Hill neighborhood of Cincinnati in 1949. (Pat Carmody photograph—Clifford R. Scholes collection)

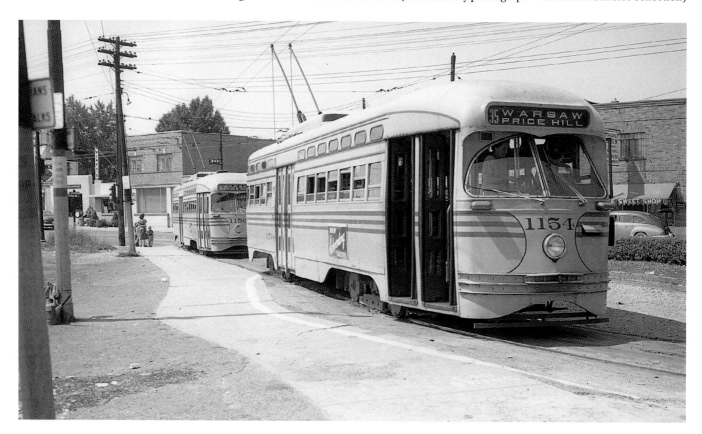

CSRC route 35 PCC cars Nos. 1154 and 1150 are at the Glenway Avenue and Ferguson Road streetcar terminal loop in 1949. (Clifford R. Scholes photograph)

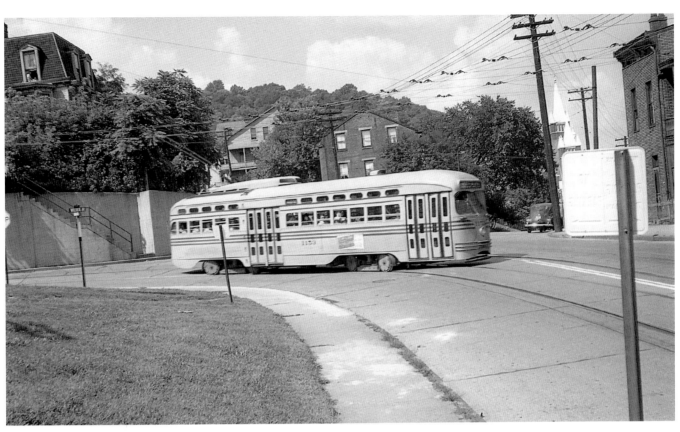

In 1949, CSRC route 35 PCC car No. 1153 is on Wilder Avenue turning onto Glenway Avenue. (Clifford R. Scholes photograph)

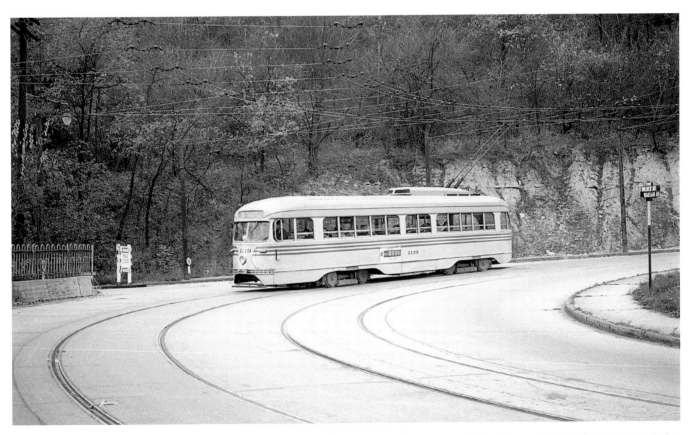

CSRC route 35 PCC car No. 1119 is on the sharp curve turning from Warsaw Avenue onto Wilder Avenue in 1949. (Clifford R. Scholes photograph)

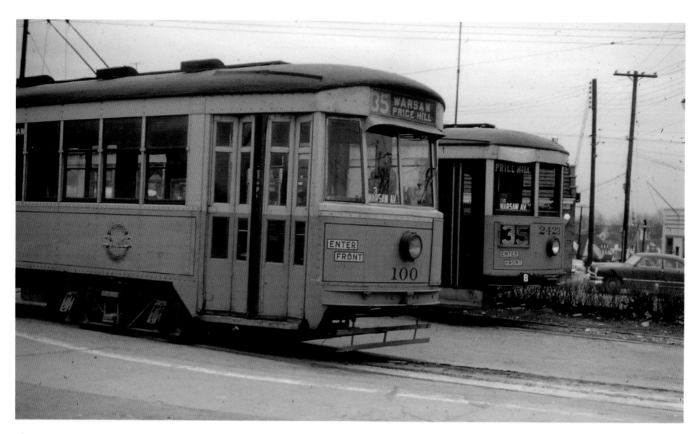

The route 35 terminal loop on Glenway Avenue at Ferguson Road is the location of CSRC 100 series car No. 100 and rail excursion car No. 2423 in 1949. (Pat Carmody photograph—Clifford R. Scholes collection)

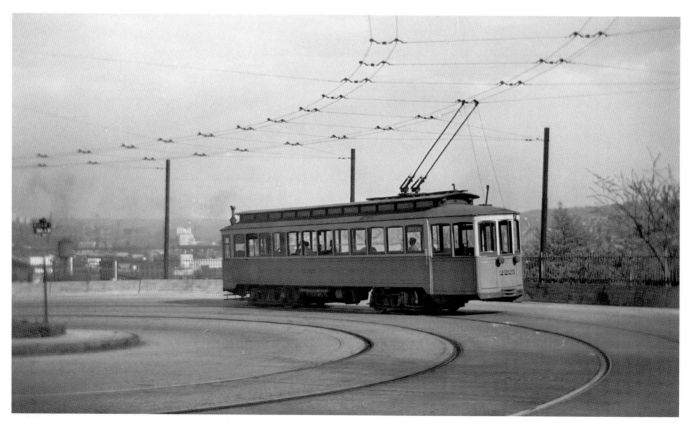

CSRC car No. 2225 is on Wilder Avenue having turned from Warsaw Avenue on a rail excursion over route 35 in 1950. (Ed O'Meara photograph—Clifford R. Scholes collection)

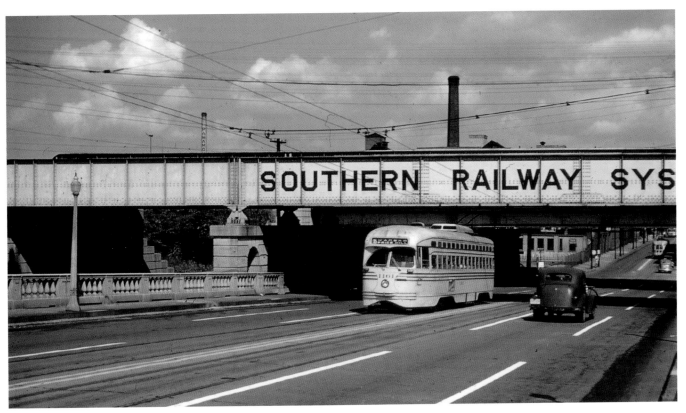

In 1950, CSRC route 35 PCC car No. 1161 is under the Southern Railway bridge on the Eighth Street viaduct. (Pat Carmody photograph—Clifford R. Scholes collection)

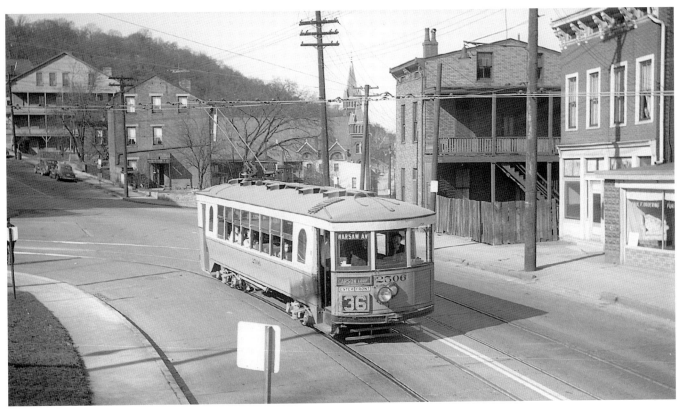

Glenway Avenue south of Wilder Street is the location of CSRC car No. 2506 (originally No. 106) on March 26, 1950, over route 35 on a rail excursion. This car was one of five cars Nos. 103-107 built by the Cincinnati Car Company in 1923 for the Maumee Valley Railway & Light Company and acquired by CSRC, becoming cars Nos. 2503-2507. (Clifford R. Scholes photograph)

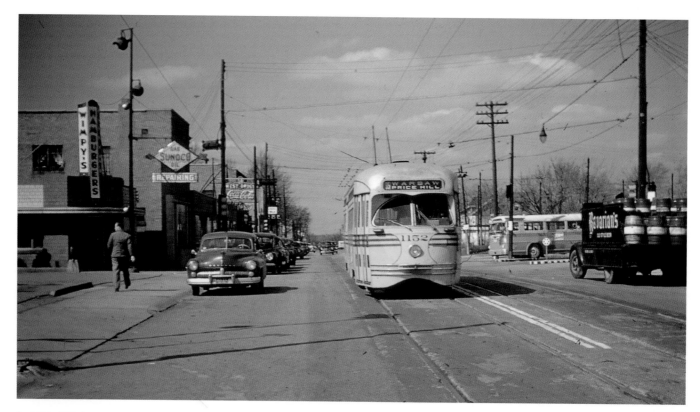

In 1950, CSRC route 35 PCC car No. 1152 is on Glenway Avenue east of Ferguson Road. On the right is a bus built by Twin Coach Company operating on shuttle route G (Price Hill/Cheviot). (Clifford R. Scholes photograph)

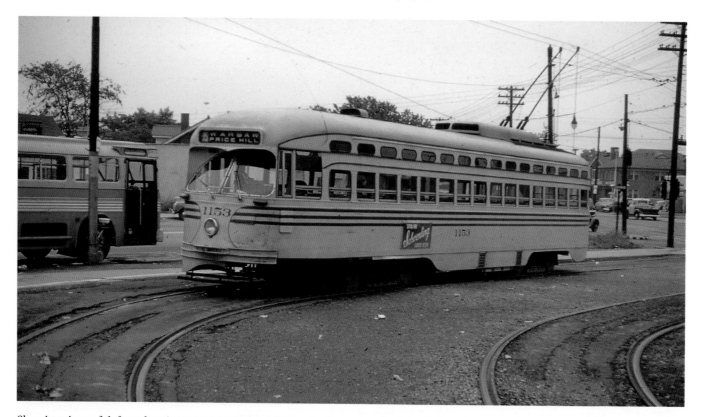

Showing signs of deferred maintenance with the right hand side under skirting missing due to a traffic accident, CSRC route 35 PCC car No. 1153 is at the terminal loop at Glenway Avenue and Ferguson Road on May 28, 1950. On the left is a Route G bus built by Twin Coach Company operating on a suburban shuttle line. The skirting was replaced before the streetcar was sold to the Toronto Transit Commission. (Pat Carmody photograph—Clifford R. Scholes collection)

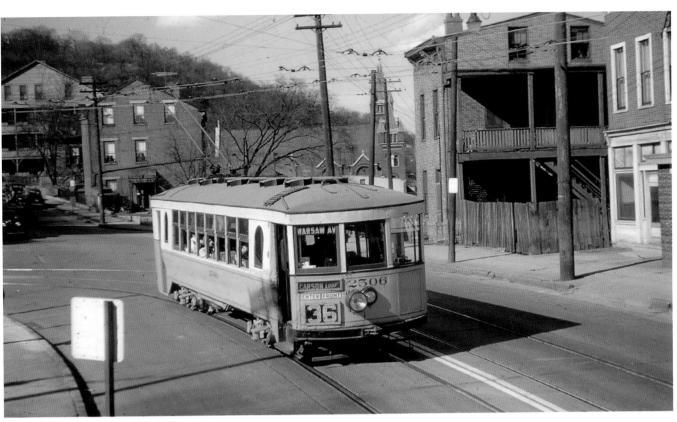

On March 26, 1950, CSRC car No. 2506 (originally No. 106 of the Maumee Valley Railway & Light Company) is at Glenway Avenue south of Wilder Avenue on a rail excursion covering streetcar route 35. (Pat Carmody photograph—Clifford R. Scholes collection)

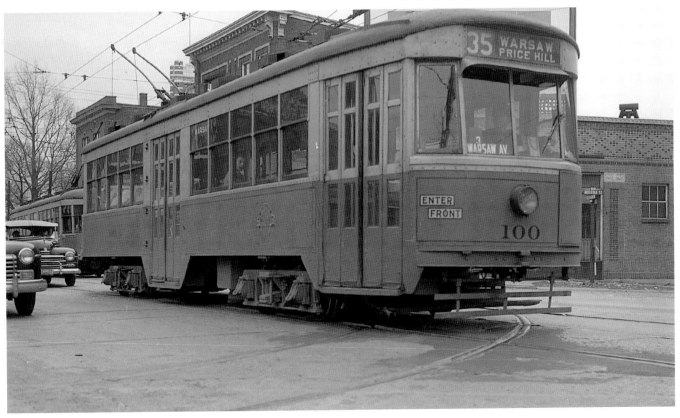

CSRC 100 series car No. 100 is on Glenway Avenue at Rutledge Avenue on streetcar route 35 in 1950. The track turning to the left is for short turn trips. (Clifford R. Scholes photograph)

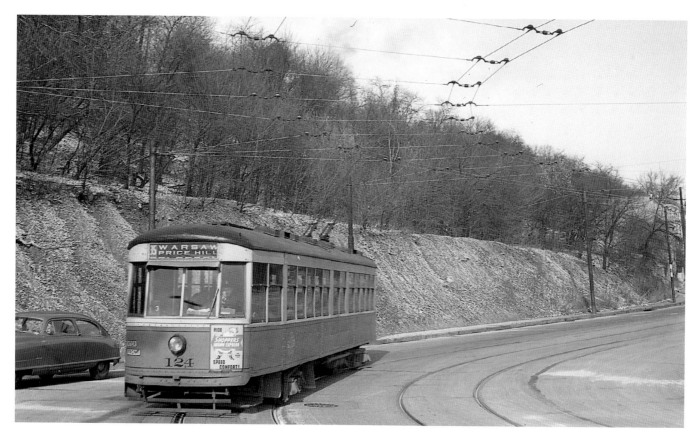

In 1950, CSRC 100 series car No. 124 is on streetcar route 35 turning from Warsaw Avenue to Wilder Avenue. (Clifford R. Scholes photograph)

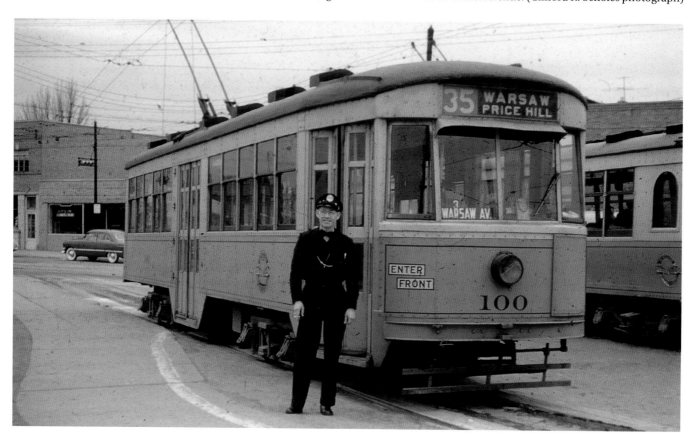

Glenway Avenue at Ferguson Road is the location of CSRC streetcar route 35 car No. 100 in 1951. The motorman proudly stood by the streetcar. (Clifford R. Scholes photograph)

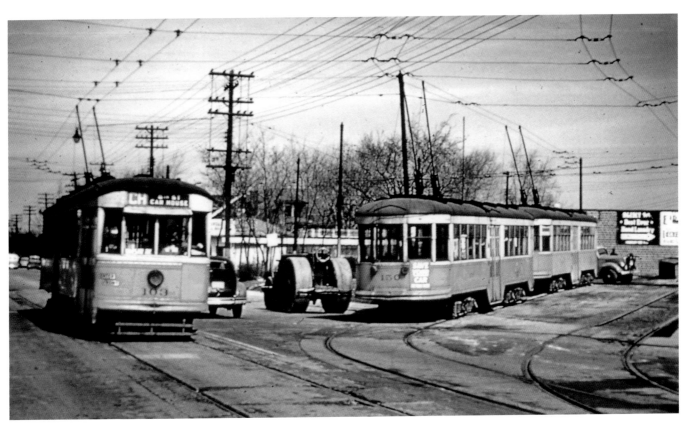

In 1951, CSRC 100 series cars Nos. 103 and 150 are at the route 35 Glenway and Ferguson Avenue route 35 terminal loop. The highway roller at the loop was there for the rebuilding of the loop for trackless trolley operation. (Clifford R. Scholes collection)

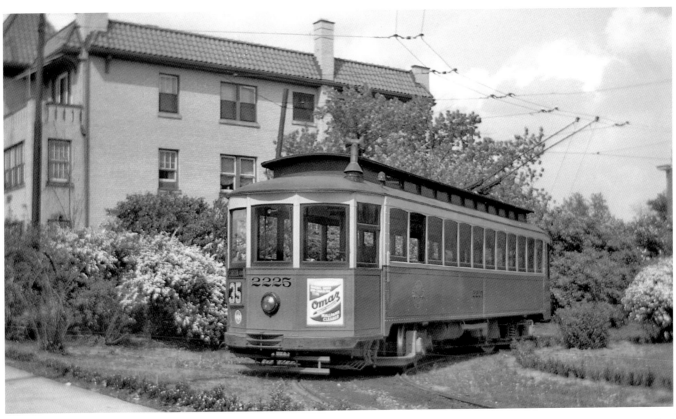

The route 36 Glenway Avenue and Rutledge Avenue loop is the location of CSRC car No. 2225 on a May 30, 1948, rail excursion. (Ed O'Meara photograph—Clifford R. Scholes collection)

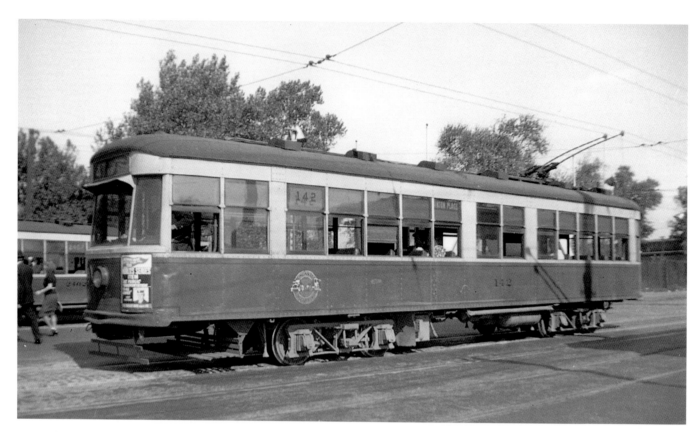

In October 1939, CSRC 100 series car No. 142 is at the in the street Spring Grove Avenue route 41 Chester Park loop. On the left is a 2400 series curved side streetcar. (Bob Crockett photograph—Clifford R. Scholes collection)

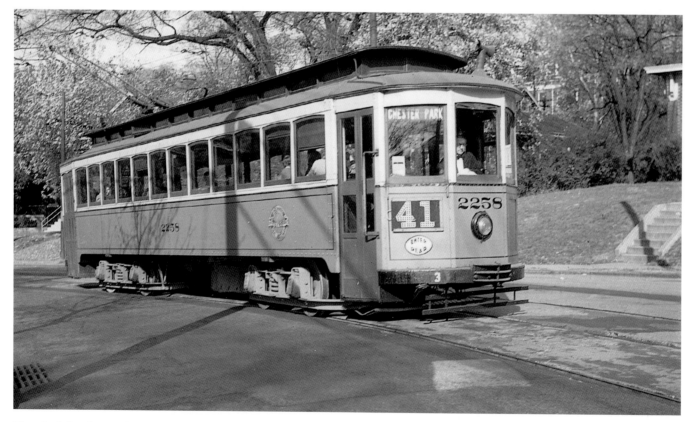

The nicely landscaped residential area of Mitchell Avenue near Clinton Springs Avenue is the location of route 41 car No. 2258 on September 27, 1947. Clifford R. Scholes photograph)

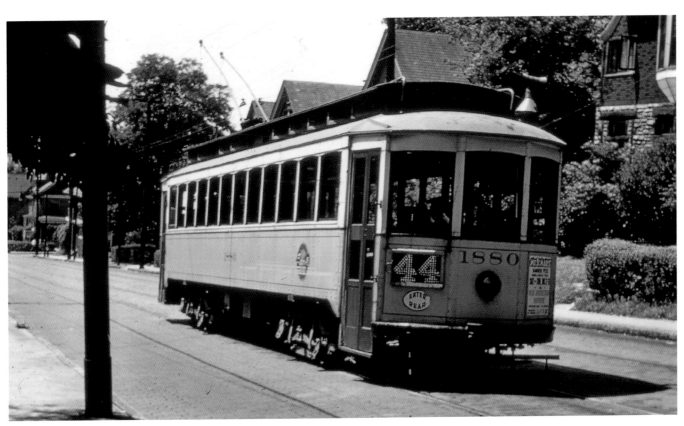

CSRC car No. 1880 is on Dorchester Avenue and Josephine Street on a route 44 rail excursion in 1947. (Pat Carmody photograph—Clifford R. Scholes collection)

McMillan Street west of Andrew Street, with its ornate brick row homes, is the location of CSRC 100 series car No. 104 handling a route 46 trip in 1940. (R. Wagner photograph—Clifford R. Scholes collection)

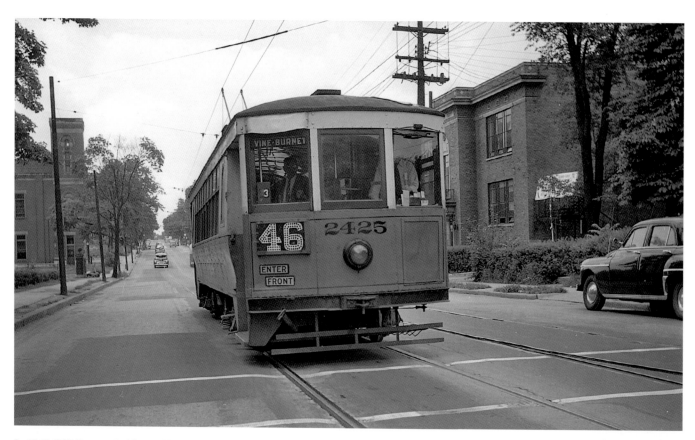

In 1947, CSRC curved side car No. 2425 is on Rockdale Avenue at the route 46 terminal wye. Clifford R. Scholes photograph)

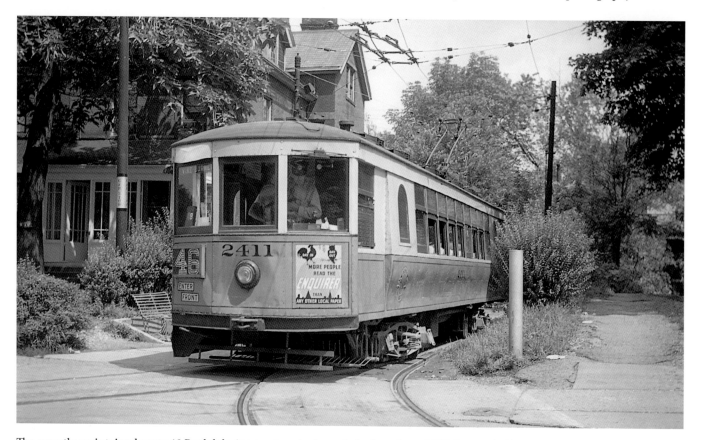

The smartly maintained route 46 Rockdale Avenue terminal wye is the location of CSRC curved side car No. 2411 in 1947. (Clifford R. Scholes photograph)

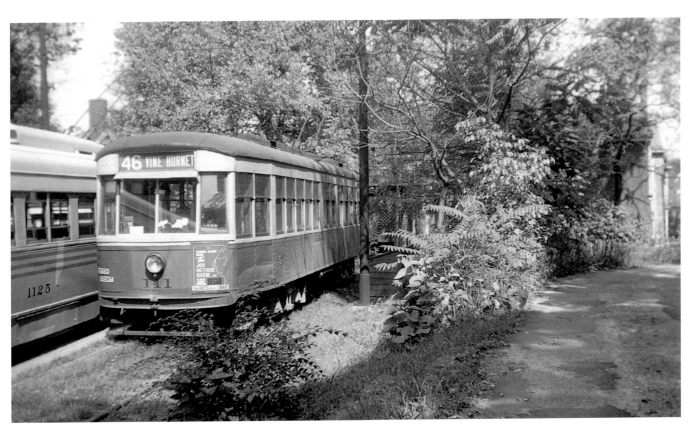

On September 19, 1948, CSRC 100 series car No. 111 and PCC car No. 1125 (on a rail excursion) are at the route 46 Rockdale Avenue terminal wye. (Clifford R. Scholes photograph).

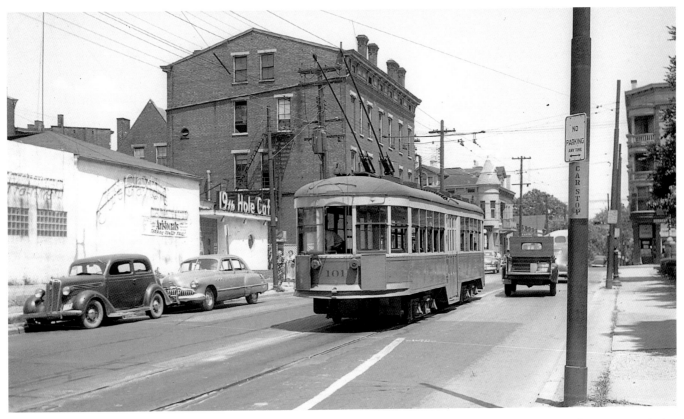

CSRC 100 series car No. 101 is on Rockdale Avenue west of Reading Road at the route 46 terminal wye in 1948. (Clifford R. Scholes photograph)

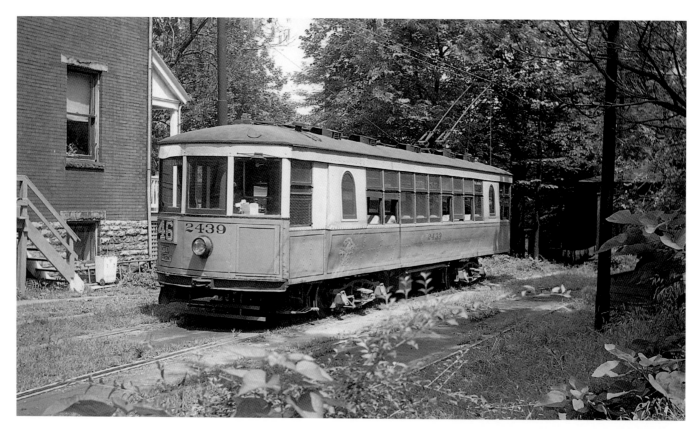

On July 21, 1949, CSRC curved side car No. 2439 is waiting for departure time at the route 46 Rockdale Avenue terminal wye. (Clifford R. Scholes photograph)

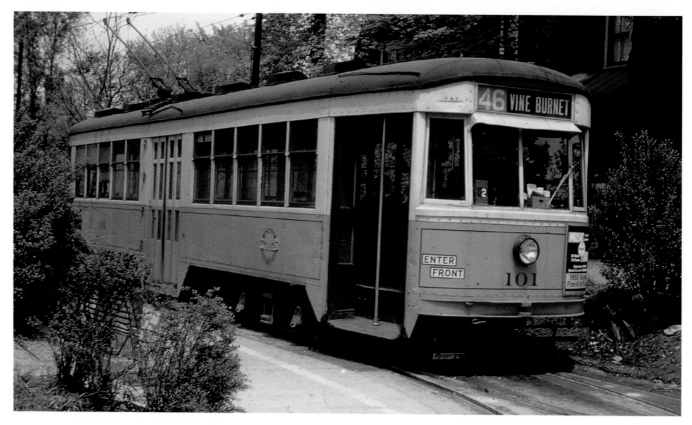

The route 46 Rockdale Avenue terminal wye is the location of CSRC 100 series car No. 101 on May 7, 1950. (Pat Carmody photograph—Clifford R. Scholes collection)

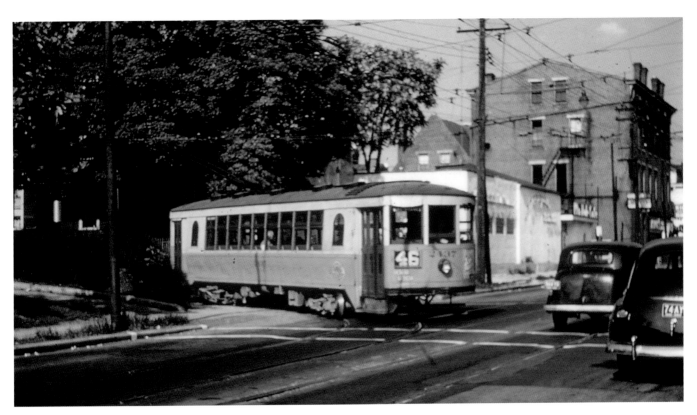

CSRC curved side car No. 2437 is leaving the route 46 Rockdale Avenue terminal wye in 1950. (Pat Carmody photograph—Clifford R. Scholes collection)

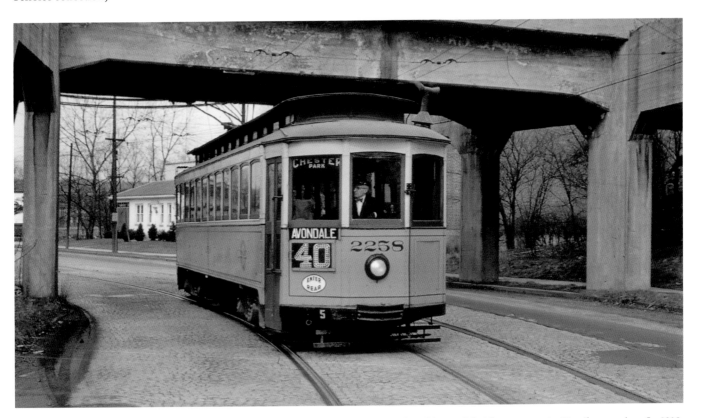

In 1949, CSRC car No. 2258 is on Mitchell Avenue passing under the Cincinnati rapid transit bridge on a route 47 rail excursion. In 1916, Cincinnati City Council authorized a $6 million bond issue to build a 16-mile subway/elevated rapid transit system. Construction work began in 1920 and stopped in 1927 with seven miles dug or graded, but no track was laid. The bond issue was paid in 1966 at a cost of $13,019,982.42, and the line was never completed. (Pat Carmody photograph—Clifford R. Scholes collection)

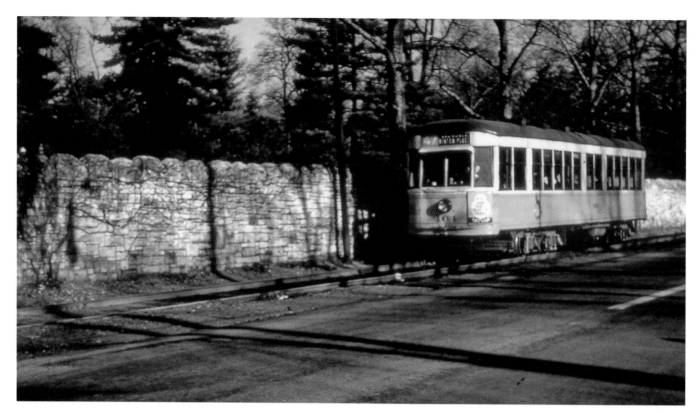

CSRC 100 series car No. 164 is on the route 47 Winton Road private right of way in 1948. Behind the stone wall is the Spring Grove Cemetery, founded in 1845, which became the Spring Grove Cemetery and Arboretum in 1987 with 733 acres of which 450 acres are landscaped and the remainder remains undeveloped to ensure it permanence for many years. (Pat Carmody photograph—Clifford R. Scholes collection)

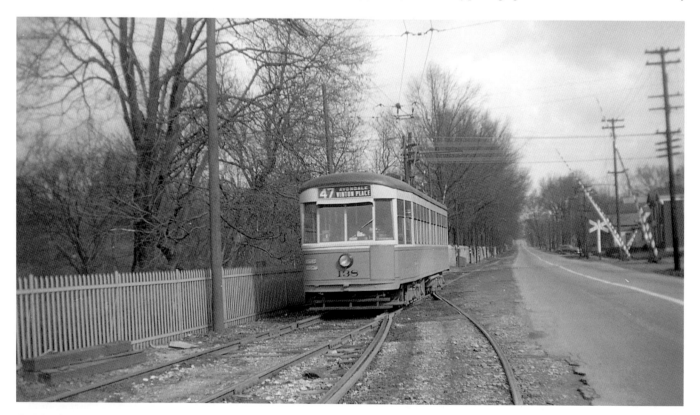

On March 11, 1949, CSRC 100 series car No. 138 is on the route 47 Winton Road private right of way at the end of the single track section. To the left of the streetcar is the Spring Grove Cemetery, and behind the streetcar is the Baltimore & Ohio Railroad crossing. (Clifford R. Scholes photograph)

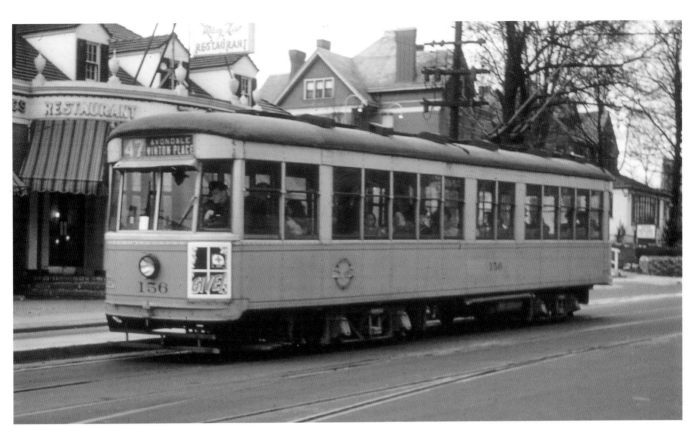

Reading Road and Oak Street is the location of CSRC 100 series car No. 156 on a 1949 route 47 trip. (Pat Carmody photograph—Clifford R. Scholes collection)

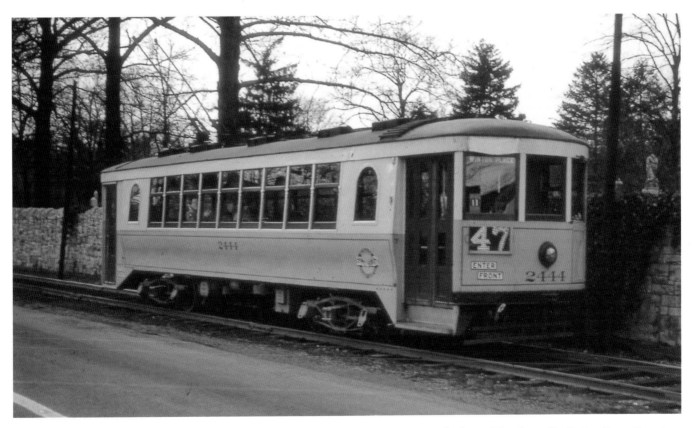

In 1949, CSRC curved side car No. 2444 is on a route 47 rail excursion on the Winton Road private right of way. The Spring Grove Cemetery is behind the streetcar. (Pat Carmody photograph—Clifford R. Scholes collection)

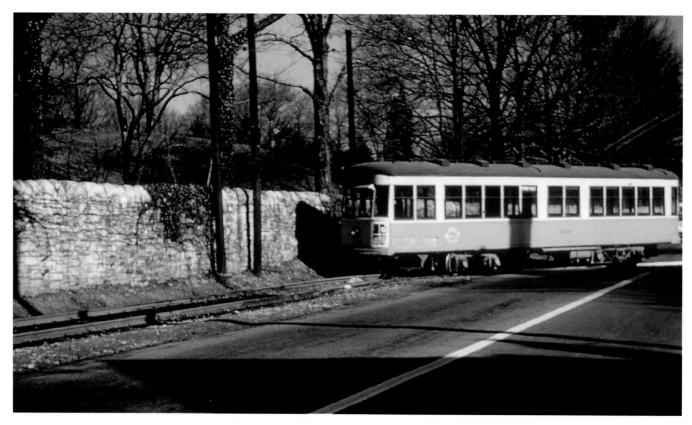

On March 26, 1950, CSRC 100 series car No. 186 is turning from Epworth Avenue to the Winton Road private right of way on a route 47 rail excursion with the Spring Grove Cemetery behind the stone wall. (Pat Carmody photograph—Clifford R. Scholes collection)

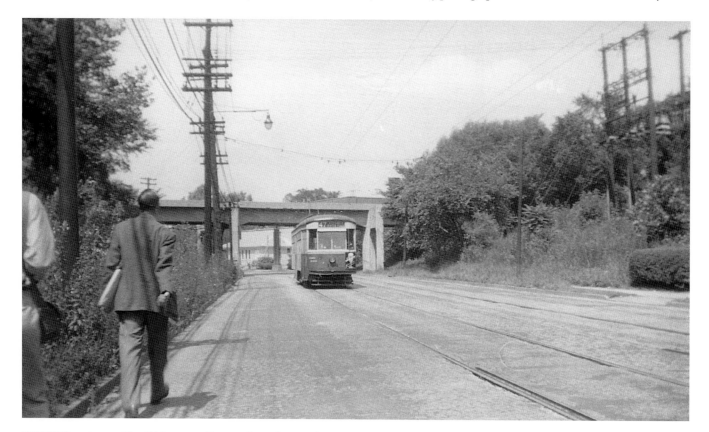

CSRC 100 series car No. 114 is on a rail excursion trip covering route 47 on Mitchell Avenue and Kesslar Avenue in 1950. A Cincinnati Subway bridge, for the line that was never completed, is in the background. (Clifford R. Scholes photograph)

# Chapter 5
# Routes 49, 53, 55, 60, 61, and 64

Route 49 (Zoo-Eden Park) operated from Zoo Garden via Erkenbrecher, Burnet, Melish, Reading, Oak, May, McMillan, Gilbert, Sinton, private right of way, Mount Adams Incline, private right of way, Eggleston, Fifth, Broadway, Fourth and Main to Fifth and Main in downtown Cincinnati and returned via Fifth, Eggleston, private right of way, Mount Adams Incline, Ida, private right of way, Sinton, Gilbert, McMillan, May, Oak, Reading, Melish, Burnet, and Erkenbrecher to Zoo Garden. On April 17, 1949, streetcar route 49 (Zoo-Gilbert) and bus route 49B (Mt. Adams) were merged into bus route 49 (Zoo-Eden).

Route 53 (Auburn) operated from Auburn and McMillan via McMillan, Highland, Milton, Sycamore, and Sixth to Sixth and Main in downtown Cincinnati and returned via Main, Broadway, Liberty, Highland, Ringgold, Josephine, Dorchester, and Auburn to Auburn and McMillan. This became a trackless trolley line on August 17, 1947.

Route 55 (Vine-Clifton) operated from Clifton Public School via McAlpine, Middleton, Ludlow, Jefferson, private right of way, Vine, Ninth, Walnut, and Fifth to Vine in downtown Cincinnati and returned via Vine, private right of way, Jefferson, Ludlow, Telford, Bryant, Middleton, and McAlpine to Clifton Public School. On April 29, 1951, route 55 was converted to trackless trolley operation.

Route 60 (Fairview) operated from Fairview Incline via Fairview, McMillan, Clifton, Vine, Ninth, Walnut and Sixth to Sixth and Vine in downtown Cincinnati and returned via Vine, Clifton, McMillan, and Fairview to Fairview Incline. Trackless trolleys took over route 60 on March 6, 1949, and the line was combined with route 62 (Ohio Avenue) and became route 60 (Fairview-Ohio).

Route 61 (Clifton-Ludlow) operated from Hamilton and Springlawn via Hamilton, Spring Grove, Ludlow, Clifton, McMillan, Clifton, Vine, McMicken, Main, Ninth, Walnut, and Sixth to Sixth and Vine in downtown Cincinnati and returned via Vine, Clifton, McMillan, Clifton, Ludlow, Spring Grove and Hamilton to Hamilton and Springlawn. Trackless trolleys took over route 61 on March 6, 1949, and its outer terminal was changed from Spring Lawn Avenue and Hamilton Avenue to Chase and Dane Avenues.

Route 64 (McMicken-Main) operated from McMicken and Hopple via McMicken, Main, Ninth, Sycamore, and Sixth to Sixth and Main in downtown Cincinnati and returned via Main and McMicken to McMicken and Hopple. Trackless trolleys took over route 64 on October 9, 1938.

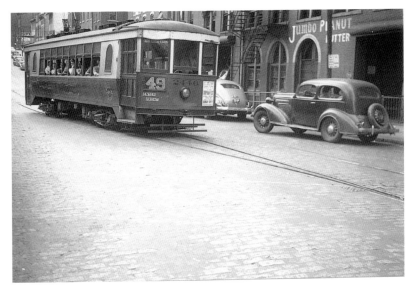

CSRC route 49 curved side car No. 2446 is on Fifth Street near Eggleston Avenue in 1941 at the beginning of the single track that led to the Mount Adams Incline. (Bob Crockett photograph—Clifford R. Scholes collection)

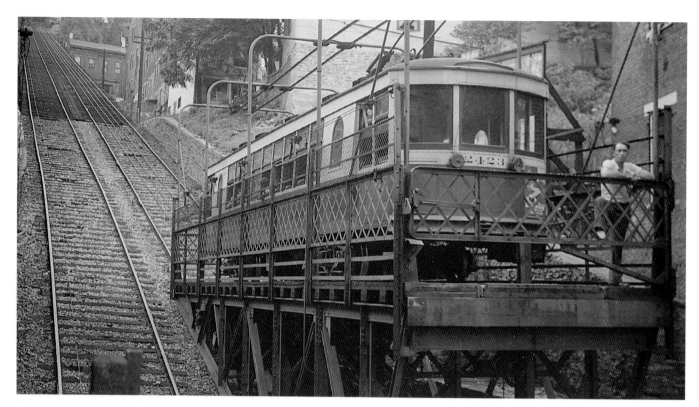

In September 1941, CSRC route 49 curved side car No. 2423 is at the base of the Mount Adams Incline. The Mount Adams & Eden Park Inclined Railway, incorporated June 26, 1873, made its first official run March 8, 1876. In April 1880, horse cars began operating from Fountain Square in downtown Cincinnati via the 945-foot-long incline to Eden Park and Reading. With a grade of about 28.9 percent, the incline rose 270 feet from the lower station. (Bob Crockett photograph—Clifford R. Scholes collection)

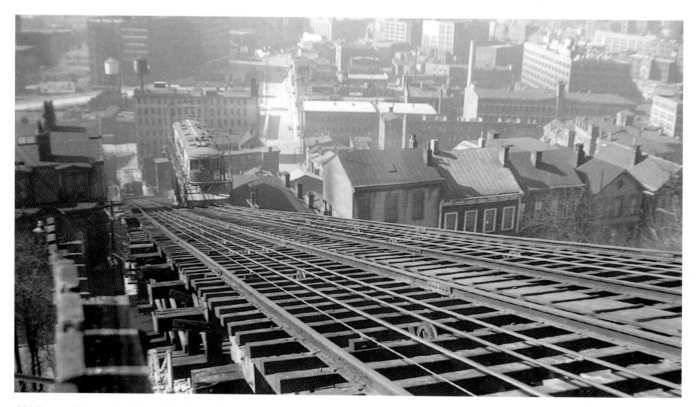

CSRC route 49 curved side car No. 2448 is descending on the Mount Adams Incline in 1942. The incline's two tracks were built to a 7-foot gauge with a 5.5-foot distance between tracks. Each track had a 20-ton incline plane cart that was designed to handle a loaded streetcar and foot passengers. (Bob Crockett photograph—Clifford R. Scholes collection)

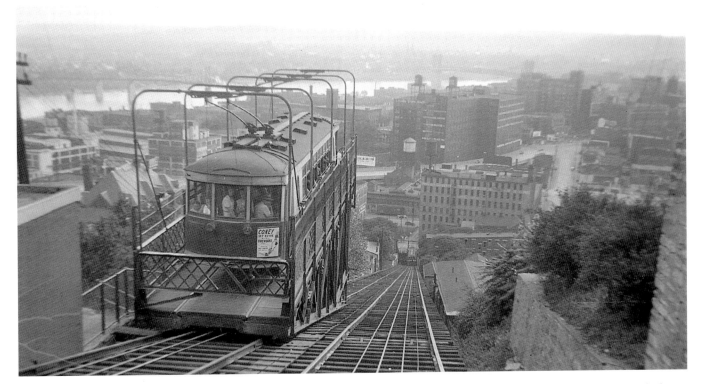

On August 6, 1949, CSRC route 49 curved side car No. 2423 is descending on the Mount Adams Incline. In 1926, the incline platforms were lengthened to handle double truck streetcars, and new lifts were installed in 1936. (Clifford R. Scholes photograph)

With the Cincinnati Art Museum on the hill to the left of the streetcar, route 49 CSRC car No. 2191 is on the Eden Park private right of way in 1944. This was one of 100 cars Nos. 2100-2199 built by Cincinnati Car Company in 1917. The 44-foot-long-by-8.17-foot-wide car weighed 34,080 pounds and seated 48 passengers. Deterioration of the stone archway which was the foundation for the streetcar trestle over the Gilbert Avenue entrance to Eden Park resulted in the conversion of route 49 to bus operation in 1947, and the Mount Adams Incline hauled buses until the incline ended operation on April 16, 1948. The incline plane was scrapped in 1952, and the building was demolished in 1954. (Clifford R. Scholes photograph)

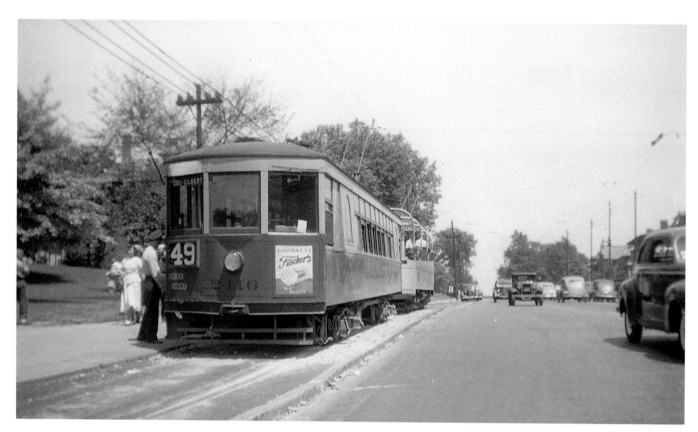

The Erkenbrecher Avenue private right of way at the Zoo entrance route 49 terminal is the location of CSRC curved side car No. 2416 with the Hiawatha sightseeing car on a rail excursion behind it in 1948. (Clifford R. Scholes photograph)

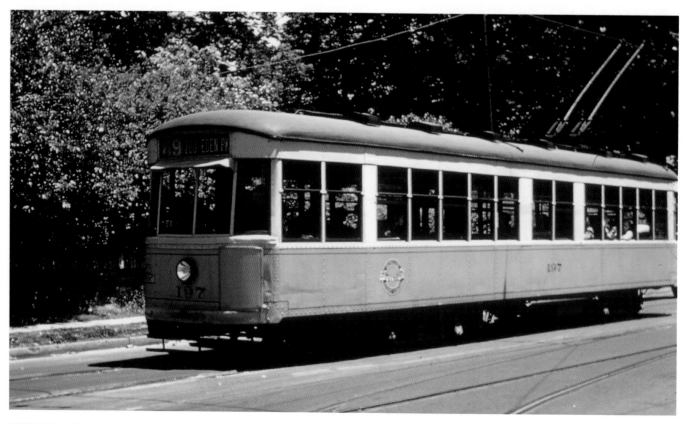

CSRC 100 series car No. 197 is on a route 49 trip on Oak Street and Reading Road in 1948. (Pat Carmody photograph—Clifford R. Scholes collection)

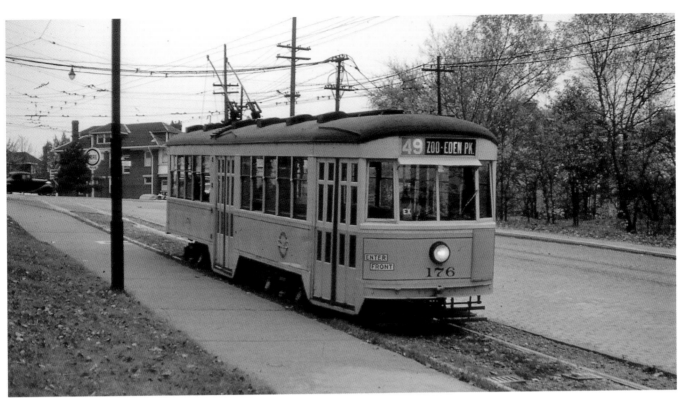

In 1949, CSRC 100 series car No. 176 is on a rail excursion over route 49 on the Vine Street side of the road private right of way north of Erkenbrecher Avenue at the Zoo entrance. (Pat Carmody photograph—Clifford R. Scholes collection)

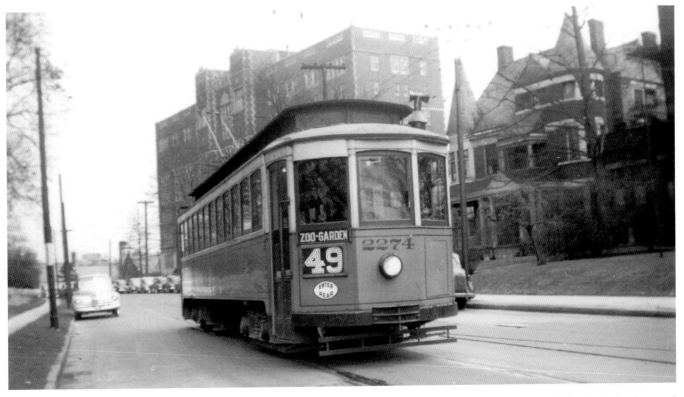

Oak Street and Reading Road is the location of CSRC car No. 2274 on a 1949 route 49 rail excursion. The large building in the background was the Bethesda Hospital. In 1886, Methodist Episcopal Church Minister Dr. Christian Golder founded the German Methodist Deaconess Association in Cincinnati. Deaconesses went out into the community on foot and by streetcar to minister spiritually and physically to the community. The association purchased a 20-bed hospital in 1898 for $55,000 on the corner of Oak Street and Reading Road which later became the Bethesda Hospital. (Clifford R. Scholes photograph)

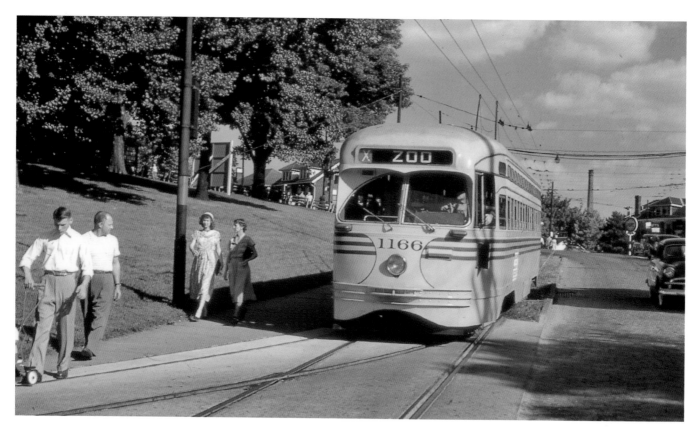

On an August 6, 1949, rail excursion over the CSRC system, PCC car No. 1166 is at the route 49 Zoo terminal loop. The straight track ahead of the streetcar is route 78 to Lockland, Ohio. (Pat Carmody photograph—Clifford R. Scholes collection)

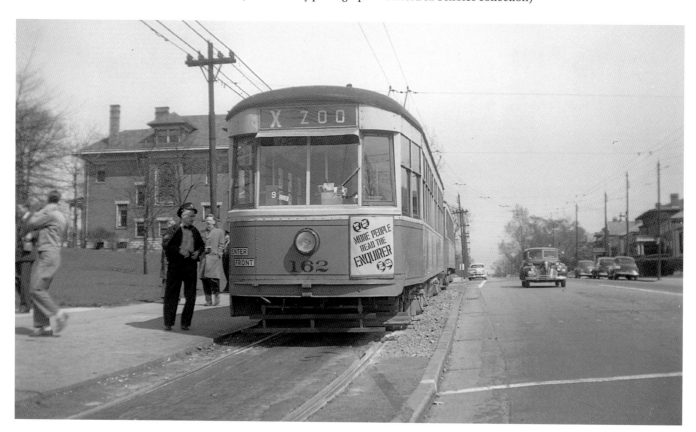

The route 49 terminal on Erkenbrecher Avenue at the Zoo entrance is the location of 100 series car No. 162 and a 2200 series car on October 9, 1949. (Clifford R. Scholes photograph)

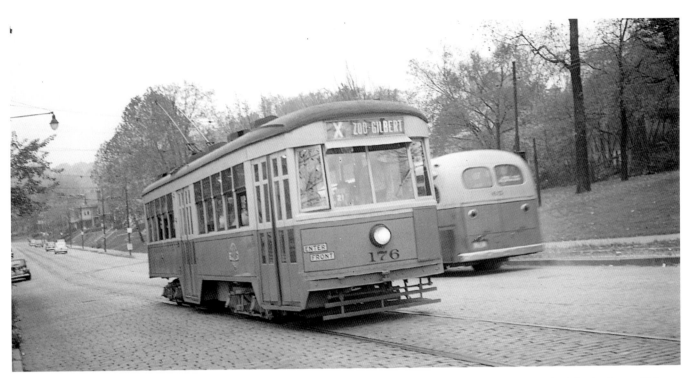

On October 10, 1949, CSCR 100 series car No. 176 operating on a rail excursion over route X (Zoo) has passed a bus built by the General Motors Corporation on Vine Street north of Erkenbrecher Avenue. The Cincinnati Zoo is on the hill on the right. (Clifford R. Scholes photograph)

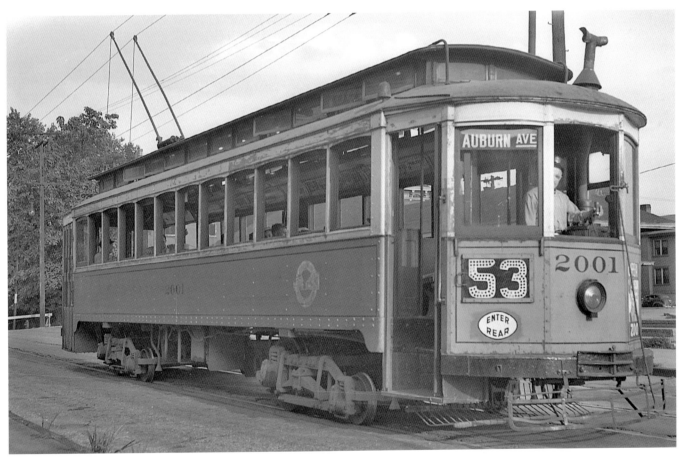

Dorchester Avenue between Auburn Avenue and Josephine Street is the location of route 53 CSRC car No. 2001 on February 6, 1947. Streetcar route 53 operated clockwise around the large loop, while route 44 operated counterclockwise on the same streets. (Tom Scholey photograph—Clifford R. Scholes collection)

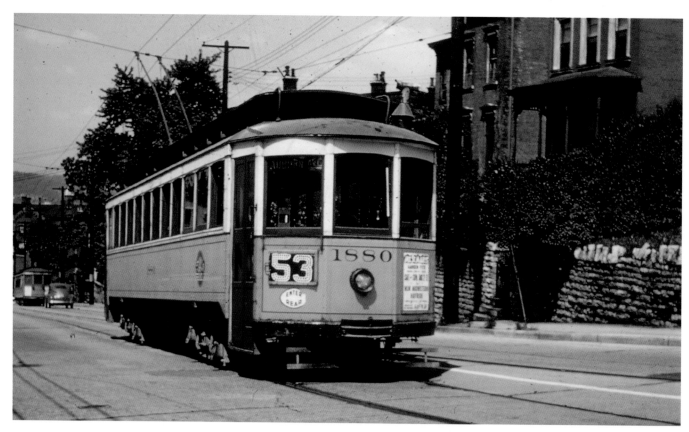

In 1947, CSRC car No. 1880 is on Liberty Street near the turn to Highland Avenue on a rail excursion over streetcar route 53. (Pat Carmody photograph—Clifford R. Scholes collection)

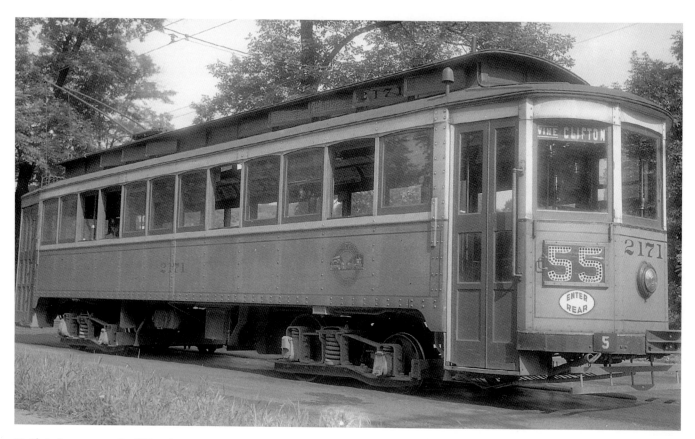

McAlpin Avenue near the Clifton Avenue route 55 terminal wye is the location of CSRC car No. 2171 in August 1942. (Clifford R. Scholes collection)

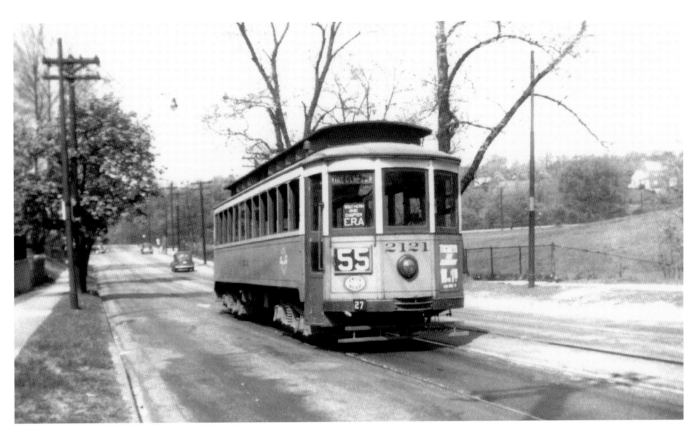

CSRC car No. 2121 is on McAlpin Avenue near Clifton Avenue at the route 55 terminal in 1947. This car was on a rail excursion with the sign on the left front window stating, "Southern Ohio Chapter ERA." ERA is the Electric Railroaders' Association, Inc. (Clifford R. Scholes photograph)

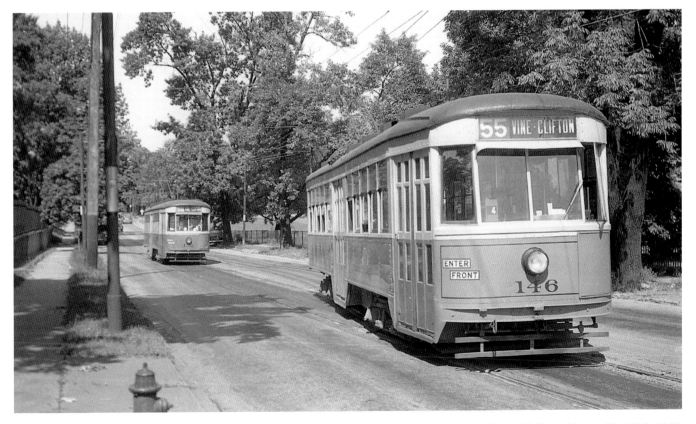

The route 55 terminal on McAlpin west of Clifton Avenue is the location of CSRC 100 series car No. 146 followed by car No. 152 in 1949. (Clifford R. Scholes photograph)

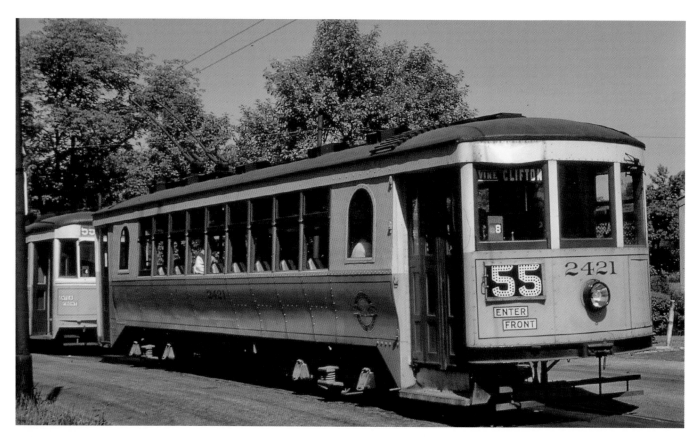

CSRC curved side car No. 2421 on a rail excursion followed by a 100 series car are at the route 55 terminal wye on McAlpine Avenue near Clifton Avenue on August 6, 1949. (Pat Carmody photograph—Clifford R. Scholes collection)

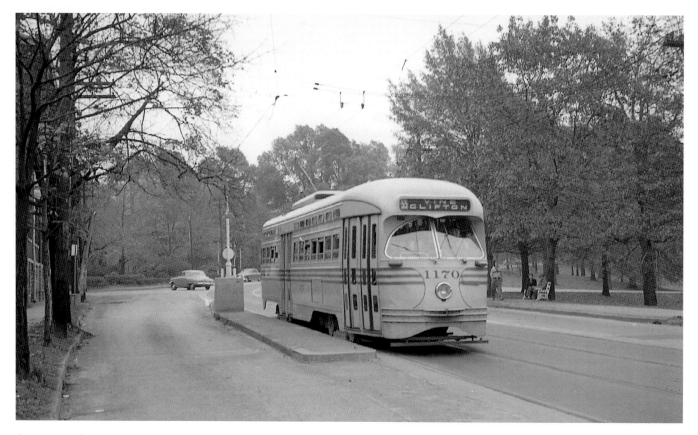

On a 1949 rail excursion, PCC car No. 1170 is on CSRC route 55 at Jefferson and Brookline Avenues. (Clifford R. Scholes photograph)

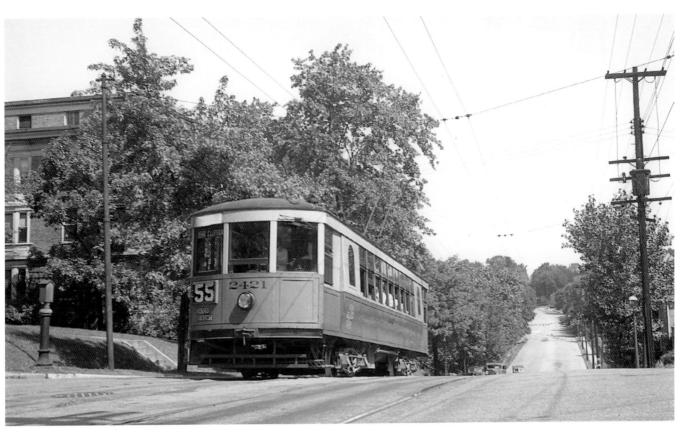

In 1950, CSRC curved side car No. 2421 is on a route 55 trip at Middleton and Resor Avenues. (Clifford R. Scholes collection)

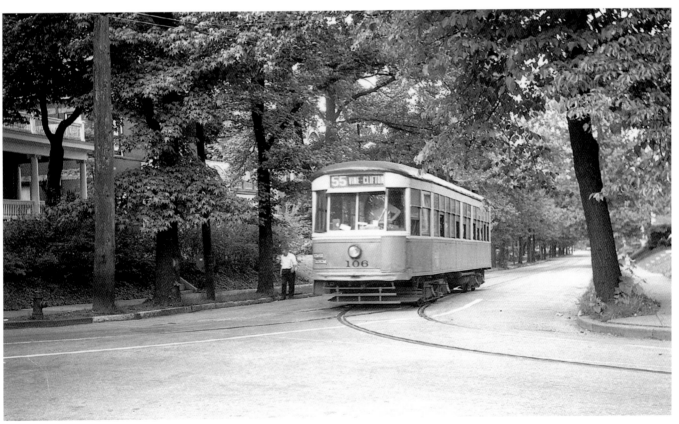

CSRC 100 series car No. 106 is on a route 55 trip on Bryant and Middletop Avenues in 1950. The track turning to the right under the streetcar was for the short turn route 65 (Clifford-Ludlow). (Clifford R. Scholes photograph)

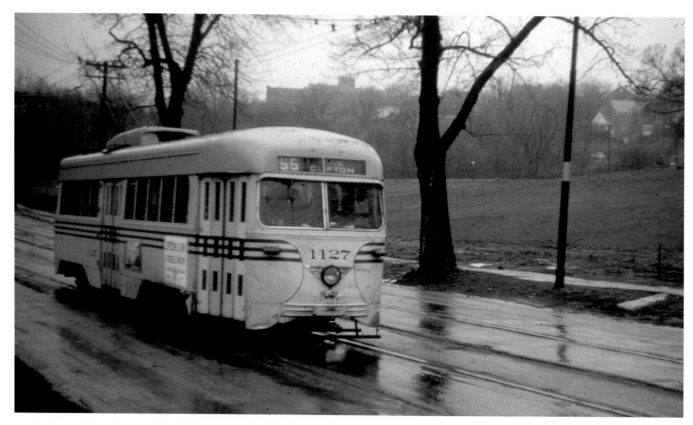

On a rainy April 22, 1951, PCC car No. 1127 is at the CSRC route 55 terminal wye on McAlpine Avenue near Clifton Avenue on a rail excursion. (Clifford R. Scholes photograph)

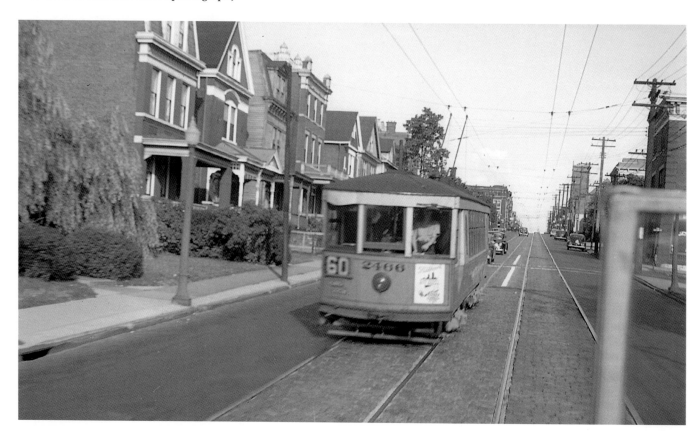

In this photograph taken from the CSRC car "Hiawatha," route 60 curved side car No. 2466 is on Clifton Avenue and Parker Street in 1948. (Clifford R. Scholes collection)

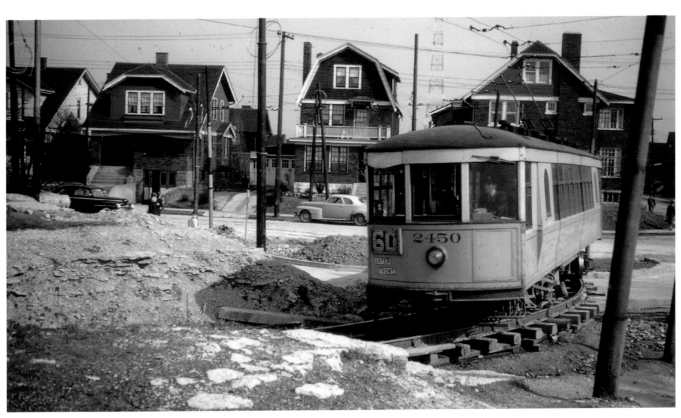

The CSCR route 60 Fairview Avenue terminal loop is the location of curved side car No. 2450 in 1949. In this scene, the loop was being reconstructed with concrete roadway for trackless trolley operation, and temporary track was in place for streetcar service until trackless trolley operation began on March 6, 1949. (Pat Carmody photograph—Clifford R. Scholes collection)

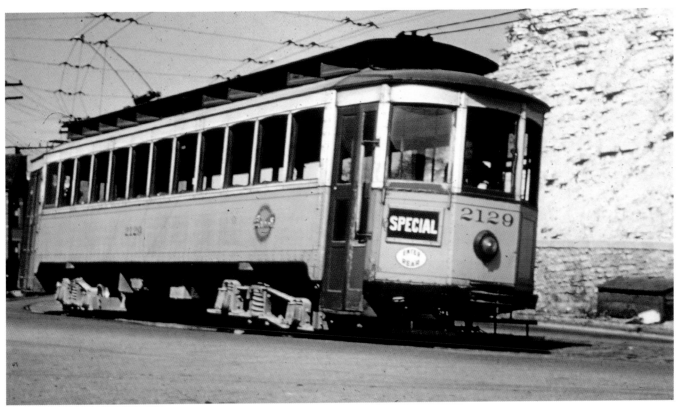

In 1947, CSRC car No. 2129 is on route 61 at the curve on the hill on Clifton Avenue on a rail excursion. (Pat Carmody photograph—Clifford R. Scholes collection)

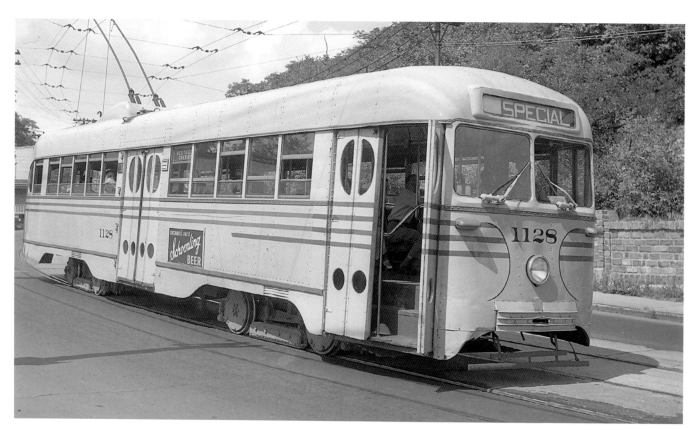

On Clifton Avenue at the CSRC route 61 streetcar track curve on a hill, car No. 1128 (originally delivered as No. 1200 by J. G. Brill Company on May 31, 1939) is on a 1949 rail excursion. (Clifford R. Scholes photograph)

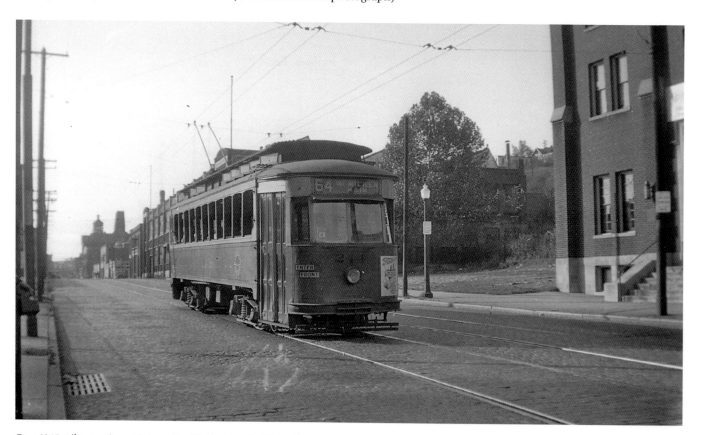

On a 1945 rail excursion, CSRC car No. 244 (originally 2000 series two-man operated deck roof car No. 2044 that was rebuilt for one-man operation with a new wide front windshield in 1932) is on McMicken Avenue west of Elm Street on route 64 trackage. (Clifford R. Scholes photograph)

# Chapter 6
# Routes 68, 69, 70, 71, and 78

Route 68 (Madison Road) operated from Eastern and Delta via Delta, Erie, Madison, Woodburn, McMillan, Gilbert, Broadway, and Fourth and Main to Fifth and Main in downtown Cincinnati and returned via Fifth, Broadway, McMillan, Woodburn, Madison, Erie, and Delta to Eastern and Delta. On June 18, 1950, trackless trolleys took over route 68 with through service to downtown Cincinnati only during rush hours.

Route 69 (Madisonville) operated from the Baltimore & Ohio Railroad station in Madisonville via Madison, Whetzel, Bramble, Erie, Madison, Woodburn, McMillan, Gilbert, Broadway, Fourth and Main to Fifth and Main in downtown Cincinnati and returning via Fifth, Broadway, Gilbert, McMillan, Woodburn, Madison, Erie, Bramble, Whetzel, and Madison to the Baltimore & Ohio station in Madisonville. Trackless trolleys replaced streetcars on route 69 on July 6, 1947.

Route 70 (Oakley) operated from Columbia and Madison via Madison, Woodburn, McMillan, Gilbert, Broadway, Fourth and Main to Fifth and Main in downtown Cincinnati

and returning via Fifth, Broadway, Gilbert, McMillan, Woodburn, and Madison to Columbia and Madison. Route A (Mariemont) buses took over route 70 on June 18, 1950.

Route 71 (Milford) operated from Milford over streets and private right of way through Plainville and Mariemont to Milford Junction and via Erie, Madison, Woodburn, McMillan, Gilbert, Broadway, Fourth and Main to Fifth and Main in downtown Cincinnati and returning via Fifth, Broadway Gilbert, McMillan, Woodburn, Madison, and Erie to Milford Junction and over streets and private right of way through Mariemont and Plainville to Milford. Buses took over route 71 on August 24, 1936.

Route 78 (Lockland) operated from Mills and Dunn via Dunn, Williams, Benson, Wyoming, Anthony Wayne, Lockland Avenue, Carthage, Vine, McMicken, Main, Ninth, Sycamore, and Sixth to Six and Main in downtown Cincinnati and returning via Main, McMicken, Vine, Carthage, Lockland Avenue, Anthony Wayne, Wyoming, Benson, and Mills to Mills and Dunn. Route 78 was converted to bus operation on April 28, 1951.

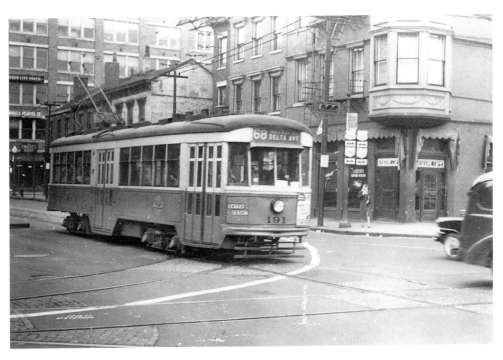

In March 1948, route 68 CSRC 100 series car No. 191 is at Broadway and Fifth Streets in downtown Cincinnati. (Clifford R. Scholes collection)

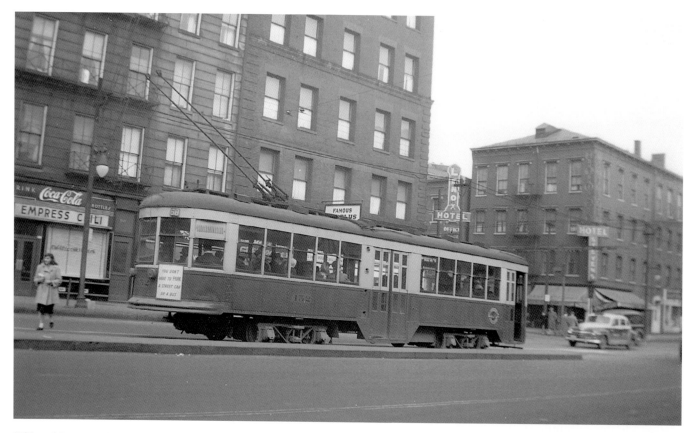

Fifth and Sycamore Streets in downtown Cincinnati is the location of route 68 CSRC 100 series car No. 152 in 1948. (Clifford R. Scholes collection)

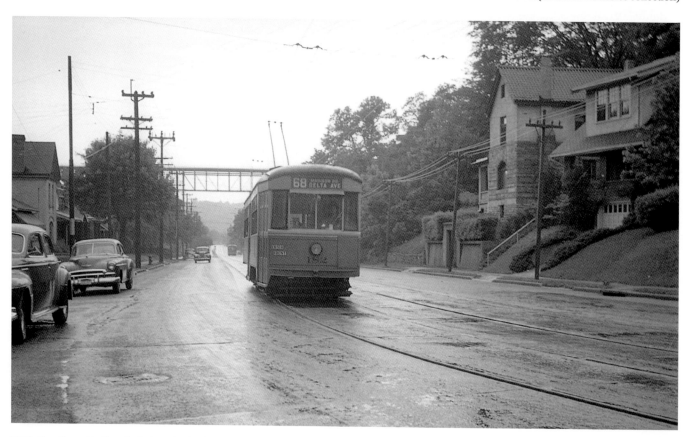

With the Grandin Road viaduct in the background, route 68 CSRC 100 series car No. 182 is on Delta Avenue and Mica Street in 1949. (Clifford R. Scholes photograph)

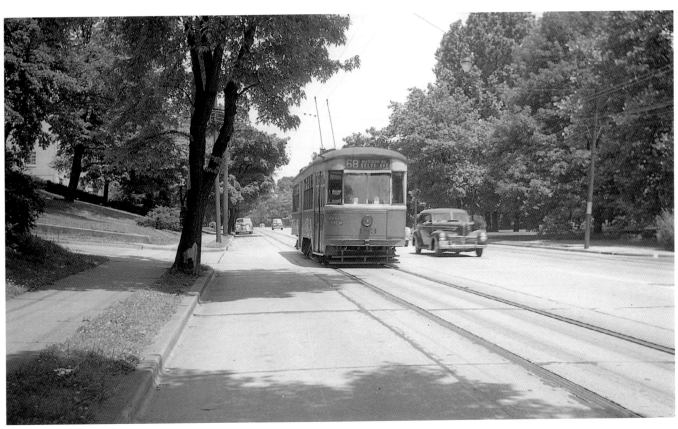

Delta Avenue and Griest Street is the location of CSRC 100 series car No. 183 on route 68 in 1949. (Clifford R. Scholes photograph)

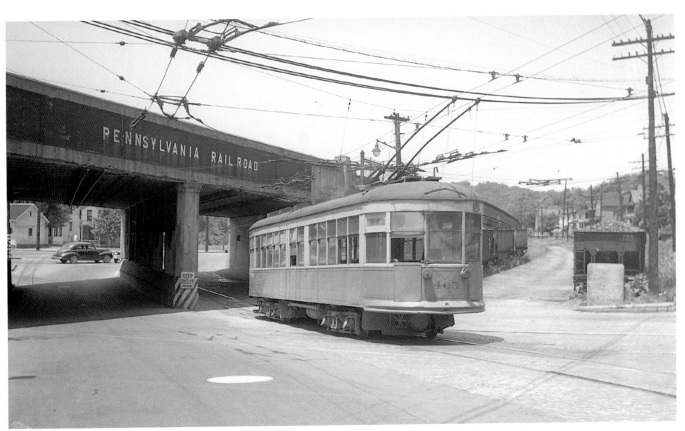

On October 9, 1949, CSRC 100 series car No. 165 is ready to go under the Pennsylvania Railroad overpass at the route 68 terminal wye on Delta and Eastern Avenues. (Clifford R. Scholes photograph)

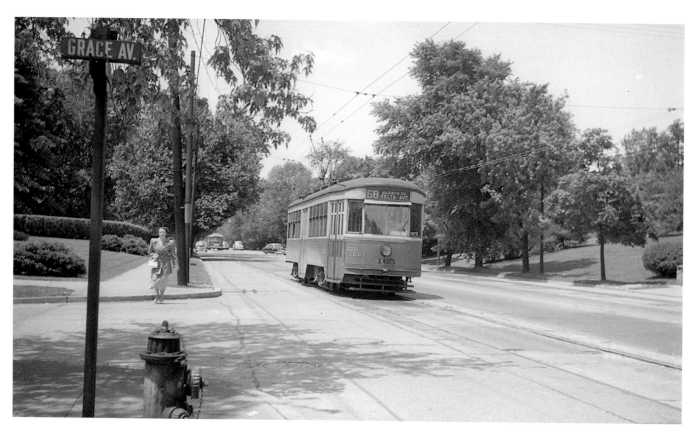

Route 68 CSRC 100 series car No. 165 is on Erie and Grace Avenues on October 9, 1949. (Clifford R. Scholes photograph)

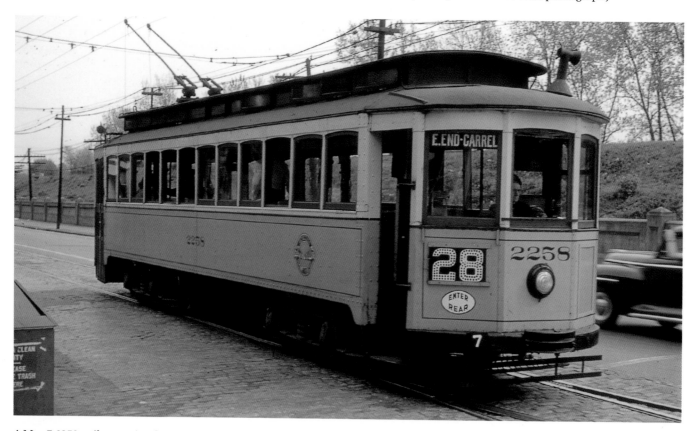

A May 7, 1950, rail excursion features CSRC car No. 2258 at the route 68 terminal wye on Eastern and Delta Avenues. Route 28, shown on the front of the streetcar for the photo stop, was a short turn cutback for route 27. Both routes 27 and 28 were abandoned on September 28, 1947. (Pat Carmody photograph—Clifford R. Scholes collection)

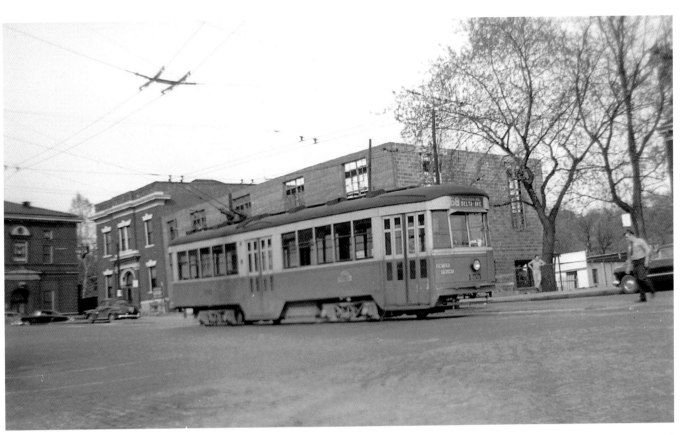

On March 26, 1950, CSRC 100 series car No. 155 is at the Delta and Eastern Avenues route 68 terminal wye. (Clifford R. Scholes photograph)

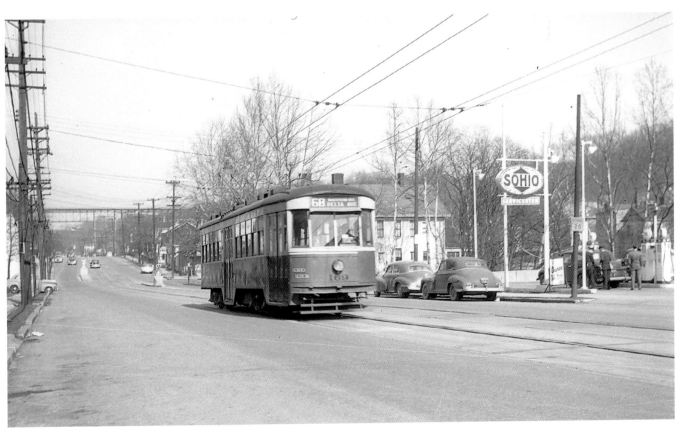

With the high Grandin Road viaduct in the background, route 68 CSCR 100 series car No. 169 is on Delta Road north of Columbia Parkway on March 26, 1950. (Clifford R. Scholes photograph)

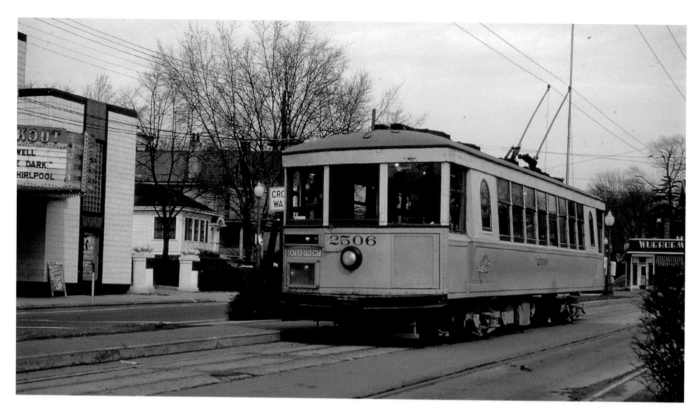

On March 26, 1950, route 68 CSRC curved side car No. 2506 (originally No. 106 for the Maumee Valley Railway & Light Company) is on Delta and Linwood Avenues at Mount Lookout Square in Mount Lookout, Ohio, which over the years has been noted for its tree-lined streets, charming homes, and walkability to its shopping district. Overlooking the Ohio River Valley, Mount Lookout is the location, since 1873, of the Cincinnati Observatory Center, making it the oldest working telescope in the United States. (Pat Carmody photograph—Clifford R. Scholes collection)

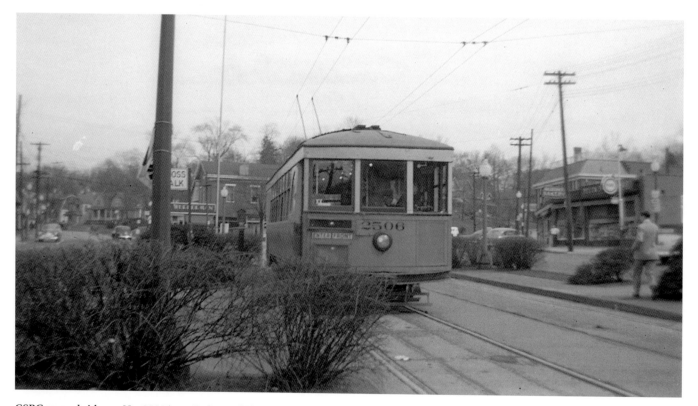

CSRC curved side car No. 2506 is on Delta and Linwood Avenues at Mount Lookout Square on a March 26, 1950, route 68 rail excursion. (Clifford R. Scholes photograph)

The CSRC route 68 terminal wye at Eastern and Delta Avenues is the location of 100 series car No. 183 on May 7, 1950. (Pat Carmody photograph—Clifford R. Scholes collection)

The route 68 terminal wye at Delta and Eastern Avenues is the location of CSRC 100 series car No. 181 in 1950. (Pat Carmody photograph—Clifford R. Scholes collection)

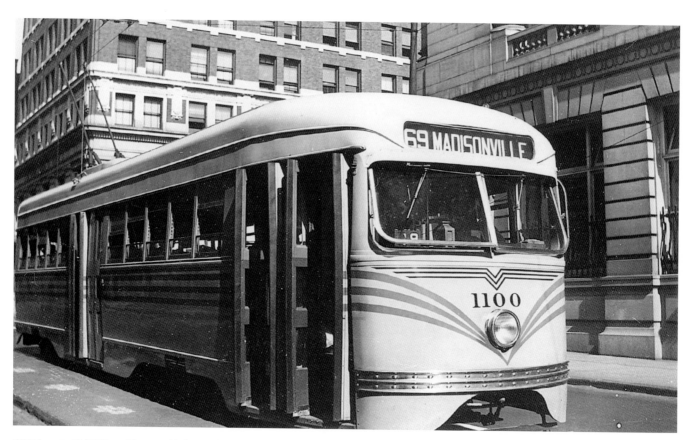

CSRC route 69 PCC car No. 1100 (delivered by the St. Louis Car Company on September 4, 1939) is at Fourth and Main Streets in downtown Cincinnati in 1939. The streetcar has its original striping just below the front window. (Clifford R. Scholes photograph)

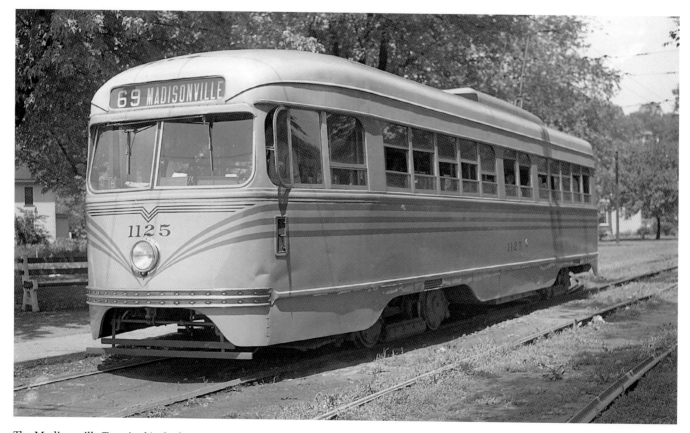

The Madisonville Terminal is the location of CSRC route 69 PCC car No. 1125 on September 13, 1941. (Clifford R. Scholes collection)

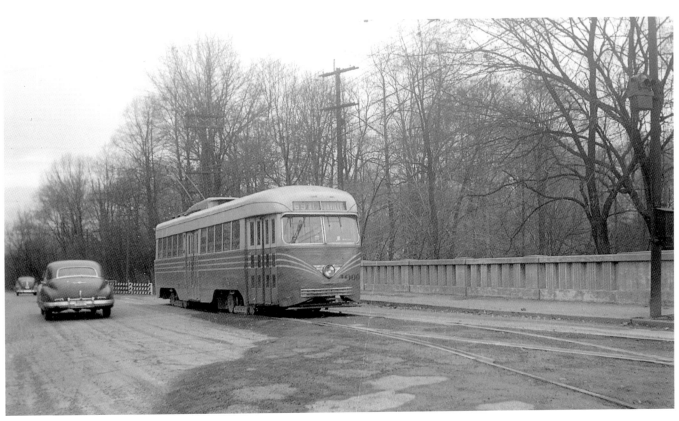

On May 27, 1946, CSRC route 69 PCC car No. 1000 (delivered by Pullman Standard Car Building Company in 1939 and was renumbered 1127 in December 1947) is on the Erie Avenue Duck Creek bridge in its original orange in the lower portion of car body, cream in the upper portion of car around the window section, grey roof, and original striping. (Bob Crockett photograph—Clifford R. Scholes collection)

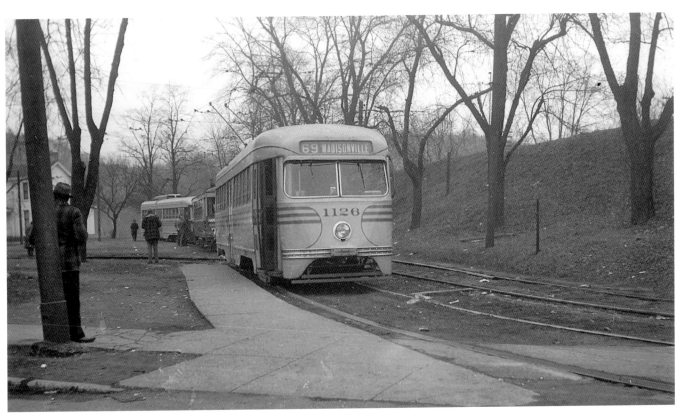

CSRC route 69 PCC car No. 1126 followed by a conventional car and another PCC car are at the Madisonville loop on May 27, 1946. (Bob Crockett photograph-Clifford R. Scholes collection)

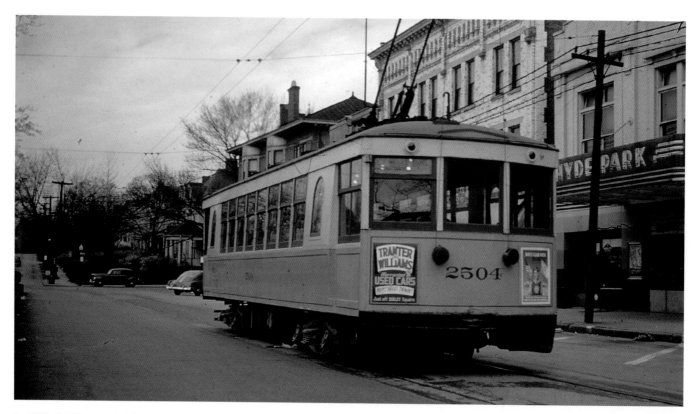

In 1949, CSRC curved side car No. 2504 is on Erie Avenue at Hyde Park Square on a route 69 rail excursion. Hyde Park Square (featuring a park in the center surrounded by stores and restaurants) was established in 1892 on the east side of Cincinnati and was named for New York City's Hyde Park area. (Pat Carmody photograph—Clifford R. Scholes collection)

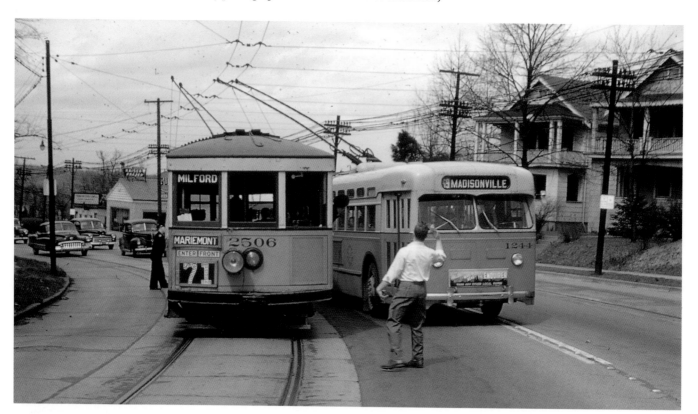

On March 26, 1950, CSRC curved side car No. 2506 (on a rail excursion) and route 69 trackless trolley No. 1244 (built by St. Louis Car Company in 1948) are on Erie Avenue and St. Johns Place. The individual directing the trackless trolley operator is Clifford R. Scholes, who was the source of most of the pictures used in this book. (Pat Carmody photograph—Clifford R. Scholes collection)

The CSRC route 70 Oakley terminal loop is the location of Brilliner car No. 1200 on October 5, 1939. This car was built by J. G. Brill Company on May 31, 1939, and was later renumbered 1128. It was similar to the 25 Brilliners built for the Atlantic City Transportation Company of Atlantic City, New Jersey, which operated streetcars until December 1955. (Bob Crockett photograph—Clifford R. Scholes collection)

Passing by a used car lot filled with automobiles that may contribute to fewer future transit riders, route 70 CSRC 100 series car No. 179 is on Madison Road near Marburg Avenue in 1945. (Clifford R. Scholes photograph)

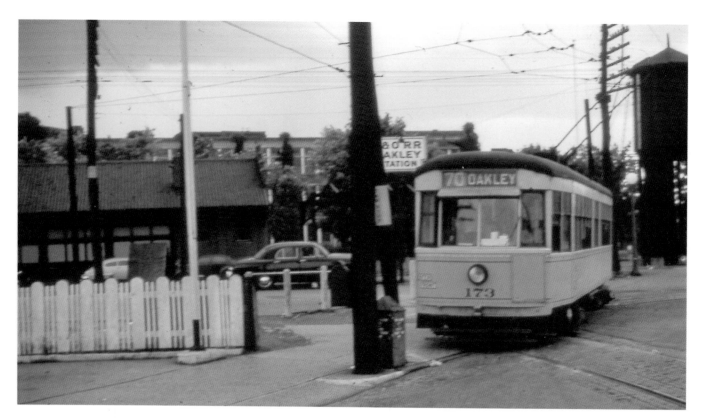

CSRC 100 series car No. 173 is at the route 70 Madison Road Oakley terminal loop in 1949. The Oakley station of the Baltimore & Ohio Railroad is to the left of the streetcar. According to the September 30, 1951, Baltimore & Ohio Railroad train schedule, there was one daily passenger train in each direction stopping at this station on the Pittsburgh via Wheeling and Columbus to Cincinnati line and four daily passenger trains in each direction stopping at this station on the Washington, D.C. via Parkersburg to Cincinnati line. (Clifford R. Scholes photograph)

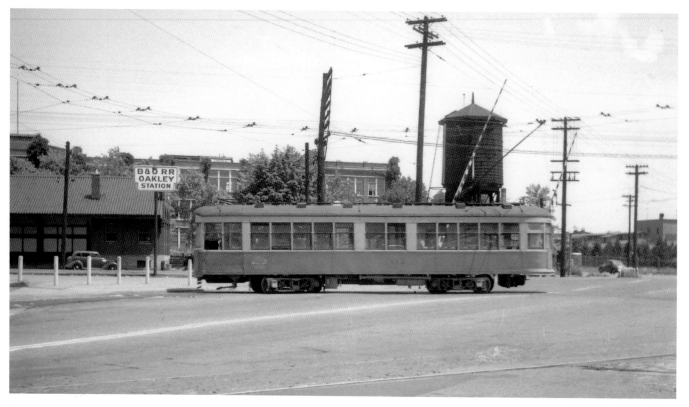

In 1949, route 70 CSRC 100 series car No. 152 is at the Madison Road Oakley terminal with the Baltimore & Ohio Railroad line and station in the background. (Clifford R. Scholes photograph)

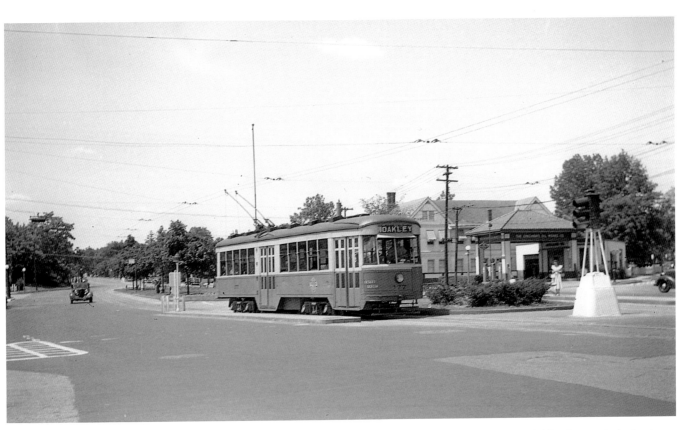

Route 70 CSRC 100 series car No. 177 is on Madison Road and Markbreit Avenue at Oakley Square in 1950. Oakley Square is the business district for the Oakley neighborhood in Cincinnati. (Clifford R. Scholes photograph)

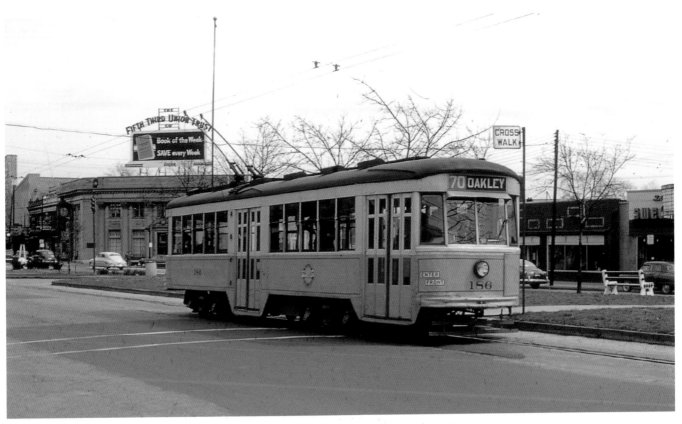

On March 26, 1950, CSRC 100 series car No. 186 is on Madison Road and Markbreit Avenue at Oakley Square on a rail excursion on route 70. (Pat Carmody photograph—Clifford R. Scholes collection)

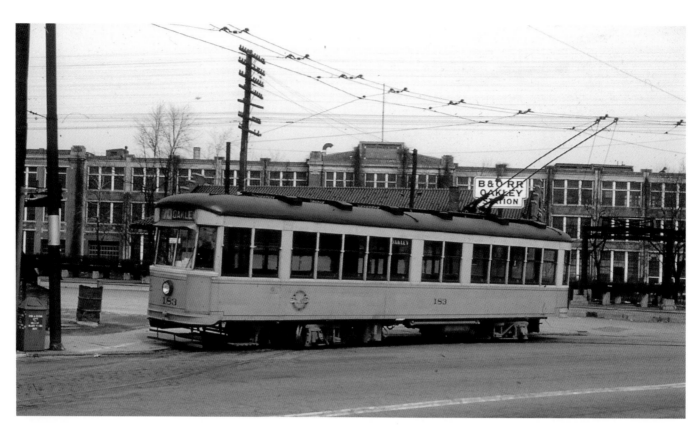

The Madison Road Oakley terminal loop is the location of route 70 CSRC 100 series car No. 183 on March 26, 1950, with the Suburban Baltimore & Ohio Railroad station to the left of the streetcar. The large building in the background was the Cincinnati Milling Machine Company which from the 1890s through the 1960s was one of the largest builders of milling machines. In 1970, it became Cincinnati Milacron Inc. and later Ferromatik Milacron India Pvt. Ltd. The building was later demolished. (Pat Carmody photograph—Clifford R. Scholes collection)

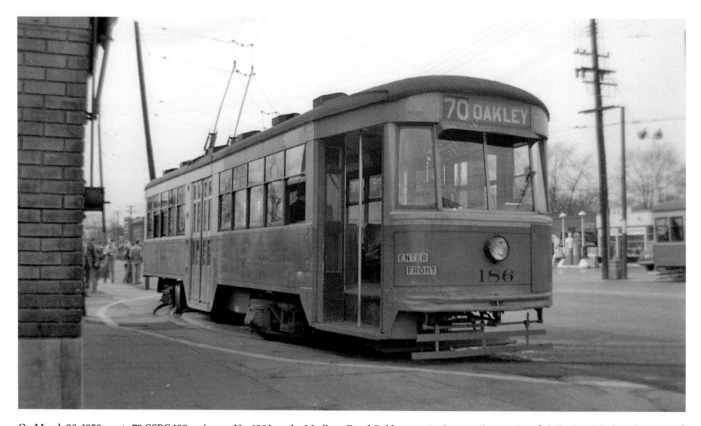

On March 26, 1950, route 70 CSRC 100 series car No. 186 is at the Madison Road Oakley terminal on a rail excursion. (Clifford R. Scholes photograph)

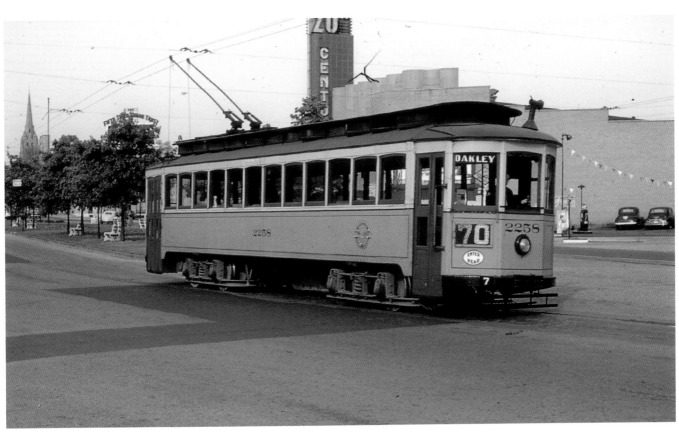

With the 20th Century Theatre in the background, CSRC car No. 2258 is on Madison Road and Markbreit Avenue in Oakley Square on a May 7, 1950, rail excursion. (Pat Carmody photograph—Clifford R. Scholes collection)

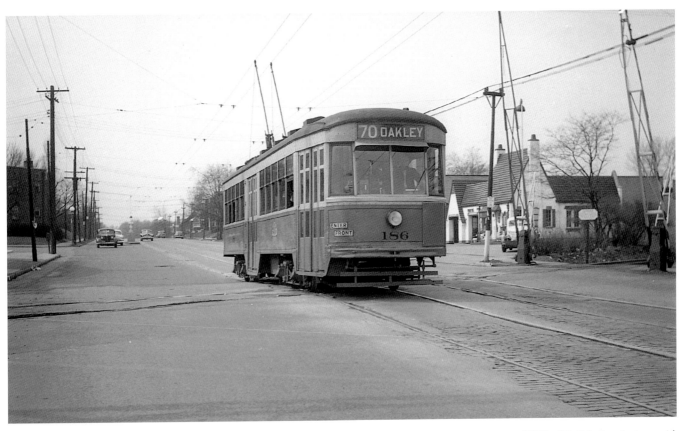

In 1950, route 70 CSRC 100 series car No. 186 is on Madison Road at the Norfolk & Western Railway crossing. (Clifford R. Scholes photograph)

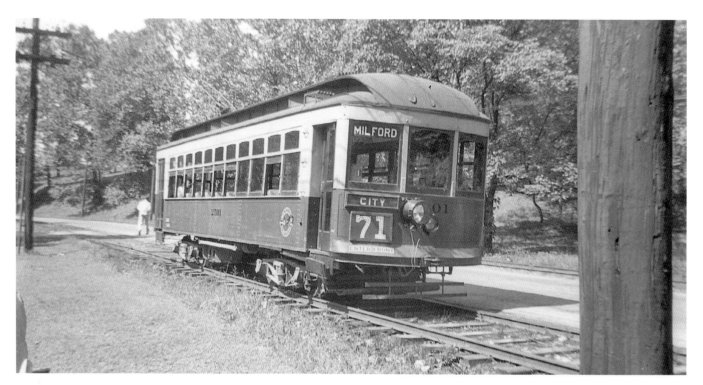

On August 6, 1944, CSRC car No. 2501 is on the private right of way along Erie Avenue on a rail excursion. This was one of three interurban cars Nos. 300-302 built in 1919 by the Cincinnati Car Company with a railroad style roof for the Cincinnati, Milford & Blanchester Traction Company (CMBTC). After the CMBTC ended service in January 1927 on their 37-mile line, which connected Cincinnati via Mariemont and Milford to Blanchester, the CSRC acquired eleven miles of their line from Hyde Park to Milford which became route 71, and their three cars which were repainted and renumbered 2500-2502. The route 71 was converted to bus operation on August 24, 1936, and the route sign was used on the rail excursion for picture stops. (Clifford R. Scholes photograph)

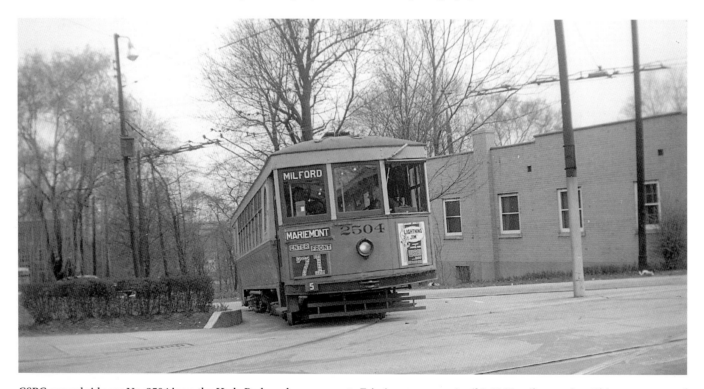

CSRC curved side car No. 2504 is on the Hyde Park car house ramp to Erie Avenue on an April 3, 1949, rail excursion. This car was one of five cars Nos. 103-107 built in 1923 by the Cincinnati Car Company for the Maumee Valley Railways & Light Company and after acquired by CSRC became Nos. 2503-2507. The route 71 sign was for picture purposes as route 71 was converted to bus operation on August 24, 1936. (Clifford R. Scholes photograph)

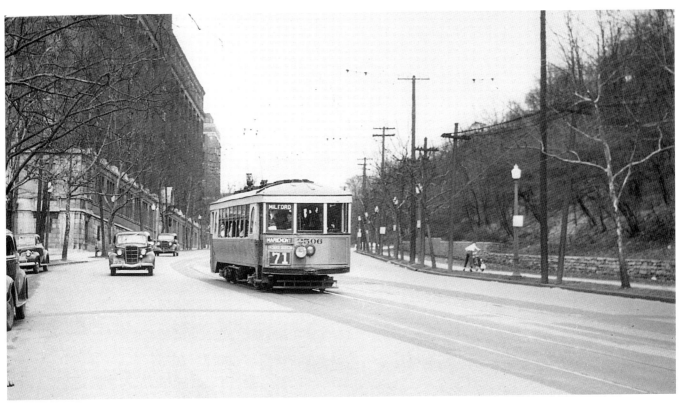

On March 26, 1950, curved side CSRC car No. 2506 (originally No. 106 built in 1923 by the Cincinnati Car Company for the Maumee Valley Railways & Light Company and acquired by CSRC, becoming No. 2506) is on Gilbert Avenue south of Eden Park Drive on a rail excursion. Route 71 was converted to bus operation on August 24, 1936, and the route 71 sign was used for picture stop purposes. (Ed O'Meara photograph—Clifford R. Scholes collection)

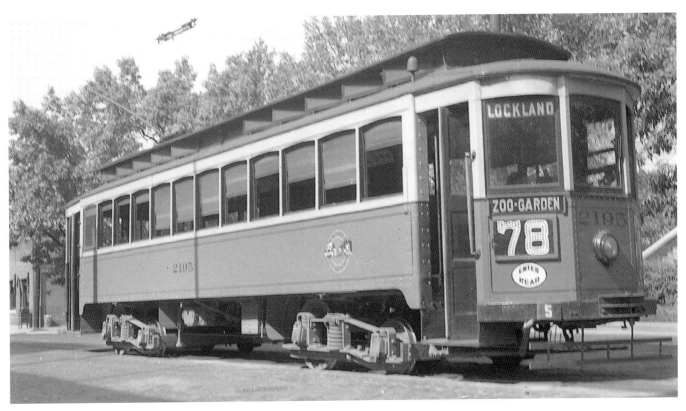

CSRC car No. 2195 is at the route 78 terminal on William Street and Wyoming Avenue in Lockwood, Ohio, in 1947. (Ed O'Meara photograph—Clifford R. Scholes collection)

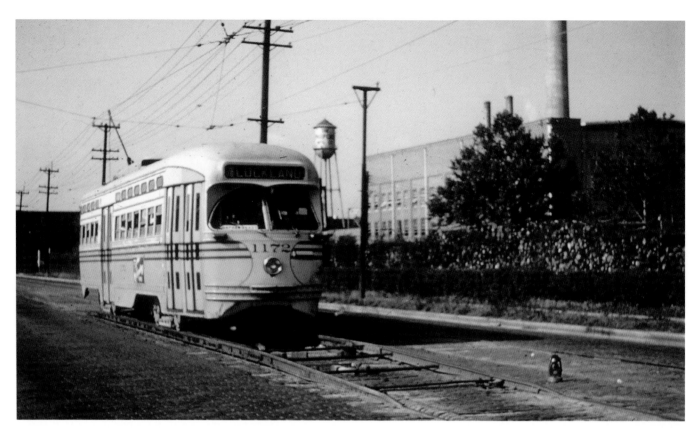

Anthony Wayne and Millesdale Avenues is the location of CSRC route 78 PCC car No. 1172 in 1948 on a shoe fly, which is temporary track used to avoid an obstacle, which in this case was for the construction of a new loop when the city of Lockwood, Ohio, forced abandonment of all track north of this location at the Lockwood, Cincinnati city limits. (Pat Carmody photograph—Clifford R. Scholes collection)

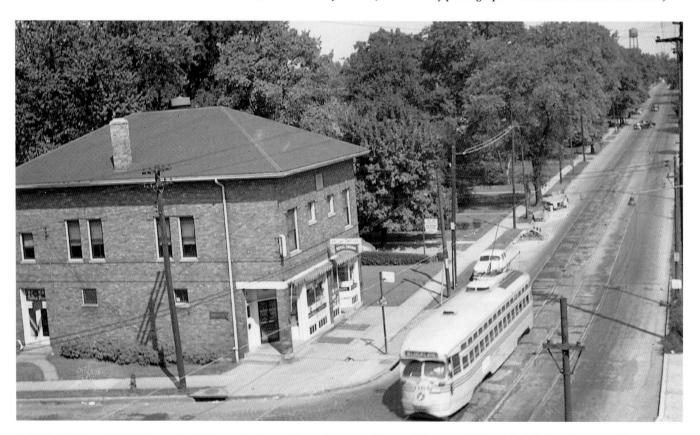

In 1948, CSRC route 78 PCC car No. 1164 is on Anthony Wayne Avenue at Hartwell Avenue. (Clifford R. Scholes photograph)

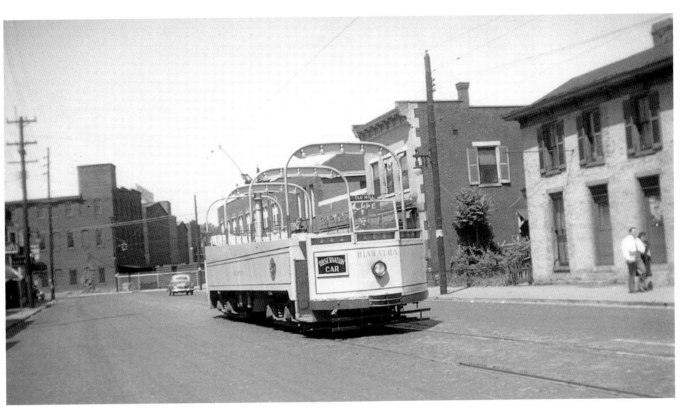

CSRC open car "Hiawatha" is on Mill Street between Wyoming Avenue and Dunn Street in the city of Lockwood, Ohio, on a May 30, 1948, rail excursion over streetcar route 78. (Clifford R. Scholes photograph)

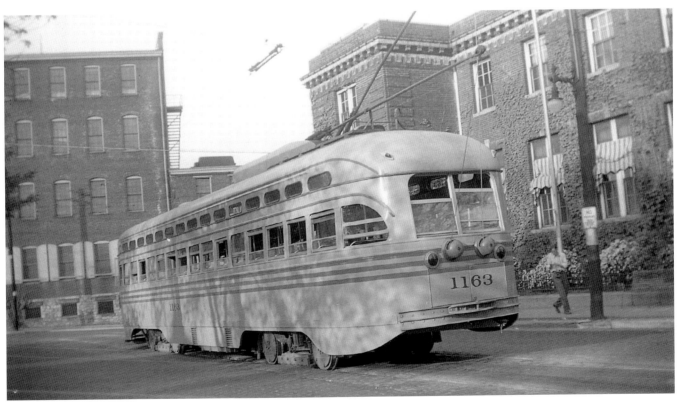

In 1948, CSRC route 78 PCC car No. 1163 is at the William Street and Wyoming Avenue terminal. The building in the background is the Stearns & Foster Mattress Company with the office on the right and the manufacturing plant on the left. At its peak in the 1970s, the plant employed more than 1,200. The business went through ownership changes and later all operations were moved to Mason, Ohio. (Clifford R. Scholes photograph)

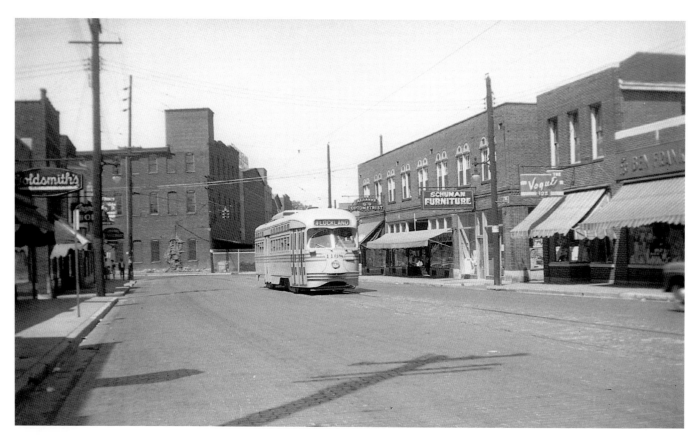

Mill Street between Wyoming Avenue and Dunn Street is the location of CSRC route 78 PCC car No. 1168 in 1948. (Clifford R. Scholes photograph)

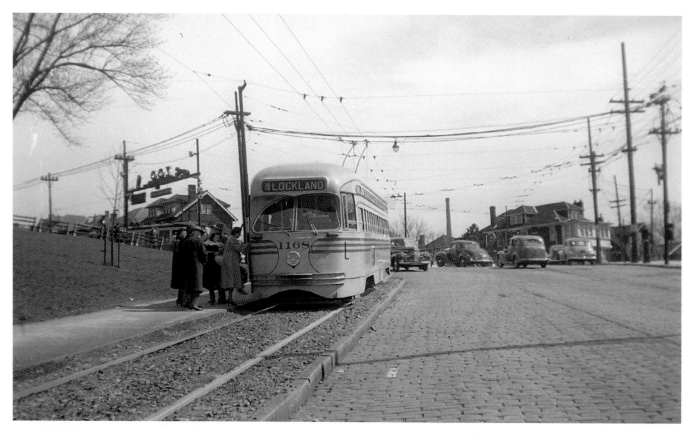

In 1948, CSRC route 78 PCC car No. 1168 is on the private right of way along the side of Vine Street north of Erkenbrecher Avenue at the zoo entrance. (Clifford R. Scholes photograph)

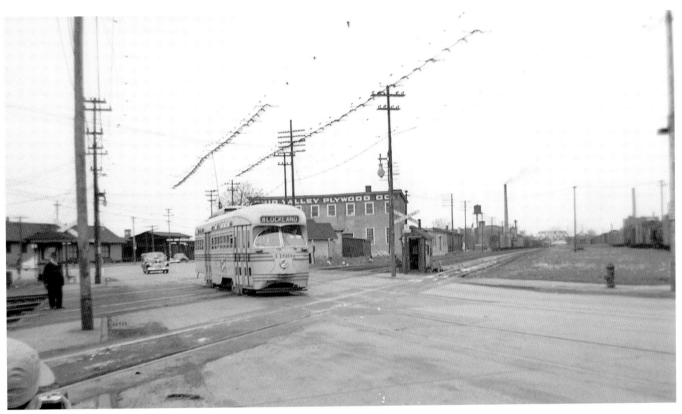

CSRC route 78 PCC Car No. 1169 is on Vine Street at the New York Central Railroad crossing in 1948. The streetcar line was protected in both directions with derails built into the track before crossing. (Clifford R. Scholes photograph)

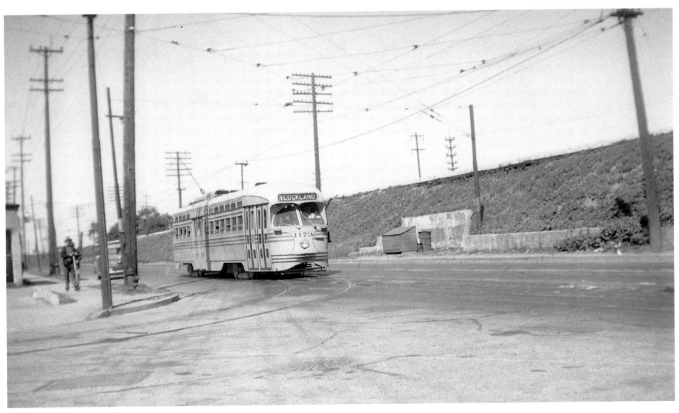

On May 30, 1948, CSRC route 78 PCC car No. 1173 is on Anthony Wayne and Woodbine Avenues at Hartwell Junction. The New York Central Railroad track is on the embankment. Curving off to the left in front of the streetcar was the abandoned Cincinnati & Hamilton Traction Company (Mill Creek Valley Line) connecting Cincinnati via Glendale and Springdale to Hamilton, Ohio. (Clifford R. Scholes photograph)

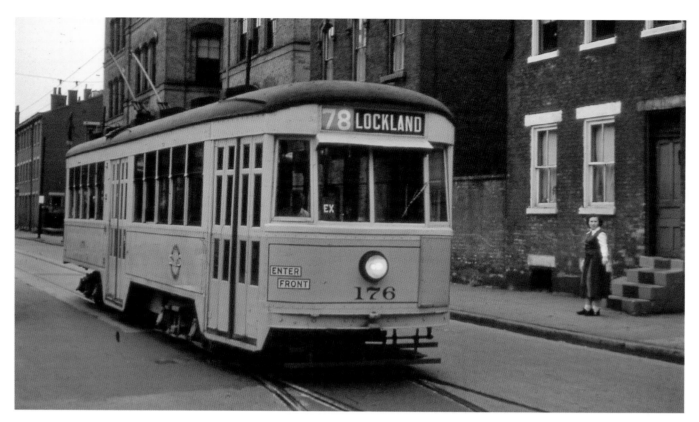

CSRC 100 series car No. 176 is at Woodward and Sycamore Streets on a 1949 rail excursion over streetcar route 78. (Pat Carmody photograph—Clifford R. Scholes collection)

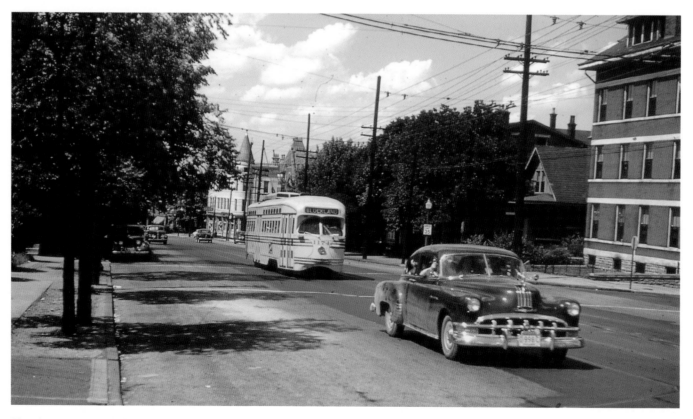

Vine Street near Rochelle Street is the location of CSRC route 78 southbound PCC car No. 1174 in 1949. The track from the Vine Street car house parallel to the bottom of the picture in front of the postwar Pontiac automobile made a very sharp turn to the northbound track. (Pat Carmody photograph—Clifford R. Scholes collection)

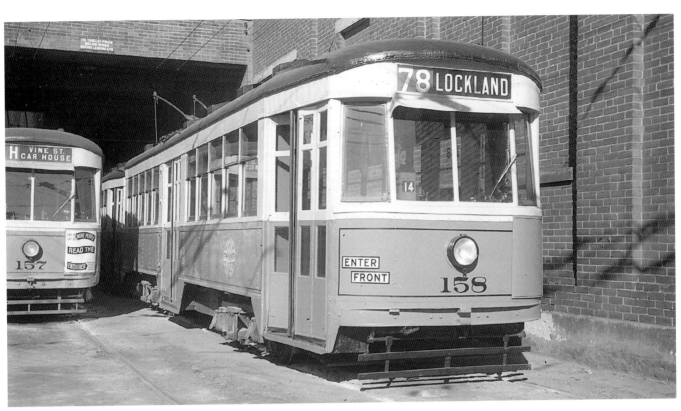

CSRC 100 series cars Nos. 157 and 158 are at the Vine Street car house in this 1950 scene. In 1950, the Vine Street car house housed routes 55 (Vine Clifton) and 78 (Lockland). (Clifford R. Scholes photograph)

On March 5, 1950, CSRC hoist car No. S-92 is at the Winton Place shop yard. This was the only double truck standard gauge car used to move inbound railroad cars around the power house. After abandonment of streetcar service, the car remained at the yard until 1964 and was sent to Trolleyville USA in Olmsted Township, Ohio, where the trucks were used for car No. 2227. (Pat Carmody photograph— Clifford R. Scholes collection)

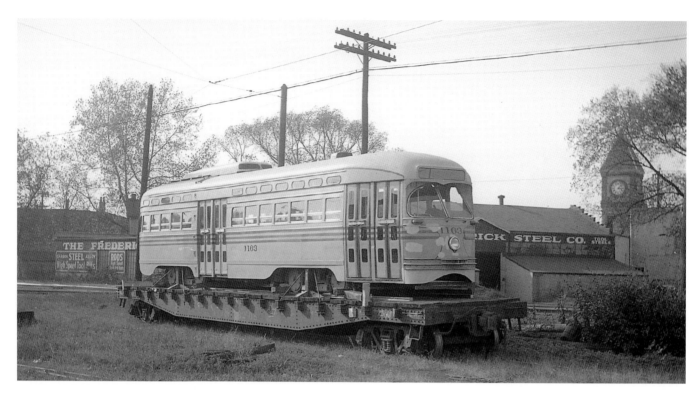

In September 1950, PCC car No. 1163 is on a railroad flatcar at the Winton Place shops being shipped to Toronto, Canada. Since 1928, the Winton Place shops, with its heavy machine shop equipment, had been the major CSRC repair center and in its time was a model for other streetcar systems. On July 28, 1950, the Toronto Transit Commission (TTC) agreed to buy 52 PCC cars from CSRC for $750,000. The St. Louis Car Company built cars Nos. 1100-1126 in 1939-1940, and 1150-1174 built in 1947 were reworked by the TTC, which included regauging the trucks for Toronto's 4-foot-10.875-inch track gauge; the double trolley poles and retrievers were replaced by one of each, and each car was repainted in the TTC color scheme. (Clifford R. Scholes photograph)

CSRC snow sweepers Nos. S-25 (built by Cincinnati Car Company in 1912), S-21 (built by Brill) and car No. 2442 (built by Cincinnati Car Company in 1923) are at the Winton Place shop yard in 1951. The two snow sweepers were in the process of being scrapped. (Pat Carmody photograph—Clifford R. Scholes collection)

# Chapter 7

# Cincinnati Trackless Trolleys

Cincinnati Street Railway Company (CSRC) decided to convert streetcar route 15 (Clark Street) to trackless trolley because of the high cost of replacing a two-mile section of track on Spring Grove Avenue from the Western Hills Viaduct to the Millcreek bridge. The Cincinnati City Council, by April 22, 1936, ordinance, approved the change which included an extension of the trackless trolley line in Cumminsville. On December 1, 1936, trackless trolleys (ten Nos. 600-609 built by Twin Coach Company of Kent, Ohio and seven Nos. 650-656 built by Mack International Truck Corporation of Allentown, Pennsylvania) replaced route 15 streetcars. While Cincinnati's double wire system made it an ideal candidate for trackless trolley operation, most of the overhead special work had to be rebuilt, and there were streets where the double wires had to be moved closer to the curb to allow curb loading for passengers.

On October 9, 1938, trackless trolleys replaced route 64 (McMicken-Main) streetcars using six trackless trolleys (built by Twin Coach Company) purchased secondhand from the Department of Street Railways of Detroit Michigan and numbered 594-599. Trackless trolleys replaced streetcars on route 69 (Madisonville) on July 6, 1947; routes 44 (Highland) and 53 (Auburn) on August 17, 1947; route 27 (East End) on September 28, 1947; route 31 (Crosstown) on April 11, 1948; route 16 (Colerain) on June 6, 1948, and route 17 (College Hill) on June 27, 1948. The pace quickened with trackless trolleys replacing streetcars on route 8 (South Norwood) and route 9 (Vine-Norwood) on January 1, 1949; route 60 (Fairview) was combined with route 62 (Ohio) and became 60 (Fairview-Ohio) on March 6, 1949: route 61 (Clifton-Ludlow) on March 6 1949; route 47 (Winton-Place) and route 41 (Chester Park) on April 17, 1949; and routes 4 (Kennedy Heights), 7 (North Norwood), and 10 (Vine-Woodburn) on July 24, 1949. Trackless trolleys replaced streetcars on route 68 (Madison Road) on June 18, 1950; route 46 (Vine-Burnet) on July 23, 1950; route 35 (Warsaw) on March 25, 1951; route 21 (Westwood) and route 55 (Vine-Clifton) on April 29, 1951. In the 1950s, there was a gradual conversion from trackless trolley to diesel bus operation. Cincinnati's trackless trolley service ended on June 18, 1965.

After World War II, ridership decline resulted in a decline in transit revenue and cost increases made it more difficult to invest in overhead wire infrastructure for trackless trolleys. From 1950 to 1964, it was difficult for private transit companies to invest in future projects. Efforts were focused on survival, which often meant reduction in service to reduce costs, increased fares, and avoiding investment. Investment in trackless trolleys was less likely to be considered. There were exceptions such as the City of Philadelphia, which purchased 43 new trackless trolleys Nos. 301-343 from Marmon-Herrington Company in 1955 that were leased to the Philadelphia Transportation Company.

On November 16, 1941, Cincinnati Street Railway Company (CSRC) trackless trolley No. 599, seating 40 passengers, is on Winchell Avenue in front of the Brighton Car House. This was one of six model 40TT trackless trolleys Nos. 594-599 built by Twin Coach Company in 1930 and purchased from Detroit in 1936. (Dave McNeil photograph—Clifford R. Scholes collection)

Winchell Avenue in front of the Brighton car house is the location of CSRC trackless trolley No. 610 on November 16, 1941. Seating 40 passengers, this was one of five model 41RTT trackless trolleys Nos. 610-614 built by Twin Coach Company in 1936. (Dave McNeil photograph—Clifford R. Scholes collection)

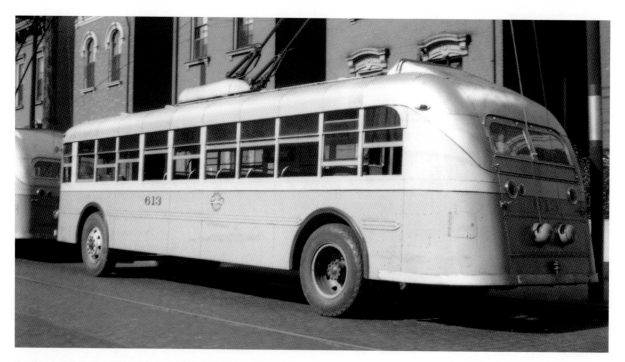

On September 3, 1939, CSRC model 41RTT trackless trolley No. 613, built by the Twin Coach Company in 1936, is on Western Avenue near Liberty Street at Crosley Field, which was a Major League Baseball Park for the Cincinnati Reds that opened as Redland Field on April 11, 1912. It was renamed Crosley Field in 1934 when local businessman Powel Crosley bought the Reds. The last game was played there on June 24, 1970, and the field was torn down in 1972. (Dave McNeil photograph—Clifford R. Scholes collection)

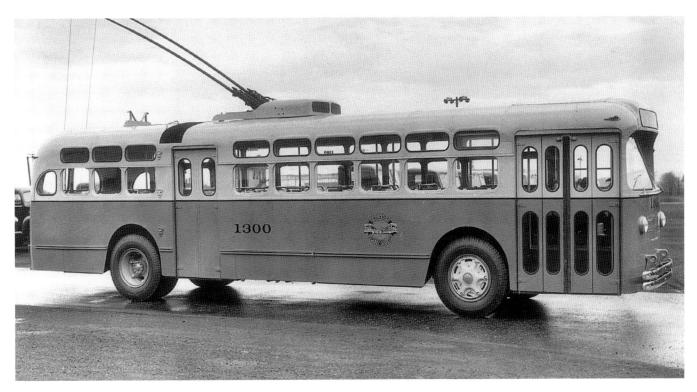

Trackless trolley No. 1300 looks sharp in this builder's photo taken at the Marmon-Herrington Company plant at Indianapolis, Indiana, in 1947. Seating 44 passengers, this was one of 45 model TC44 trackless trolleys Nos. 1300-1344 built in 1947 for CSRC. This trackless trolley gained wide acceptance because it weighed 17,250 pounds, which was 4,000 pounds lighter than most 66 passenger trackless trolleys. Constructed of aluminum and steel alloys, it was noted for its great strength, rigidity, and durability. (Marmon- Herrington Company photograph—Clifford R. Scholes collection)

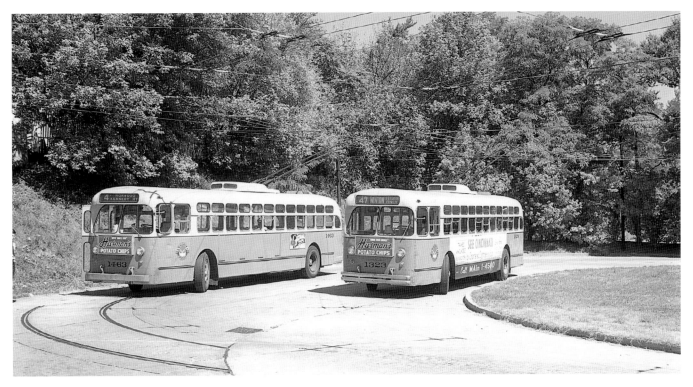

On September 13, 1959, trackless trolley No. 1463 (one of 65 model TC48 Nos. 1404-1468 built in 1949) and No. 1323 (one of 45 model TC44 Nos. 1300-1344 built in 1947), both built by Marmon-Herrington Company of Indianapolis, Indiana, are at the CSRC route 4 Kennedy Heights terminal loop. Trackless trolleys had a superior power to weight ratio, which provided faster acceleration rates, especially on hills. The trackless trolley had nothing to freeze in winter, cost less to service and maintain, and was quiet and fume free. (Clifford R. Scholes photograph)

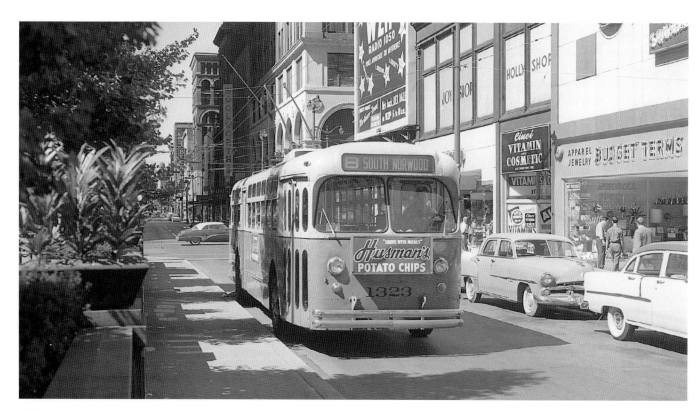

Fifth Street on the north side of Fountain Square in downtown Cincinnati is the location of CSRC trackless trolley No. 1323 on September 13, 1959. Seating 44 passengers, this trackless trolley was built by the Marmon-Herrington Company in 1947. The center piece of Fountain Square is the Tyler Davidson Fountain donated and dedicated in 1871 "To the people of Cincinnati" by Cincinnati businessman Henry Probasco in honor of his business partner and brother-in-law Tyler Davidson. (Clifford R. Scholes photograph)

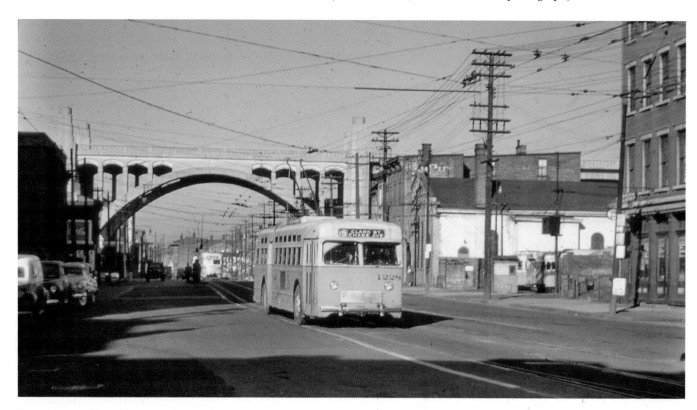

Under sunny skies, CSRC route 15 trackless trolley No. 1228 is on Spring Grove Avenue between the Western Hills Viaduct and Harrison Avenue on January 7, 1950. Seating 44 passengers, this was one of 30 (Job No. 1743) Nos. 1200-1229 trackless trolleys built in 1946 by the St. Louis Car Company. (Pat Carmody photograph—Clifford R. Scholes collection)

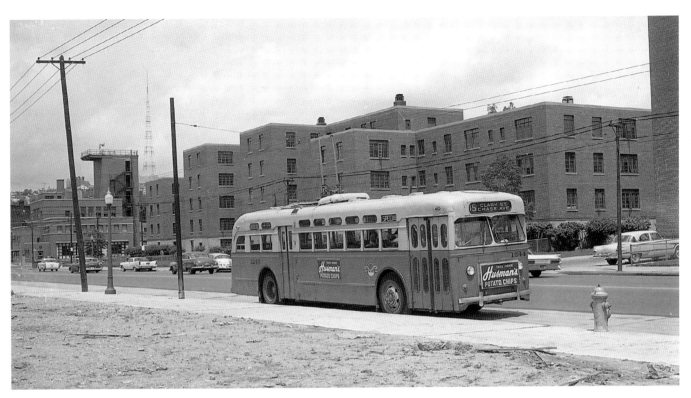

On a 1960 excursion trip, CSRC trackless trolley No. 1244 is on Linn Street south of Liberty Street. Seating 44 passengers, this was one of 30 (Job No. 1751) Nos. 1230-1259 trackless trolleys built in 1946 by the St. Louis Car Company. While route 15 showed on the front destination sign, route 16 was the normal route for this location. (Clifford R. Scholes photograph)

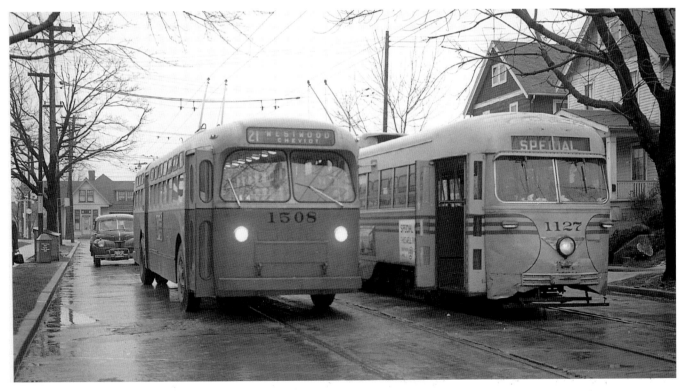

CSRC model TC48 trackless trolley No. 1508 (one of 45 Nos. 1469-1513 built by Marmon-Herrington Company in 1951) and PCC car No. 1127 (originally car No. 1000 built by Pullman Standard Car Building Company in 1939 that was renumbered 1127 in December 1947) are at the route 21 terminal on Montana Avenue east of Glenmore Avenue on April 22, 1951. The PCC car was on a rail excursion for the last full Sunday of streetcar operation, and the trackless trolley was on a training trip in preparation for the end of streetcar service. (Clifford R. Scholes photograph)

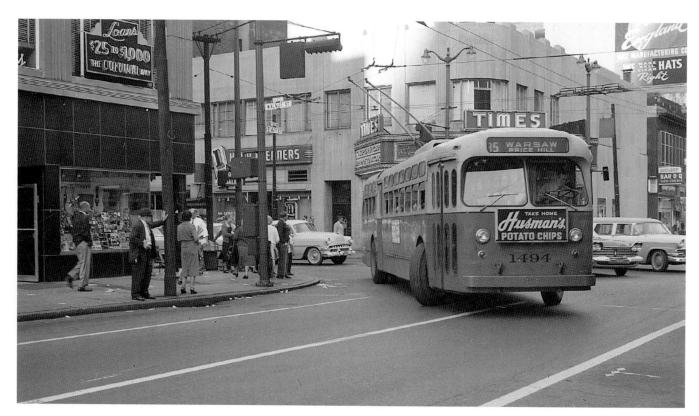

In 1960, route 35 CSRC model TC48 trackless trolley No. 1494 (built in 1951 by Marmon-Herrington Company and seating 48 passengers) is on Walnut Street turning onto Sixth Street in downtown Cincinnati. Marmon-Herrington Company during its production of trackless trolleys had one basic model which it could lengthen or shorten depending on the customer seating requirements. It was the first company to produce a 48-passenger trackless trolley. (Clifford R. Scholes photograph)

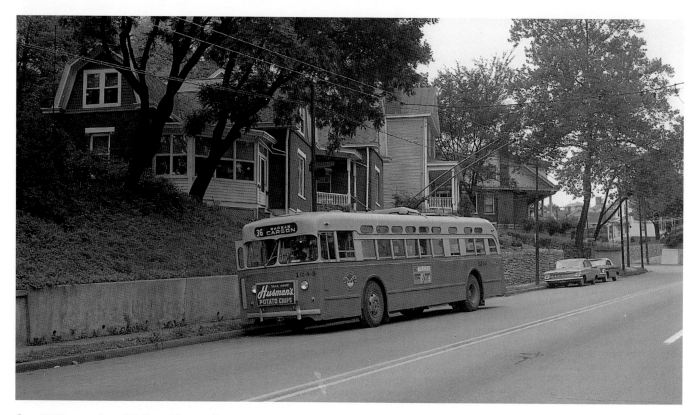

On a 1960 excursion, CSRC trackless trolley No. 1244 (built in 1948 by St. Louis Car Company) is pausing for a photo stop over route 36 on Warsaw Avenue at Peerless Street. Route 36 was a short turn routing for route 35. Clifford R. Scholes photograph)

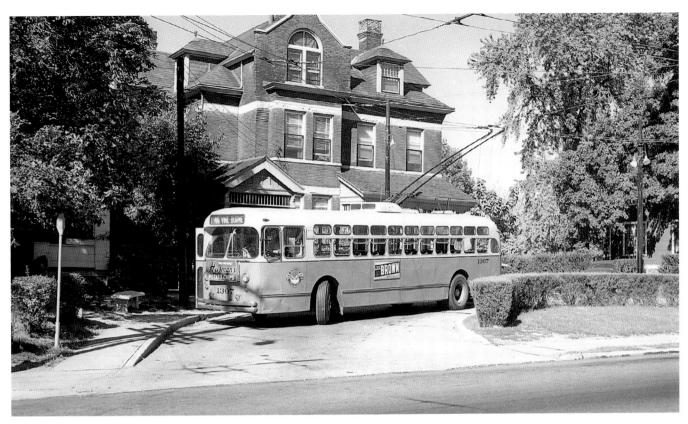

CSCR route 46 trackless trolley No. 1307 (built by Marmon-Herrington Company in 1947) is at the Rockdale Avenue terminal loop in 1960. The front yard of this magnificent home was purchased by CSRC for the loop that was built in 1950. (Clifford R. Scholes photograph)

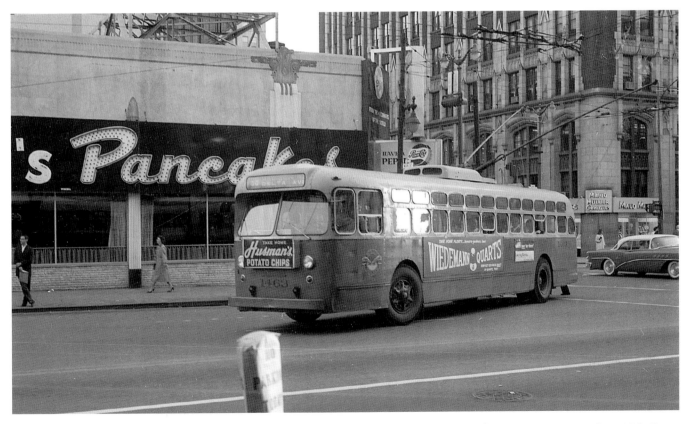

In 1960 route 68 CSRC trackless trolley No. 1463 (built by Marmon-Herrington Company in 1949) has halted on its turn from Main Street to Fifth Street in downtown Cincinnati with the operator positioning the pole back on the overhead wire. (Clifford R. Scholes photograph)

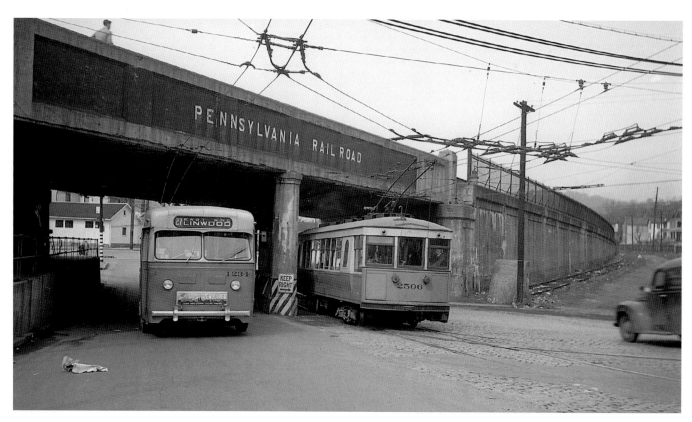

At Eastern Avenue and Delta Avenue passing under the Pennsylvania Railroad, CSRC route 27 trackless trolley No. 1234 (built by St. Louis Car Company in 1948) passes streetcar No. 2506 (originally car No. 106 built by the Cincinnati Car Company for the Maumee Valley Railways & Light Company) is on a rail excursion in 1950. (Clifford R. Scholes photograph)

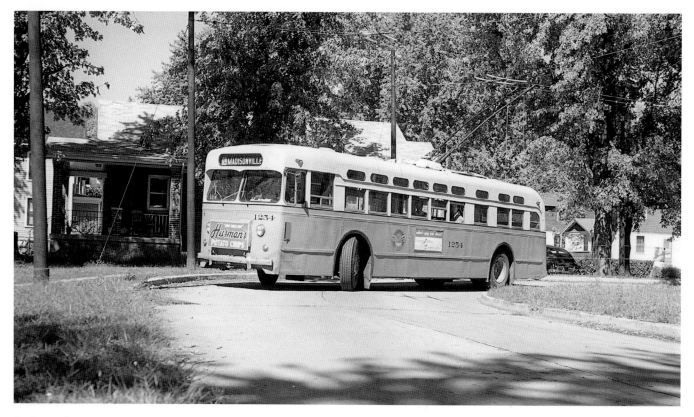

On September 13, 1959, an excursion using CSRC trackless trolley No. 1254 (built by St. Louis Car Company) is at the route 69 Madisonville terminal loop off Madison Avenue. Trackless trolleys replaced streetcars on route 69 (Madisonville) on July 6, 1947. (Clifford R. Scholes photograph)

# Chapter 8

# Cincinnati Bell Connector (Cincinnati Streetcar)

A 2007 feasibility study supported the building of a streetcar line to link downtown Cincinnati with the Over-the-Rhine neighborhood just north of the central business district. The study noted that Cincinnati would gain new residences, gain property tax revenues, improve market values of existing properties, enhance neighborhoods by making them more walkable, and see an increase in retail activity. On April 23, 2008, Cincinnati City Council approved a plan to build the new streetcar line. A 2009 referendum that would have prohibited the city from spending any monies for right of way acquisition or construction of improvements for passenger service was defeated in the November 3, 2009 local election. Opponents of the streetcar project in a 2011 referendum attempted to pass issue 48 which would have banned any spending on rail until December 31, 2020. Issue 48 was defeated in the November 8, 2011, local election. Groundbreaking for the streetcar project was held on February 17, 2012. A construction contract for the tracks, power system, and maintenance facility was signed on July 15, 2013. In the November 6, 2013, election, newly elected Mayor John Cranley, who had opposed the project, indicated his intent to cancel the project. Although project executive of the Cincinnati Streetcar, John Deatrick provided data to the Cincinnati City Council that showed it would cost nearly as much to cancel the project as to finish it; City Council voted to pause construction of the streetcar project on December 4, 2013 to allow for an audit of the project. The independent audit confirmed Deatrick's data. After the Haile Foundation committed to provide $9 million to support the project, City Council voted six to three on December 19, 2013, to resume the project. The line uses five low floor three section streetcars built by Construcciones Y Auxiliar de Ferrocarriles (CAF) of Spain that were part of an order of nine cars assembled in Elmira, New York, of which four went to the Kansas City Streetcar Authority. In August 2016, Cincinnati Bell (local telephone and internet provider) signed a ten-year $3.4 million naming rights agreement for the line to be called the Cincinnati Bell Connector, with the revenue to be used to help fund the streetcar operation.

Car No. 1177 made the first run on opening day September 9, 2016, as long lines of passengers came for a weekend of free rides. According to the September 13, 2016, *Cincinnati Business Courier*, ridership for Friday, September 9, 2016, was 18,141; Saturday, September 10, 2016, was 17,160; and Sunday,

September 11, 2016, was 15,345. Service schedule in 2016 was: Monday-Thursday 6:30 a.m.-midnight; Friday 6:30 a.m.-1 a.m.; Saturday 8 a.m.-1 a.m., and Sunday/Holiday 9 a.m.-11 p.m. The fare in April 2017 was $1.00 for a two-hour pass, $2.00 for an all-day pass, and free for children under 35 inches.

At the northern end of the line on Henry Street where the depot is located, the 3.6-mile modern streetcar line costing $148 million, with eighteen stops, makes a loop heading south on Race Street passing Findlay Market and Washington Park, and crosses the return line at Twelfth Street and turns east onto Central Parkway. The line turns south on Walnut Street passing the Public library and Fountain Square in the heart of the business district, and turns east on Second Street just north of the Ohio River. Passing Banks station stop, the line turns north on Main Street, and turns west on Twelfth Street. It crosses the southbound track at Race Street, turns north on Elm Street and passes the other side of Washington Park in the Over-the-Rhine neighborhood. Across the street from the Washington Park stop is the picturesque Music Hall. The line passes the other side of the Findlay Market, turns east on Henry Street, and turns south on Race Street to complete the loop. The entire route is single track and is predominately on one-way streets. There are two loops: one through the Over-the-Rhine neighborhood and the other in the Downtown portion. The City of Cincinnati owns the line, track, overhead wire, and infrastructure, and contracts with the Southwest Ohio Transit Authority (SORTA) to operate the line. SORTA subtracts with a private company, Transdev, to actually operate the line.

In March 2017, flaws were noted in the concrete flooring that hold the track in place in two locations in the downtown loop: one near the intersection of Court and Walnut Streets and the other near Walnut and Fourth Streets. New concrete has been poured to correct the problem. The January 4, 2017 *Cincinnati City Beat* reported that, "more than 22,000 rode the line Saturday September 17 and Sunday September 18, but only 1,625 rode the streetcar the following Monday." The article noted that malfunctioning ticket kiosks at stops, inaccurate streetcar arrival times listed on digital displays at stops, and traffic signal timing problems have kept the cars from running on time. Uncertainty about when the next car will come will discourage potential riders. Having ridden, walked, and studied the area served by the streetcar line, this author believes that if everybody works together, this streetcar line can be successful.

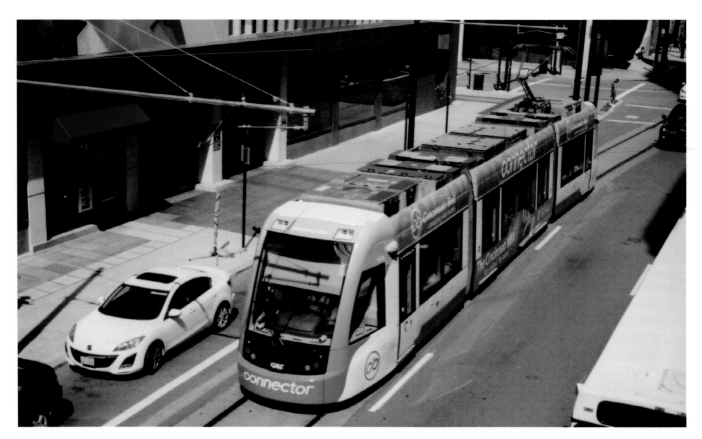

On September 10, 2016, a Cincinnati Bell Connector streetcar is southbound on Walnut Street south of the Cincinnati Public Library in downtown Cincinnati. (Kenneth C. Springirth photograph)

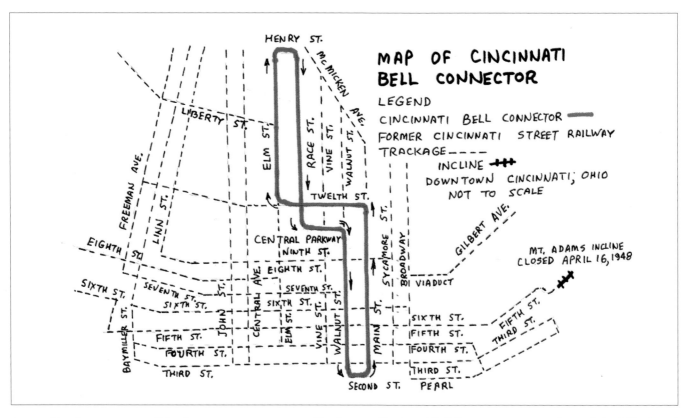

As noted by the map, many of the downtown streets traversed by the new Cincinnati Bell Connector streetcar formerly had Cincinnati Street Railway Company streetcar trackage.

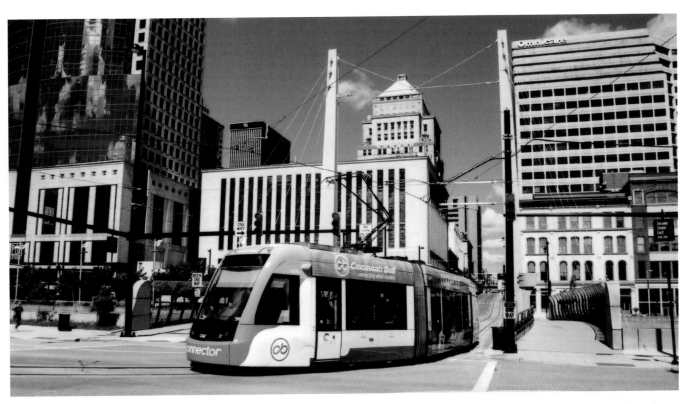

Conventionally powered by an overhead wire, Cincinnati Bell Connector streetcar No. 1178 is turning from Second Street to Main Street in the Banks section of downtown Cincinnati on September 11, 2016. The 3.6-mile line travels in a loop linking the central business district with the historic Over-the-Rhine neighborhood. (Kenneth C. Springirth photograph)

In this interior view, the low floor three section streetcar built by Construcciones Y Auxiliar de Ferrocarriles (CAF) of Spain will soon be filled to its 150 passenger capacity on Saturday September 10, 2016, the second day of the three-day opening celebration. The five Cincinnati Bell Connector streetcars were assembled at the CAF facility in Elmira, New York. Vehicle maintenance is performed at the new facility located at Henry and Race Streets. (Kenneth C. Springirth photograph)

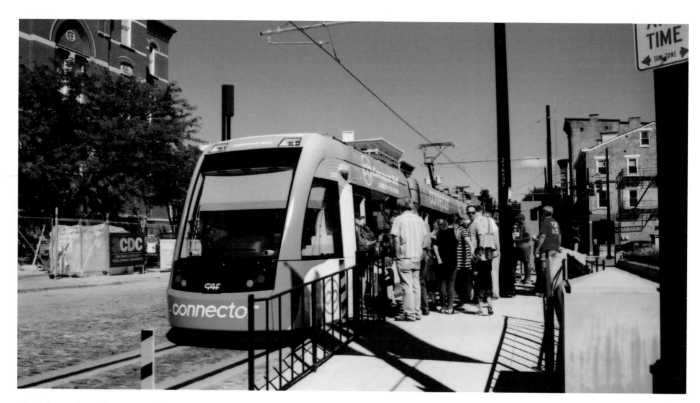

Northbound on Elm near 14th Street, Cincinnati Connector streetcar No. 1176 is at the passenger stop serving the west side of Washington Park. Numerous people are preparing to board the car on September 11, 2016, the third day of the grand opening. The Venetian Gothic style Cincinnati Music Hall, built in 1878 and recognized in January 1975 as a National Historic Landmark, is on the other side of the street. (Kenneth C. Springirth photograph)

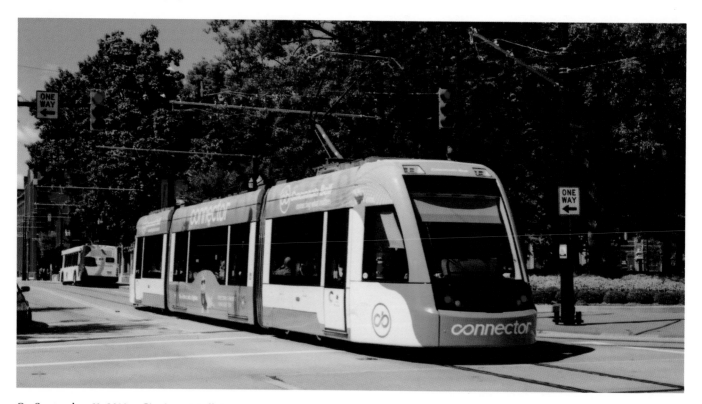

On September 11, 2016, a Cincinnati Bell Connector streetcar is on Twelfth Street, having just crossed the Race Street southbound track, which is the only track crossing on the system. To the right is the eight-acre Washington Park that was renovated (reopened July 6, 2012) by a partnership between the Cincinnati Park Board (which owns and operates the park) and the Cincinnati Center City Development Corporation. (Kenneth C. Springirth photograph)

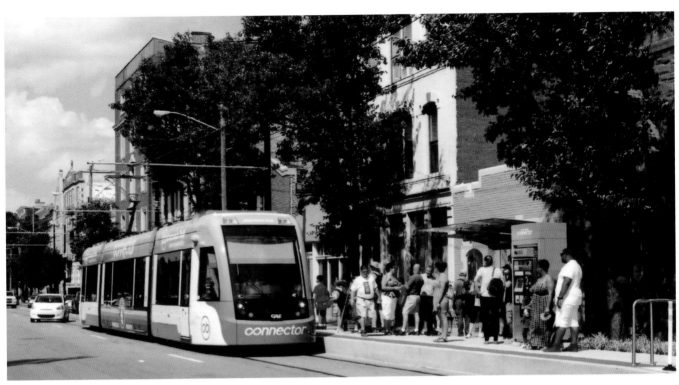

A crowd of people are at the passenger stop on Race Street north of Twelfth Street (on the east side of Washington Park) ready to board the arriving Cincinnati Bell Connector streetcar for the southbound trip to downtown Cincinnati on September 10, 2016. This is in the Over-the-Rhine neighborhood with its Italianate architecture that was originally settled by Germans. Population declined from 44,475 in 1900 to 4,970 by 2007. The area is seeing a rebirth with the population reaching 7,000 in 2010. (Kenneth C. Springirth photograph)

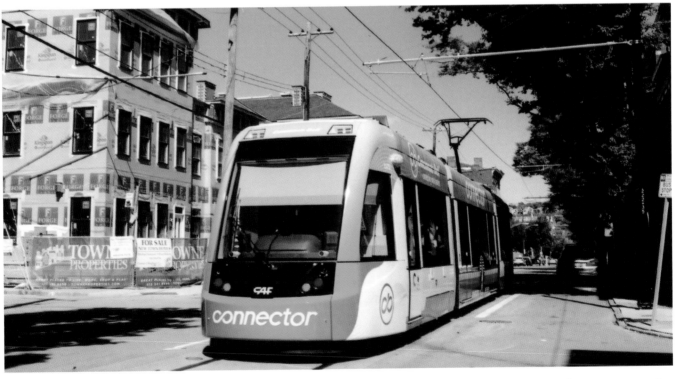

Southbound Cincinnati Bell Connector streetcar No. 1178 is on Race Street crossing Fifteenth Street in passing new housing construction the Over-the-Rhine neighborhood of Cincinnati on September 11, 2016. The new Cincinnati Bell Connector may already be a factor in the rise of property values. According to the January 9, 2017, article titled "Cincinnati's Streetcar and a Downtown Revival" by Ryan Ori in the magazine *Urbanland*, in 2012 developers paid an average cost of $17 per square foot for adaptive use buildings. By late 2015 and early 2016 the average was $78 per square foot. (Kenneth C. Springirth photograph)

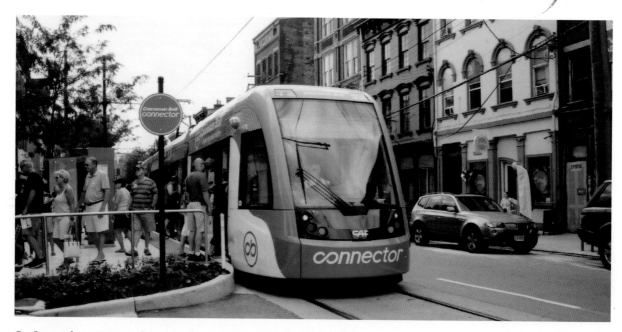

On September 10, 2016, a large number of passengers are getting off Cincinnati Bell Connector streetcar No. 1178 on Elm Street near Elder to visit the Findlay Market. Founded in 1852, the Findlay Market (named for James Findlay an early settler and Mayor of Cincinnati) is Ohio's oldest continuously operated public market, was listed on the National Register of Historic Places on June 5, 1972, and is the last remaining of the nine markets that once served Cincinnati. The Findlay Market is a center of economic activity in the Over-the-Rhine neighborhood of Cincinnati, and the author personally witnessed the large number of customers that arrived at the market by streetcar. (Kenneth C. Springirth photograph)

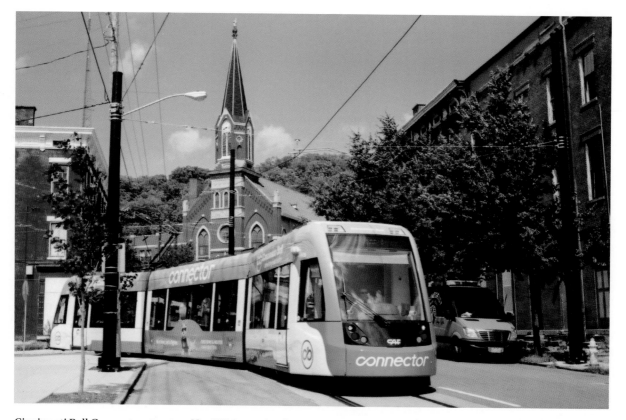

Cincinnati Bell Connector streetcar No. 1179 is turning from Henry Street onto Race Street on September 10, 2016. Behind and just north of the streetcar is the Gothic Revival style (characterized by a steep roof and arched windows) red brick Philippus United Church of Christ on West McMicken and Ohio Avenues. This church was dedicated in 1891 to serve the large German community in the Over-the-Rhine neighborhood of Cincinnati. In 1933, it became the Philippus Evangelical and Reformed Church which was merged into the United Church of Christ in 1957. (Kenneth C. Springirth photograph)

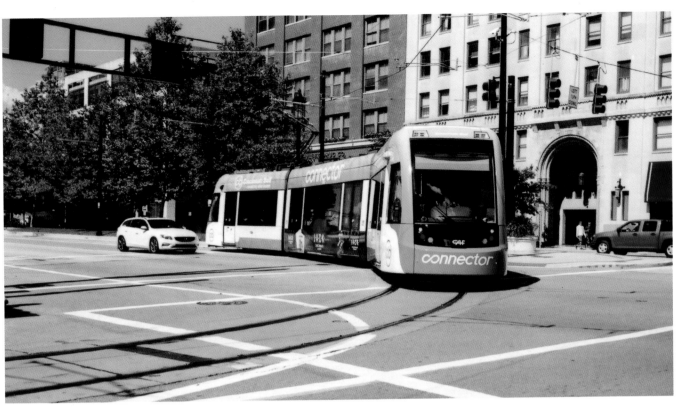

On September 11, 2016, Cincinnati Bell Connector streetcar No. 1178 is turning from Central Parkway to Walnut Street for a southbound trip into downtown Cincinnati. It is rare for a United States company to buy naming rights for a streetcar project. In August 2016, Cincinnati Bell bought the naming rights for the Cincinnati streetcar line, and in March 2016 Quicken Loans bought the naming rights for the Detroit streetcar line which opened on May 12, 2017, as the Q Line. (Kenneth C. Springirth photograph)

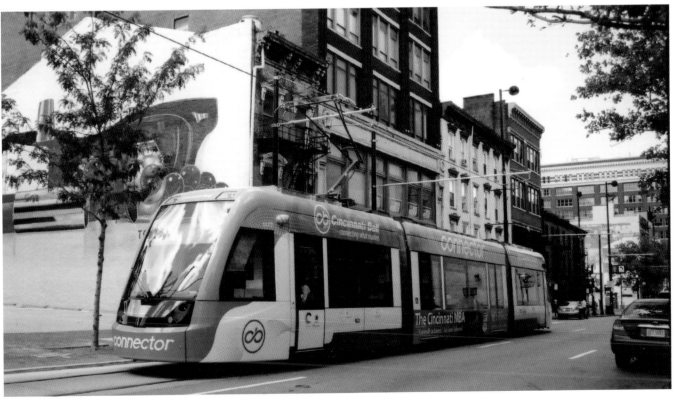

Northbound Cincinnati Bell Connector streetcar No. 1177 is on Main Street at Eighth Street in downtown Cincinnati on September 11, 2016. (Kenneth C. Springirth photograph)

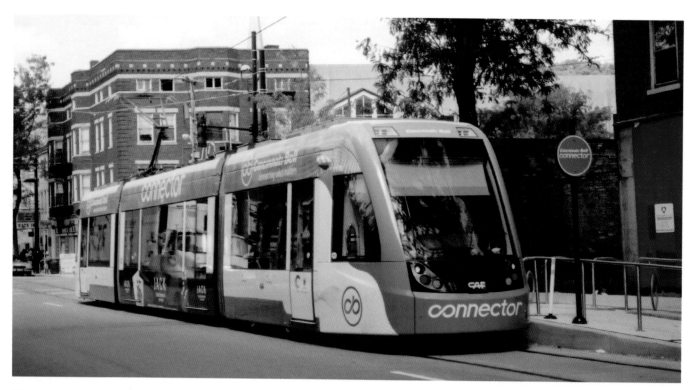

The passenger stop on Race Street at Liberty Street is the location of a Cincinnati Bell Connector streetcar in the Over-the-Rhine neighborhood of Cincinnati on September 10, 2016. Each of the eighteen passenger stops has a simple shelter to protect riders from rain and snow. During the three-day grand opening, the new streetcar line carried 50,646 passengers of which there were 18,141 on Friday, September 9, 2016; 17,160 on Saturday, September 10, 2016; and 15,345 on Sunday, September 11, 2016. As of May 31, 2017, there have been 540,514 passenger trips on the Cincinnati Bell Connector since it opened on September 9, 2016. (Kenneth C. Springirth photograph)

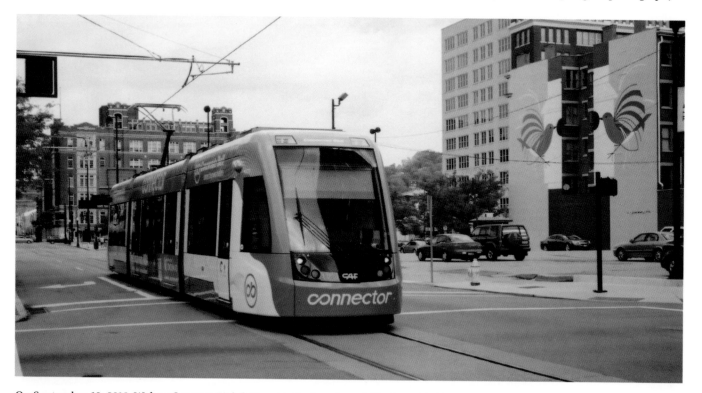

On September 10, 2016, Walnut Street at Eighth Street is the location of Cincinnati Bell Connector Streetcar No. 1177. While it may take years to fully understand the amount of new investment made because of the streetcar, the neighborhood has another item for its toolbox, making it more attractive for those who want to live and work close to downtown Cincinnati without needing an automobile. (Kenneth C. Springirth photograph)

# Chapter 9

# Cincinnati's Streetcar Legacy

On April 29, 1951, when the Cincinnati Street Railway Company (CSRC) ended streetcar service, a group of ten rail enthusiasts raised $400 to acquire sand car No. S-223 without the motors (as the price would have been too high), and the car was moved to a prepared rented site in Dayton, Ohio. This was originally car No. 2227, one of 105 cars Nos. 2200-2304 built by the Cincinnati Car Company in 1919 for the Cincinnati Traction Company. The car worked out of the Eighth Street car, was later transferred to the Vine Street car house, and after World War II returned to the Eighth Street car house where it operated on route 31 (Crosstown) until that line was converted to trackless trolley operation on April 11, 1948. At the Winton Place Shops, it was converted to a sand car, renumbered S-223, and housed at the Hyde Park car house.

Following a newspaper article about the car, the group that saved it, and the problems of vandalism, Howard Kahoe, village manager of Yellow Springs, Ohio, provided space on his farm for the car. On Labor Day 1964, the car was donated to Gerald Brookins of Trolleyville USA in Olmsted Township, Ohio. The car was restored and operated at the August 22, 1998, Trolleyfest celebration. During 2002, Trolleyville USA closed. In 2009, the car was acquired by the Pennsylvania Trolley Museum. The car trucks have been re-gauged and rebuilt. This is the only operating Cincinnati Street Railway Company car in existence. There are two Presidents' Conference Committee (PCC) cars No. 1057 in San Francisco and No. 4616 in Kenosha, Wisconsin, that have been painted in the same paint scheme that was used on PCC cars once operated by CSCR. However, both cars never operated in Cincinnati.

On June 17, 2000, streetcar service was returned to Kenosha, Wisconsin, using five former Toronto Transit Commission (TTC) class A8 Presidents' Conference Committee (PCC) cars on a 1.7 mile streetcar loop that begins at the Metra commuter rail station, goes south on 11th Avenue to 56th Street, east on 56th Street, turns north for two blocks, and continues west on 54th Street passing the downtown Transit Center, and returns to the Metra station. Kenosha's original streetcar system operated from 1903 to 1932. The TTC cars were originally part of a group of 50 cars Nos. 4500-4549 assembled by Canadian Car & Foundry Company in 1951 using equipment and parts furnished by the St. Louis Car Company. Between 1986 and 1992, nineteen of these cars were completely rebuilt with the body remanufactured, trucks motors plus electrical components rebuilt, all wiring replaced, and renumbered 4600-4618. Declining ridership, and an insufficient number of light rail vehicles to handle the existing lines plus the future Spadina line, were among the reasons for the November 23, 1995, decision to remove PCC cars from regular service. Kenosha purchased five of the PCC cars. Each car was converted from the TTC broad gauge to standard gauge by swapping trucks from retired Chicago rapid transit cars, a wheel chair lift was installed, general repairs were made, and each car was painted to represent a former North American streetcar system with car No. 4616 (originally TTC car No. 4515) finished in the Cincinnati Street Railway Company yellow with green striping and a grey roof paint scheme.

On September 1, 1995, the San Francisco Municipal Railway began operating the 3.5-mile F line using PCC cars from San Francisco, Philadelphia, and Newark, New Jersey; Peter Witt type cars from Milan, Italy; and a diverse collection of streetcars from around the world. The line was extended to Fisherman's Wharf on March 4, 2000, and has become an important part of San Francisco's transit network, carrying local commuters and tourists to business and residential areas of the city. Former Southeastern Pennsylvania Transportation Authority PCC car No. 2138 (originally built in 1947 by the St. Louis Car Company for the Philadelphia Transportation Company) was acquired by the San Francisco Municipal Railway in October 1992. It was rehabilitated by the Morrison Knudson Corporation in 1993, repainted in the former Cincinnati Street Railway Company paint scheme, renumbered 1057, and is used for F line service which connects the San Francisco's Castro neighborhood via Market Street and the Embarcadero to Fisherman's Wharf.

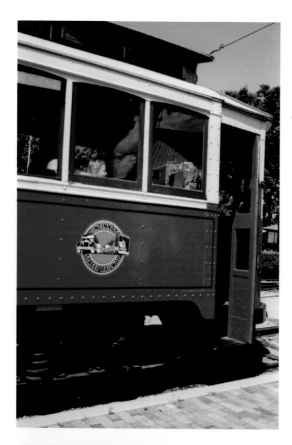

On June 25, 2016, former Cincinnati Street Railway Company car No. 2227 is at a passenger stop at the Pennsylvania Trolley Museum in this close-up view of the company emblem. In 2017, this is the only original restored operating Cincinnati Street Railway Company car in existence. The Cincinnati History Museum inside the Cincinnati (Ohio) Union Terminal has restored curved side car body No. 2435 on display with cardboard trucks. Awaiting restoration at the Seashore Trolley Museum at Kennebunkport, Maine, is Cincinnati Street Railway Company car No. 2105. Cincinnati Car Company built the 105 cars of this series Nos. 2200-2304 in 1919 for the Cincinnati Traction Company at a cost of $7,061 per car. (Kenneth C. Springirth photograph)

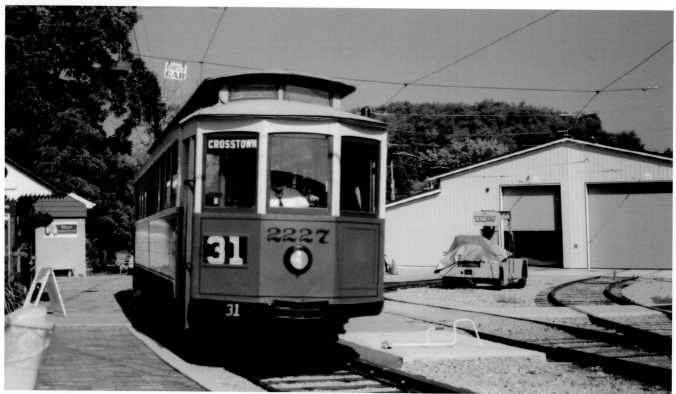

Cincinnati Street Railway Company car No. 2227 is at the Richfol shelter at the Pennsylvania Trolley Museum, on June 25, 2016. The Richfol shelter was built for Pittsburgh Railways Company riders who worked at the Standard Tin Plate Company in Canonsburg, Pennsylvania. Following the abandonment of the Washington interurban, the shelter was moved about three miles and became a school bus stop. After the shelter was brought to the Pennsylvania Trolley Museum in March 1983, it was restored and became the main boarding point for the museum's trolleys. (Kenneth C. Springirth photograph)

San Francisco Municipal Railway (SFMR) eye catching PCC car No. 1057, painted to honor the Cincinnati Street Railway Company, is leaving the route F passenger stop on the Embarcadero at Mission Street in San Francisco on June 29, 2001. Originally built and delivered in September 1948 as car No. 2138 by the St. Louis Car Company for the Philadelphia Transportation Company, this car was overhauled by the Southeastern Pennsylvania Transportation Authority (SEPTA) in May 1981. It was acquired by SFMR from SEPTA in October 1992 and was restored by Morrison-Knudsen Corporation in 1993. (Kenneth C. Springirth photograph)

On June 29, 2001, PCC car No. 1057 is on route F on Market Street near Powell Street in downtown San Francisco in a vivid canary yellow with three bright green stripes around the body to match the paint scheme once used by PCC cars in Cincinnati, Ohio. Powered by four Westinghouse type 1432J motors, the 48.42-long-by-8.33-foot-wide car seated 47 passengers and weighed 37,990 pounds. (Kenneth C. Springirth photograph)

On September 29, 2001, Kenosha Transit PCC car No. 4616 is on 56th Street at 8th Avenue in Kenosha, Wisconsin, on September 29, 2001, in its beautiful Cincinnati Street Railway Company paint scheme. This was originally car No. 4515, one of 50 cars Nos. 4500-4549 assembled by Canadian Car & Foundry Company in 1951 using equipment and parts furnished by the St. Louis Car Company for the Toronto Transit Commission (TTC). It became car No. 4616 in 1991 during a complete rebuilding program of 19 PCC cars that were renumbered 4600-4618. (Kenneth C. Springirth photograph)

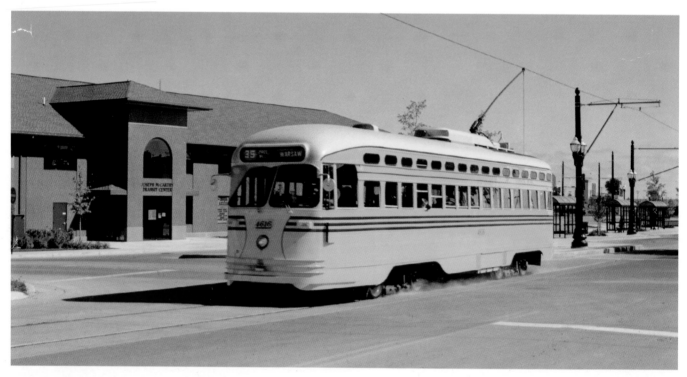

PCC car 4616 is passing by the Kenosha Transit Center on 54th Street at 8th Avenue in Kenosha, Wisconsin, on September 29, 2001. Following a November 23, 1995, TTC decision to remove PCC cars from service, this car was one of five purchased by Kenosha Transit. Since the TTC streetcar system has a 4-foot-10.875-inch track gauge, each car received type B-3 standard gauge trucks from the last of the Chicago PCC rapid transit cars for Kenosha's 4-foot-8.5-inch track gauge, general repairs, and a classic repainting representing an accurate PCC era paint scheme of a transit system. (Kenneth C. Springirth photograph)